GERMANS
IN *Louisville*
A HISTORY

C. ROBERT ULLRICH & VICTORIA A. ULLRICH, EDITORS

Foreword by Greg Fischer, Mayor of Louisville

THE
History
PRESS

Published by The History Press
Charleston, SC 29403
www.historypress.net

Front cover, bottom: Courtesy C. Robert Ullrich and Victoria A. Ullrich.

First published 2015

Manufactured in the United States

ISBN 978.1.62619.654.4

Library of Congress Control Number: 2015946485

In memory of J. William and Katherine H. Klapper

CONTENTS

FOREWORD

Germans are one of Louisville's oldest immigrant groups, having arrived in our city nearly two hundred years ago. In the nineteenth century, so many Germans immigrated to Louisville and other Ohio River cities that nearly 20 percent of our population was German born by 1850. The tide of German immigration did not subside until World War I.

German contributions to Louisville have been significant to our growth as a city. German immigrants brought with them a love of learning, music and art, as well as a physical prowess that was used to build many of the tangible structures we know today. Although the period of German immigration to our city has come to an end, more than one-third of the members of our community claim German ancestry.

Given that the last history of the German experience in Louisville was written in 1873, the addition of this book to the written history of our city is long overdue. As a fifth-generation descendant of Johann George Fischer of Zeiskam, Germany, and mayor of a city that embraces the importance and value of international diversity, I would like to thank those who were involved in writing this book for their contribution to our community, and I congratulate them on its publication.

Greg Fischer
Mayor of Louisville

ACKNOWLEDGEMENTS

We would like to thank everyone who contributed to this book, especially the chapter authors. We also would like to acknowledge John E. Kleber and Mary Jean Kinsman for serving as manuscript editors, Mary Ann Sherby for serving as copy editor and Jordan M. Gabbard for proofreading the German content of the manuscript.

Special thanks are due to Gill Holland for his initial encouragement to pursue this project, Reverend R. Dale Cieslik for his research assistance at the Archdiocese of Louisville Archives and the many individuals who graciously provided materials from personal collections. Finally, we would like to acknowledge the University of Louisville Archives and the Filson Historical Society for the use of their photographic collections.

1.

OVERVIEW

BY C. ROBERT ULLRICH, JANE K. KELLER
AND JOSEPH R. REINHART

Germans were one of the largest European groups to come to the United States. Although several Germans were part of the Jamestown colony, the first permanent German settlement in America was not established until 1683. In that year, Franz Daniel Pastorius led a group of Mennonites and Quakers from Krefeld, Westphalia, to found Germantown, northwest of Philadelphia.

About one-third of the Germans who came to America during the colonial period settled in Pennsylvania, where they became known as the "Pennsylvania Dutch." Most of the others who immigrated during this period went to Upstate New York, Maryland, Virginia and the Carolinas.

Among the early German immigrants to America were the Bruner, Blankenbaker and Funk families. Their descendants came to eastern Jefferson County as early as 1789, when Christ Lutheran Church was established near Brunerstown (now Jeffersontown). The early settlers of Jeffersontown included many German-speaking migrants from the Germanna colonies of Virginia, as well as others from Maryland and Pennsylvania and a few new arrivals from Germany.

Many settlers of German ancestry also were found in Louisville in the late eighteenth century. Among these was a Mr. Kaye, who built the first brick house in the city in 1789. However, it is believed that the first German-born immigrant to settle in Louisville was Augustus D. Ehrich, a master shoemaker from Königsberg, Prussia, who arrived in 1817.

German immigration to Louisville progressed slowly in the early nineteenth century until the introduction of steamboat travel on the Mississippi and Ohio Rivers. As upriver travel from New Orleans became easier, the German populations of river cities, such as Evansville (Indiana), Louisville, St. Louis and Cincinnati, began to flourish.

By the 1830s, distinct German immigrant neighborhoods had formed both east and west of the Louisville city center. The first churches in which German was spoken were established in the eastern neighborhood known as Uptown (now Phoenix Hill). St. Paul Evangelical Church, the first German Protestant church in Louisville, was founded in 1836. St. Boniface Catholic Church, the first German Catholic church and only the second Catholic church in the city, was established in 1837. St. John Evangelical Church was founded in 1843, the Zion Reformed Church was established in 1849 and St. Martin of Tours Catholic Church was founded in 1853. Other German Protestant churches founded before the Civil War included Methodist and Baptist churches, but the first Lutheran church was not established until 1878.

Franz Daniel Pastorius sculpture, Philadelphia. *Courtesy Library of Congress.*

In the western neighborhood, Immaculate Conception (St. Mary) Catholic Church was established in 1845. St. Peter Evangelical Church was formed in 1847, and St. Luke Evangelical Church was founded in 1850. St. Peter Catholic Church was established south of Broadway in 1855.

Temple Adas Israel, the first Jewish congregation in Louisville, was organized by German immigrants in late 1842, and it was chartered early the next year. Adas Israel was reformist in its outlook, so in 1851, Beth Israel was founded to serve more traditional Jews.

In 1849, the administration of St. Boniface Catholic Church was assumed by Austrian Franciscan priests assigned to Louisville from Cincinnati. Later, St. Martin of Tours Church and several other German Catholic churches also were staffed by the Franciscans. In 1858, Bishop Martin J. Spalding sent Father Leander Streber, OFM, the pastor of St. Martin of Tours Church,

to Germany to seek nuns to teach German children in his parish and other parishes in the Diocese of Louisville. Three Ursuline sisters from Straubing, Bavaria, arrived in Louisville that year and immediately began teaching at St. Martin of Tours School. By the turn of the century, Ursuline sisters staffed all of the schools in the German-speaking Catholic parishes.

Schools also were established by several German Protestant congregations, most notably St. Paul Evangelical Church and St. John Evangelical Church. Both the First German Lutheran Church (now Concordia) and the Second German Lutheran Church (now Redeemer) organized long-lived schools in the late nineteenth century.

The first of the German public schools, the Freie Bürgerschule, was established in 1852. The German-English Academy, attended by future Supreme Court justice Louis D. Brandeis, was founded by William N. Hailmann in 1865. Hailmann established one of the first ten kindergartens in the United States at his school. All of the German schools, public and parochial, were noted for their emphasis on bilingual education.

St. Joseph Catholic Orphan Society was founded in 1849 in the wake of a cholera epidemic. Father Karl Boeswald of Immaculate Conception Church and Father Otto Jair, OFM, of St. Boniface Church collaborated to establish the society, which later had branches at six German Catholic parishes. The German Protestant Orphan Asylum was established in 1851, and the German Baptist Orphan's Home was founded in 1871.

There were at least twenty-eight German-language newspapers in Louisville. The first of these, the *Volksbühne*, appeared in 1841 but was short-lived. The *Beobachter am Ohio*, which had the support of liberal Germans, lasted from 1844 to 1856, and the *Volksblatt* and *Omnibus* were published well after the Civil War. However, the most successful German-language newspaper was the *Louisville Anzeiger*, first published on February 28, 1849. The *Anzeiger* became a daily newspaper several months after its founding and did not cease publication until 1938.

German brew masters practiced their skills in many breweries both small and large, such as Armbruster's Brewery, the Frank Fehr Brewing Company, Senn & Ackermann Brewing Company and the Oertel Brewing Company. German beer gardens abounded, the most popular of which was Woodland Garden, founded in 1848. Phoenix Hill Park, another popular beer garden, was associated with the Phoenix Brewing Company. Also, Germans were important in the whiskey industries with the Weller Brothers, the Stitzel Brothers and the Bernheim Brothers being among the most prominent.

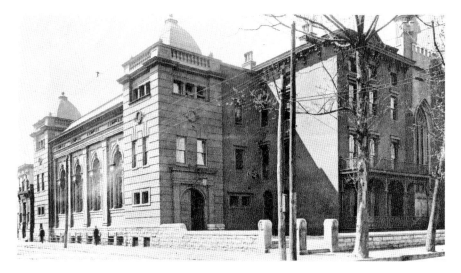

Liederkranz Hall. *Courtesy Filson Historical Society.*

The Liederkranz Singing Society was founded in 1848. This society was one of the founding members of the Nord-Amerikanischer Sängerbund (North American Singers Association) and hosted its second *Sängerfest* (singing festival) in 1850. The Orpheus Choral Society, founded in 1849, was one of the most prominent among the Louisville singing groups. In 1865, the Singing Federation of Louisville was founded and included the Liederkranz, Orpheus and Frohsinn singing groups. The first Liederkranz Hall, located on Market Street, was completed in 1873 and became the center of German social life in Louisville. Also, a number of Germans were members of the Louisville Philharmonic Society, which once was conducted by the Bavarian Louis Hast.

The Louisville Turnverein, among the first of the German gymnastics societies in the United States, was founded on September 2, 1850. The first *Turnfest* (gymnastics festival) in Louisville was held in 1852 on the Stein and Zink farm on Salt River Road. In 1854, the Turnverein dedicated the first Turner Hall on Market Street between Third and Fourth Streets. Many of the early Turners had liberal political views and were regarded with suspicion by American-born citizens.

German businessmen established many financial institutions, but the best known was the German Insurance Company, founded in 1854. In its early history, the German Insurance Company conducted business both as an insurance company and also as a bank. However, in 1872, new state

German Insurance Company, about 1889. *Courtesy University of Louisville Rare Books.*

laws made it necessary to separate the insurance and banking functions of the company; thus, the German Insurance Bank was established. By this time, too, the company had outgrown its original building, so a new building was planned on the north side of Market Street between Second and Third Streets. The new structure, designed by C.L. Mergell, opened amid much fanfare in 1887.

The German Bank, founded in 1869, erected a building at Fifth and Market Streets in 1914, which is now on the National Register of Historic Places. Other well-known German financial institutions included the German Security Bank, established in 1867, and the German National Bank, founded in 1875.

By 1850, the German-born population of Louisville had grown to 7,502, which was about 20 percent of the total population. Including the children of German immigrants, about 12,500 persons were members of German households. About half of the German-speaking population was Catholic.

The unsuccessful European revolutions of 1848 resulted in the immigration of many educated Germans to the United States, where they became known as Forty-Eighters. The Forty-Eighters, who advocated liberal political views, were extremely outspoken. Most German immigrants, especially those with strong religious beliefs, did not agree with the Forty-Eighters, whose actions colored the opinions of American-born citizens about Germans.

The Forty-Eighters, unable to align themselves with any of the established national political parties, formed the Bund Freier Männer (League of Free Men) in 1853. A group of these men in Louisville, led by newspaper editor Karl Heinzen, authored the *Louisville Platform*, which was published in March 1854 and espoused the abolition of slavery, equality of women and other liberal principles. These ideas conflicted with the philosophy of the anti-foreigner, anti-Catholic American ("Know-Nothing") Party, which found broad support in Louisville. George D. Prentice, the editor of the *Louisville Daily Journal*, supported the American Party in a series of inflammatory editorials preceding the gubernatorial and congressional elections of August 1855.

On election day, Monday, August 6, 1855, American Party committees, supported by the police, took control of the polls and attempted to allow only card-carrying American Party members to vote. Fights broke out and violence escalated as nativist mobs ransacked and burned German businesses and homes in the Uptown neighborhood. Only the intervention of Mayor John Barbee prevented the destruction of St. Martin of Tours Church and the newly constructed Cathedral of the Assumption. After leaving German

neighborhoods, rioters proceeded to Irish neighborhoods on West Main Street, where Quinn's Row was burned and owner Francis Quinn was killed. Father Karl Boeswald, the pastor of the German Immaculate Conception Church, was called to attend an injured parishioner and was mortally wounded by stone-throwing rioters as he left the church rectory. On August 7, the *Louisville Daily Journal* reported that twenty-two had died in the riots, but other estimates suggest that many more were killed. Following Bloody Monday, many Germans left Louisville, and those who immigrated later avoided Louisville in favor of other cities. The 1860 census of Louisville showed that the German population of Louisville had decreased to less than 20 percent of the total population.

German immigrants were among the strongest supporters of the Union during the Civil War. They voted overwhelmingly for pro-Union candidates in state elections in 1861, helping to ensure that Kentucky stayed in the Union. Out of a total German population of about 13,000, more than 1,200 men joined the Union army. In addition, German-born residents of Louisville contributed money to the Union cause, volunteered for work in hospitals and prepared meals and made clothing for soldiers. Turner Hall was converted into a hospital for sick and wounded soldiers. German contributions to the Union cause did much to change the attitudes of native-born Louisvillians toward them. Even *Louisville Daily Journal* editor George D. Prentice wrote articles praising the German immigrants. In 1865, Louisvillians elected their first German-born mayor, Philipp Tomppert.

German immigration slowed during the Civil War but resumed in earnest afterward, reaching a peak in 1882. Germans were active participants in the economic and professional expansion of Louisville in the post–Civil War period. By the end of the century, Ahrens & Ott Manufacturing Company (the predecessor of American Standard) was engaged in producing plumbing fixtures. The Henry Vogt Machine Company made steam boilers, while the C.C. Mengel & Brother Company manufactured wood products. J.F. Hillerich & Son was one of several Louisville businesses that manufactured bats for the new American pastime of baseball.

Germans were well represented in the food industries, such as wholesale and retail groceries that sold meats, produce and dairy products. Butchertown was an area of Louisville where many Germans established meatpacking businesses. The Fischer Packing Company was founded in 1899 by Henry Fischer, a German immigrant. In addition, Germans, especially German-speaking Swiss, were involved in dairying, with family farms operated by the Zehnders, Von Allmens, Bisigs and Ehrlers being among the best known.

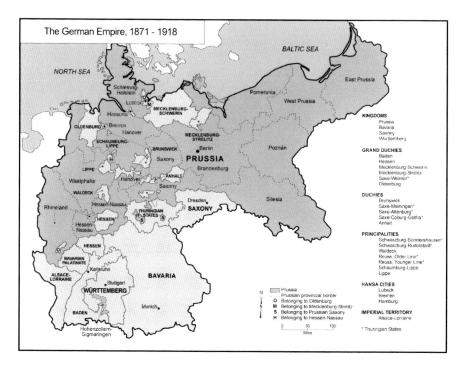

Germany at the peak of immigration to America. *Copyright German Historical Institute, Washington, D.C., and James Rettalack, 2007.*

While many Germans were engaged as hoteliers, none were more successful than Louis and Otto Seelbach. Louis Seelbach emigrated from Bavaria in 1869 and opened his first tavern on Main Street in 1874. His brother Otto joined him in 1878, and they opened a hotel at Sixth and Main Streets in 1886. After nearly twenty years, the Seelbachs were able to build a grand Beaux-Arts hotel at Fourth and Walnut Streets, which was completed in 1905. That hotel is famous for its European marble and wood construction and for its Rathskeller, which is decorated with Rookwood pottery tiles. Although the Seelbachs sold their hotel in 1926, it still operates as the Seelbach Hilton Louisville.

Many Germans were engaged in the restaurant business from the very early days of immigration to Louisville. However, the best-known German restaurants were, undoubtedly, the Vienna Bakery & Restaurant and Kunz's "The Dutchman" Restaurant. The Vienna opened in 1893 and relocated to an Art Nouveau building on Fourth Street in 1905. Kunz's was established as a wholesale liquor establishment in 1892 and then became a delicatessen and, finally, a restaurant in 1941.

Several well-known Louisville department stores were established by German immigrants. These included Levy Brothers, founded by Henry and Moses Levy in 1861; Kaufman-Straus, begun by Henry Kaufman in 1879; and Besten and Langen Company, founded by Henry Besten about 1892. Loevenhart & Company was established in Lexington, Kentucky, by the German brothers Lee and Henry Loevenhart in 1867, and they opened a Louisville store in 1898. Byck Brothers & Company, founded by Louis and Werner Byck, was established in 1902.

German bakeries and confectioneries were found throughout Louisville. Many original German bakeries still exist, among them Heitzman's Bakery and Plehn's Bakery. Ehrmann's Bakery was located in the Mid-City Mall until the mid-1990s. Schimpff's Confectionery, still operating in Jeffersonville, Indiana, was opened by German immigrant Gustav Schimpff in 1891.

Many Germans were involved in the fine arts in Louisville. For example, Carl Christian Brenner, an emigrant from Lauterecken, Bavaria, gained notoriety as the most important Kentucky landscape artist of the nineteenth century. Joseph Krementz, the "dean of Southern Indiana's artists," was a well-known portrait and landscape painter and professional photographer. The American painter, photographer and ethnographer Frederick Weygold, the son of German immigrants, was active in the Louisville arts scene in the 1920s and 1930s.

Germans found prominence in service industries as photographers, jewelers, cabinetmakers, florists and blacksmiths. When commercial photography became common after the Civil War, many Germans, such as Daniel and Michael Stuber, Edward Klauber, J. Henry Doerr and Paul Günter were proprietors of well-known studios. Buschemeyer's Jewelers was established by German native William J. Buschemeyer in 1865. Edward Krekel, the son of a German immigrant, started a clock repair business in 1892, which became a family-held jewelry business for three generations. In 1854, furniture maker Gustave Bittner started a cabinet shop that would become one of Louisville's longest continuously operating businesses. German immigrants Henry Nanz, Jacob Schulz and Victor Mathis were founders of well-known Louisville floral businesses. Jacob Hutt, a native of Grunbach, near Schorndorf, Württemberg, established a blacksmith shop in 1888. The business, located at Seventh and Breckinridge Streets since 1894, was last operated by a grandson, J. Fred Hutt Jr., in the 1990s.

Embalmers and undertakers were prominent in Louisville's German community. The best known of these were the brothers John and George Ratterman, Henry Bosse and Herman Meyer. Several major cemeteries

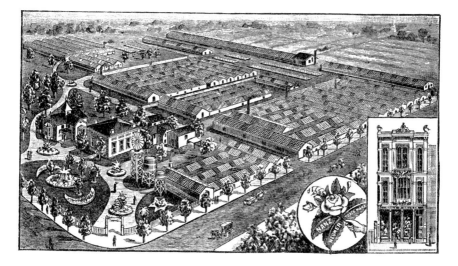

Nanz & Neuner's florist, farm and greenhouses, about 1900. *Courtesy Nanz & Kraft Florists.*

were established for Germans, including the Catholic St. Mary (now St. John) Cemetery, founded in 1849; St. Michael Cemetery, founded in 1851; and the independent St. Stephen Cemetery, established in 1851. Also, many Jewish German immigrants were interred in Adath Israel (Hebrew) Cemetery, located at Preston and Woodbine Streets.

In 1900, Louisville's population totaled 204,731, which included 13,263 Germans and about 35,000 persons who claimed at least one German-born parent. As the German immigrant population of the nineteenth century was assimilated, identifiable German customs and institutions began to fade. German neighborhoods, such as Uptown, Butchertown and Germantown, gradually changed as businesses encroached and the population moved to newer neighborhoods. German churches began giving sermons in English, and German Catholic parish schools began instruction in English.

When World War I began in 1914, American sympathies identified with the Allied cause against Germany. *Courier-Journal* editor Henry Watterson, who had once professed admiration of Germans, reversed himself to take a staunch anti-German position. As anti-German sentiments prevailed in Louisville, many German institutions changed names to downplay their German identities; for example, the German Insurance Bank became the Liberty Insurance Bank, and the German Bank became the Louisville National Bank.

Mainz vice-mayor Giesla Thews and Louisville mayor Jerry Abramson toast at Strassenfest, 1991. *Courtesy Louisville Third Century.*

As World War II approached, many of the early German churches, located in inner-city neighborhoods, were in decline, and they closed after the war. The *Louisville Anzeiger*, which had existed as a German-language newspaper for eighty-nine years, ceased publication in 1938. Among the thousands of Louisvillians who fought to defeat Nazi Germany in World War II, many were descendants of German immigrants.

Today, almost one in three persons in Jefferson County claims Germanic heritage. This heritage is preserved by such social and civic organizations as the German-American Club Gesangverein, the Gruetli Helvetia Society and Sister Cities of Louisville. Louisville has celebrated its Germanic heritage as a part of the Heritage Weekends of the 1970s, as Strassenfest in the 1980s and 1990s and as part of WorldFest since 2003. In 1977, the City of Louisville began a civic and cultural association with Mainz, Germany, the birthplace of Johannes Gutenberg. The two cities officially became Sister Cities in 1994. Oktoberfest is widely celebrated in Louisville each year, and for those brief days, everyone is "German."

2.

IMMIGRATION, XENOPHOBIA AND BLOODY MONDAY

BY JOHN E. KLEBER

Remember, remember always that all of us, you and I especially, are descended from immigrants and revolutionists." So spoke President Franklin D. Roosevelt to the Daughters of the American Revolution in April 1938. He reiterated this sentiment in a campaign speech in 1944, reminding Americans that all of our people, except the pure-blooded Native Americans, descended from immigrants, even those who came over on the *Mayflower*. Roosevelt himself was the scion of an old Dutch family. The Dutch were among the earliest immigrants to North America. In the ensuing years, however, their numbers were small when compared to the larger numbers coming from other European countries. In the history of the United States, from the colonial period through the nineteenth century, no country sent more of its peoples to what Thomas Paine called an "asylum for mankind" than did Germany. In time, Germans moved westward into Kentucky and especially to Louisville. There they would find a rising center of business and industry and an opportunity to build a strong German community.

What would compel some six and a half million Germans to immigrate to the United States in the years between 1820 and 1955, as well as those who came earlier and later? The answers are multifaceted and complex. They involve both the pull of this country and the push away from the fatherland. The greatest pull would be economic opportunity resulting in a higher living standard. America had an abundance of good and cheap farmland at the same time that it was made rich by the growth of industrial capitalism. The idea of owning one's own land or business was strong. Then, too, the pull

of American political and religious freedom would set in motion another army of emigrants. However, the idea of freedom was less significant for Germans than for some other European groups. Some religious and political radicals did come, especially following the failed revolutions of 1848, but their numbers were small. The push, says historian Oscar Handlin, started in the peasant heart of Europe. The structure of an old society began to crumble as the modernization of Germany and population growth made jobs hard to find. Rich farmers saw a bleak future, and poor farmers saw no future at all. Overpopulation, overproduction, overcrowding in farming areas, the ruin of small industries in competition with the new factory system and artisans left destitute due to cheaper manufacturing were all reasons precipitating emigration.

It is difficult to generalize about who came from Germany, for there was a great diversity in its emigrant population. Germans came with different interests and expectations, and financial means varied. Indeed, it is difficult to say who was German. Separate states existed prior to 1871. For purposes here, those peoples who came from the unified states under Prussian leadership will be considered "German." In earlier years, especially before the Civil War, Germans migrated as family groups. The family as an economic unit and as the cornerstone of the social structure was important for most Germans. A dominant role would be played by fathers, and even

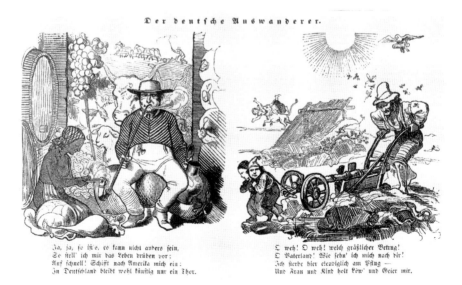

"The German Emigrant," from the *Fliegende Blätter*, 1845. *Courtesy AKG-Images, Ltd.*

in later years, few women were employed outside the home. Indeed, family solidarity would be one of their greatest strengths and a bastion of stability. Most were Protestant, but there were a large number of Roman Catholics and smaller numbers of Jews and atheists. The earliest immigrants came from rural and agricultural southern and western areas. Later, every part of Germany was represented by emigration. Some were peasants and paupers whom the state paid to leave. Some came with money to purchase land or establish a business. Some came with a skill or trade. But in general, it can be said that few ethnic groups have been as varied in religious belief, political persuasion, socioeconomic status, occupation, culture and social character.

Once the decision was made to emigrate, it was necessary to move toward a seaport and find a ship bound for America. This was the most harrowing part for all emigrants, and the experience could be numbing. It required making one's way to the seaport, the voyage, checks of identity and citizenship and examinations for disease and disability. Then, with hands filled with bits of paper and if one was lucky, it was off to a new home. If one had money, travel to an embarkation port was made easier by the railways. If poor, emigrants walked and rode in wagons. One observer noted, "There they go slowly along; their miserable tumbrils drawn by such starved drooping beasts that your only wonder is, how can they possibly reach Havre alive."

Havre was but one port of embarkation. Some traveled to Holland, especially Rotterdam, to sail. Other ports included Bremen, Hamburg and Liverpool. Once aboard ship, there was no telling how long the voyage would take. Journeys of four weeks to half a year were recorded. There were instances of piracy and mutiny. Since ship owners sought profit, provisions were often insufficient and overcrowding common. Crew members were sometimes rough, domineering and cruel. Emigrants faced poor sanitation, cholera epidemics, fevers and storms. Death rates aboard ships could reach as high as 50 percent. On September 13, 1858, a fire aboard the *Austria*, bound from Hamburg to New York, killed 453 of 542 passengers. No wonder the crossing was called a harsh and brutal filter. Emigrants may well have heeded the advice of a Swiss who said, "Whoever wishes to go to the New World should be sure to take a sack of money and also a strong stomach so he can withstand the demands of the ship."

Over the years, there were many ports of entry. Every colony had at least one to welcome immigrants. In later years, none was more important than New York City, where Castle Garden opened in 1855 and Ellis Island in 1892. Before 1820, some Germans became indentured servants. It is

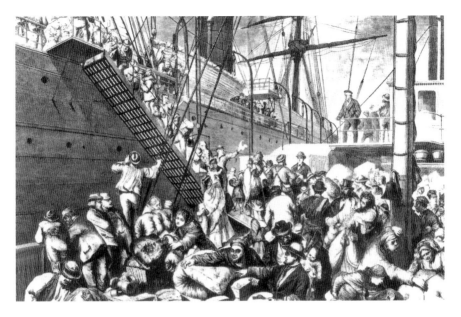

German Emigrants Boarding a Ship in Hamburg. Harper's Weekly, *November 7, 1874.*

estimated that half of all early immigrants financed their voyage in this manner. In a procedure known as "redemptioning," agents loaded ships with men and anchored in an American harbor where they were sold to the highest bidder. Naturally, this led to abuses when they fell into the hands of unscrupulous men who exploited their services. On the positive side, it hastened assimilation and provided a modicum of capital to begin life as a free person.

While most German immigrants would remain, not all did so. Like immigrants from all groups, some returned home when they did not find streets paved with gold. While most letters back to the fatherland lauded the opportunities America afforded, an occasional warning was sent. An 1859 guide advised certain types to stay away stating, "a sloppy student would end up a frantic Methodist preacher; a discarded lieutenant would end up splitting wood or boiling soap; a proud Baron would end up driving a team of oxen; a Catholic priest might end up with a wife and child, happily farming; but a clever stable hand is now in charge of one of the largest business places in St. Louis."

In the colonial period, no colony was more important for German immigrants than Pennsylvania. William Penn encoded religious principles in its laws, providing toleration for certain forms of Christianity.

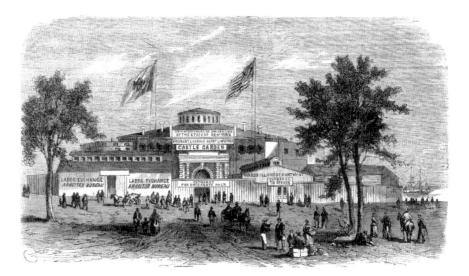

Castle Garden. Courtesy Heritage Ships: Emigrant Ship Images.

Penn recruited Germans to Pennsylvania, and their letters back home encouraged others to follow. The first to come was a group of Mennonites and Quakers who left Krefeld, Westphalia, and arrived in Philadelphia on October 6, 1683, aboard the *Concord*. With their leader, Franz Daniel Pastorius, they established Germantown, the first permanent German settlement in America, about six miles northwest of the city. After Pastorius, many others followed, and as they moved westward, they acquired farmland. In general, these farms were larger than those of their Anglo neighbors'. Their care for the land was proverbial, and it was said they took better care of it than of their children. Yet they produced in their children not only a habit of labor but a love of it. They were known for thrift, industry, punctuality and justice. It is little wonder that all colonies wanted Germans to settle in them. However, when they did, they preferred to keep to themselves, separate from the prevailing Anglo population. Many had their own brand of religion. Although separated, these German communities kept in touch with one another. For this reason, the German language and culture had a strong influence in Pennsylvania. In 1729, Thomas Mackin celebrated Pennsylvania's appeal with these words: "Twas hither first the British crossed the main; Thence many others left their native plain; Hibernia's sons forsake their native homes; And from Germania, crowded vessels come."

The historian Frederick Jackson Turner said all of American history can be explained in terms of the moving frontier. While that is questionable, no doubt the movement of peoples westward gave them and the nation unique characteristics. Germans who came later had no choice but to go west to acquire land. There they joined the Scots-Irish as true frontiersmen, forming the outer edge of settlement. Germans accompanied Daniel Boone on most of his expeditions into Kentucky. Fertile lands drew them into the vast interior of America. Germans from every colony fought in the American Revolution. They constituted part of the army of George Rogers Clark when it camped at the Falls of the Ohio in 1778. Following the war and until 1820, there was a decline in immigration. Partly this was due to the Napoleonic Wars making travel dangerous, if not impossible. Economic uncertainty and reactionary forces governed the post-Napoleonic period when liberals and democrats were persecuted and others impoverished. For that and other reasons, emigration from Germany increased. For fifty years after 1850, Germany would supply more immigrants than any other country.

In the early nineteenth century, transportation partly determined German settlement patterns. Following the opening of the Erie Canal, many Germans settled along the Great Lakes in Chicago and Milwaukee.

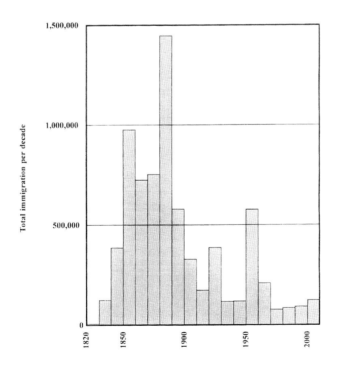

German immigration to America by decade, 1820–2010. *Data from U.S. Department of Homeland Security.*

Germans came to river cities such as Cincinnati, Louisville, Evansville and St. Louis by traveling the Ohio and Mississippi Rivers. Records indicate that Augustus D. Ehrich was the first German in Louisville, arriving in 1817. The first significant numbers of Germans arrived in Louisville in the 1820s. By then, it was becoming the premier city of Kentucky, mainly due to the river and the invention of the steamboat. The need for transport around the falls brought growth. And the building of the Portland Canal required large numbers of manual laborers. Boat building and commerce brought wealth. All of this meant jobs, from manual laborers to skilled artisans.

If the rigors of travel are any indication, then these Germans arrived in Jefferson County exhausted and ready to find what Handlin called their daily bread. The earliest Germans settled in the Jeffersontown area on self-sufficient farms. There they had large families of eight to ten children. It was good land and healthier than the city. But a larger number would seek out the city, beginning what was called their urban careers as shopkeepers, mechanics, tavern owners and laborers. Some took up urban life to get money to purchase a farm, but they were few. In time, Louisville was to offer a "rich, concentrated German life." But it was a life typical of the German propensity to remain apart. While they did not live in ghettos, they did reside on different streets in clearly delineated sections of the city in what may be called ethnic enclaves. There Germans tenaciously held on to old values, including their language. The result was the publication of many German newspapers and a prevalence of the language in church services. Indeed, religion survived the transfer and became a way to stay connected to the past. Both Protestant and Catholic religions became rigid and more conservative. In their apartness, Germans created a great variety of formal and informal institutions. Chief among them was the tavern or saloon where Germans gathered to socialize and drink beer. It was said one person would open a saloon so that two others would have a place to argue. All of this created the impression among the native-born Americans that Germans not only did not want to be assimilated but also perhaps could not be.

In their neighborhoods, two immigrant Americas existed. One consisted mainly of workers with menial jobs. The other held positions in which individuals pursued personal gain and leadership. These were two separate but related worlds—working class and middle class. While both clung to the past, especially in religion, they readily bought into the capitalistic system as part and parcel of the present, offering immediate and attainable goals—namely, a livelihood. But in time, Germans recognized that politics was also part of the present and might be another means to personal

advancements. The exercise of that right would lead to profound anti-German feelings culminating in the Bloody Monday riots.

While most Germans were strangers to politics because they had no European experience with such, the early Forty-Eighters were an exception. In May 1848, an assembly of elected German representatives met in Frankfurt, where they organized a provisional democratic government. Lacking an army and failing to secure popular backing, many fled into exile. They numbered between four and ten thousand, and some came to Louisville. Strong-headed intellectuals, they also found much wrong with America. In 1854, they published the *Louisville Platform* calling for public land grants, civil rights, minimum wages, reduction of the workday, free schools, human rights, abolition of slavery, free trade, equality for women and an end to the death penalty. Such liberal and radical ideas strained relations with native-born Americans and must be counted as another cause of the riots.

But no one or two causes can explain Bloody Monday. Rather, its roots lie deep in the character of the American nation—a melting pot of many peoples and ethnic diversities. Xenophobia, an inordinate hatred of foreigners, has been present since the first Englishman set foot at Jamestown. In the following years, it has taken different forms and known different degrees. One early example was found in the Alien and Sedition Acts. Here, too, the cause was political and a fear of the rising power of Republicanism based on immigrant support. Of all the early immigrant groups, the Irish and German were pointed out for the most extreme feelings of xenophobia. No less than Benjamin Franklin feared the German language and culture would take over Pennsylvania. In 1751, he wrote:

> *Why should the Palatine* [those who fled the war of Spanish Succession] *boors be suffered to swarm into our settlements, and, by herding together, establish their language and manners, to the exclusion of ours? Why should Pennsylvania, founded by the English, become a colony of aliens, who will shortly be so numerous as to Germanize us instead of our Anglicifying* [sic] *them, and will never adopt our language or customs any more than they can acquire our complexion?*

At the basis of Franklin's fears were large numbers of Germans inhabiting Pennsylvania. Beginning in 1850, increasing numbers of Germans came to America and to Louisville. Whereas 385,000 came in the 1840s, that number would increase to nearly 1 million in the 1850s. In 1850, when Louisville had a population of 43,194, 7,502 persons were German-born. By 1855, there

were twelve German churches and two synagogues, four parochial schools, two orphan asylums, German-language newspapers, a bank and too many political and social organizations to mention. Many of them were Roman Catholic, and they knew the power of the ballot box.

Midcentury nativism emerged first in the Democrat Party and then among the Whigs, who were losing power and saw this as a means to regain strength. As early as 1837, a nativist Whig coalition was able to elect a mayor in New York City. Several movements coalesced in the 1840s, out of which emerged a mysterious organization that asked its members but one question: "Are you willing to use your influence and vote for native-born American citizens for all offices of honor, trust or profit in the gift of the people, the exclusion of all foreigners and Roman Catholics in particular and without regard to party predilection?" Nor were they reluctant to use subterfuge or even violence to achieve their goals. Insurance companies refused to insure Catholic institutions. A priest in Maine noted that "since the 4th of July I have not considered myself safe to walk the streets after sunset." Convents and churches were likewise seen as something to attack. Horace Greeley called the instigating group Know-Nothings.

The violence in Louisville known as Bloody Monday lay in politics— namely, the election for congress and state offices in 1855. Nativists felt the fate of the whole nation depended on the outcome, greatly increasing the stakes. Earlier that year, John Barbee had been elected mayor. He was a Know-Nothing who saw that polling sites were manned by their partisans. Supportive of the mayor and movement was the renowned editor of the *Louisville Daily Journal* George D. Prentice. He called immigrants beggars, vagrants, scoundrels and knaves. When a rival editor pointed out that the founder of Christianity was a foreigner, Prentice used his wit to reply, "Why, yes, he came from Heaven, and we are afraid that Heaven will always be a foreign country to you." Much more sinister, on the morning of the election, August 6, he wrote in an editorial, "Let the foreigners keep their elbows to themselves today at the polls. Americans are you ready? We think we hear you shout 'ready,' well fire! And may heaven have mercy on the foe."

The dawn over Louisville on that Monday morning promised another sweltering day. Already, tension filled the humid air. It is impossible to determine what precipitated the riots. Since polling places were too few and under the control of the Know-Nothings, many foreigners were unable to vote. That poisoned the atmosphere. In the afternoon, east of downtown, Know-Nothings, now in a mob, ran through streets, ransacking shops, taverns and homes; beating up passersby; and setting fires. St. Martin of

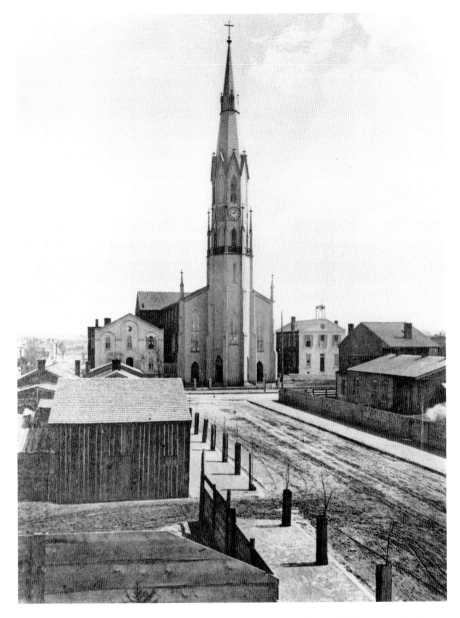

St. Martin of Tours Church, about 1870. *Courtesy University of Louisville Photographic Archives.*

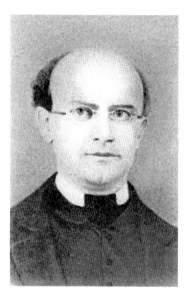

Father Karl J. Boeswald. *St. Joseph Orphan Society Diamond Anniversary Volume, 1924.*

Tours Church was barely saved from the torch by the heroic efforts of Mayor Barbee. Armbruster's brewery near Beargrass Creek was burned. Later in the day, the mob turned on the Irish area west of downtown, setting fires and bludgeoning residents. Father Karl Boeswald, the pastor of Immaculate Conception Church, was stoned by the rioters and died of his injuries a few months later, in November. An area known as Quinn's Row was burned. When its inhabitants attempted to escape, several were shot to death. The glow from that fire could still be seen early in the morning of August 7 as the stench of death hung over the city. The reported number of dead varies from nineteen to twenty-two. Bishop Martin J. Spalding thought it greater when he wrote to a friend, "We have just passed through a reign of terror...Nearly a hundred poor Irish and Germans have been butchered or burned and some 20 houses have been fired and burnt to the ground."

Very quickly, there was a feeling of regret. Prentice publically noted his mistakes. The city voted five hundred dollars as compensation to go to the most needy. In 1860, the General Assembly authorized the Louisville city council to compensate for property burned, destroyed, damaged or taken. It is difficult to say how many were compensated. Also, five indictments followed, but all of the indicted were acquitted. More sinister was damage done to Louisville as a city. Trade and commerce were disrupted. German immigration declined, and some Germans moved away. Real estate values dropped. On the positive side, Philipp Tomppert, born in Württemberg, was elected mayor in 1865. This went far to reassure new German immigrants that Louisville was a welcoming city. Nativism was diverted by the Civil War, and large numbers of Germans fought for the Union cause. Greeley was proved right in predicting that the Know-Nothing movement "is likely to run its course rapidly and vanish as suddenly as it appeared," although prejudices against Germans continued.

Germans were active participants in the economic and professional expansion of Louisville after the Civil War. They became important in many

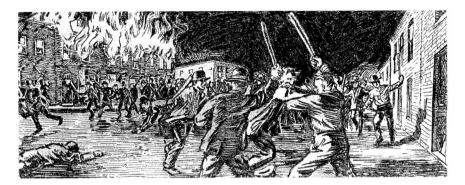

The Burning of Quinn's Row. Louisville Herald, *September 5, 1922.*

trades and manufacturing. More churches were opened, and an increasing number of social and cultural organizations began. The workplace, church, neighborhood and political bosses all competed for their attention. In 1882, German immigration to the United States reached its peak with nearly one and a half million arriving in the 1880s, some of these immigrants settling in Louisville, bringing their skills, training and work ethic. Once again, that large number was to generate another wave of xenophobia, but it was now directed at the new immigrants from southern and Eastern Europe. The Germans, who were rapidly being assimilated and would continue to constitute an ever-smaller percentage of the population of Louisville, might have avoided this feeling had it not been for the Great War, which renewed old fears and hatreds.

3.

CATHOLIC CHURCHES

BY WILLIAM C. SCHRADER

Located on the Ohio River, Louisville became a magnet for newly arriving Germans, coming from the later German empire but also Switzerland and Austria, in the early nineteenth century. In his presidential address to the American Catholic Historical Association meeting in Dallas in 1979, Eric Cochran noted that many immigrants who had been anticlerical or agnostic in the Old Country found a home in the ethnic parishes of American cities. Such parishes offered a familiar place, a taste of home, to newly arrived residents seeking to find their footing in unfamiliar surroundings.

The first priest specifically charged with the ministry to the Germans was Joseph Ferneding, who arrived in America in 1832 from Westphalia. Ferneding was ordained at Bardstown on July 25, 1833, and then assigned to assist Father Robert Abell at St. Louis Church in Louisville. He held Mass with a sermon in German, heard confessions in German and organized a school for the German-speaking children. This promising beginning was stalled when Father Ferneding left for the newly erected Diocese of Vincennes in 1834.

It was not until two years later, in November 1836, that another German-speaking priest arrived in the person of Joseph Stahlschmidt, a native of the Wupperthal region. A committee was formed to plan a new parish for the German-speaking Catholics of Louisville. Among its members was Simon Huber, of a family who appears often in the records down to the present. This committee selected a site for the new parish, named for St. Boniface (675–754), the Apostle to the Germans. They chose

a lot in Preston's Enlargement, located to the east of the town center, on the north side of Green (Liberty) Street between Hancock and Jackson Streets. The purchase was made on March 8, 1837, for $1,500. The cornerstone was laid during the summer of 1837, but it was not until November 1, 1838, that the new structure was formally dedicated by Auxiliary Bishop Guy Ignatius Chabrat, who conferred the sacrament of confirmation on about fifty persons at that time.

In November 1837, the Frauenbruderschaft zum heiligen Bonifacius was organized with seventy-four women. This was later known as the St. Anne Society, one of the oldest lay organizations in the city. These ladies made vestments, raised money for candlesticks and in innumerable ways contributed to make the parish a joyous place of worship. In 1838, a men's society was also organized but had only twenty-nine members.

This was a difficult time for the nation as a whole, with many bank failures and business closings, so raising money to continue paying off the building debt and maintain services was not easy. Late in the year 1838, Father Stahlschmidt left on a fundraising expedition. From New Orleans, he sailed for Mexico and was never heard from again. Fortunately, a successor was at hand in the person of Father Carl Blanc, a native of Freiburg in Switzerland who had studied in Rome and been recruited by Bishop Benedict Joseph Flaget in 1837. Blanc was ordained at Bardstown on October 28, 1838, and assigned to St. Boniface's when Father Stahlschmidt departed on his fundraising mission. The life of this gifted priest was cut short by brain fever on July 30, 1846.

Over the next three years, St. Boniface Church saw a variety of temporary appointments, but in 1849, the parish was entrusted to the Austrian-based Franciscans of the Province of St. Leopold. Father Otto Jair, OFM, a Tyrolian, was installed as the new pastor of St. Boniface's on July 19, 1849, serving for eight years. This provided the parish with much-needed stability. The Franciscan Friars continued to staff the parish for 148 years.

Under Father Lucas Gottbehoede, OFM, plans were advanced to build a new church. Permission was granted in 1898, with the new structure, designed by D.X. Murphy, dedicated on November 18, 1900.

The German Catholic population of Louisville continued to grow as immigrants arrived on a steady basis. At the time that Bishop Flaget moved the seat of the diocese to Louisville in 1841, he reported that the city contained about four thousand Catholics. Of those, about half were of German extraction. A second German ethnic parish was needed, and in the area to the west of the city center.

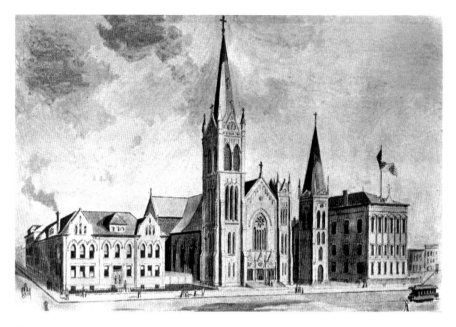

The original St. Boniface Church. *Courtesy Archdiocese of Louisville Archives.*

The parish of the Immaculate Conception of St. Mary was first formed in the basement of the Church of St. Louis in January 1845. Under the leadership of Heinrich Gieske, owner of the City Hotel, where many newly arrived Germans stayed until obtaining more permanent lodging, property was acquired at Eighth and Grayson Streets. A native of Damme in the Grand Duchy of Oldenburg, Gieske was called "der Plattdeutsche König." The new church was dedicated by Bishop Martin John Spalding on July 8, 1849. The first pastor was Karl Boeswald, a native of Weinding in Bavaria. He arrived in America in 1843, being ordained on November 5 of that year by Bishop Chabrat, and was entrusted with the spiritual direction of the Catholic Germans in the western parts of the city.

A significant lay organization begun at St. Mary Church that year was the St. Alphonsus Singing Association. Music played an important part in the life of the German community from the beginning. Important early members of the group include Heinrich Gieske, Heinrich Vogt and Frank Rattermann.

Shortly after the dedication of St. Mary Church, Father Boeswald became concerned about the orphaned children left behind by the high mortality rate of the time. With Father Jair at St. Boniface's and other

leaders of the German Catholic community, on August 5, 1849, an effort was launched to establish St. Joseph Orphans Asylum, which opened in 1850 on Eighth Street.

The influx of large numbers of Germans and Catholics provoked a reaction in the so-called Know-Nothing Party in politics. On election day, August 6, 1855, this resulted in the riots known as Bloody Monday. That same evening, Father Boeswald was called out to visit a sick parishioner. He was stoned by rioting mobs, resulting in an abscess that caused his death three months later on November 5, 1855.

In response to the continued increase in German Catholics, on July 24, 1853, in connection with the administration of the sacrament of confirmation at St. Boniface's, Bishop Spalding announced the decision to establish a third German ethnic parish. Property was purchased at Shelby and Kellar (Gray) Streets, with the parish dedicated to the Bishop's own patron, St. Martin of Tours. Entrusted with the organization of the new parish was Father Leander Streber, OFM, who had been serving as an assistant at St. Boniface's since 1849. On March 13, 1850, he was ordained to the priesthood by Bishop Spalding after studying for a time with Father Boeswald. The cornerstone of the new church was laid on October 20, 1853, with the formal dedication of the church taking place on August 20, 1854.

St. Martin's was a target of the Know-Nothings less than a year after the dedication. Mobs, convinced that weapons were stored there, threatened to burn the church. Only a tour of the facility by Mayor John Barbee saved the situation. Having weathered this storm, Father Streber set out to improve conditions among his parishioners. In 1857, he visited his native Bavaria, making contact with the Ursuline cloister at Straubing. Three sisters responded to his call led by Mother Salesia Reitmeier, arriving in Louisville on October 31, 1858, and taking charge of the parish school.

When the second pastor, Father Ludger Beck, OFM, left in 1888, Bishop William George McCloskey entrusted the parish to Franz Zabler, who had come as a Franciscan; however, he was dispensed from his vows to the order and was, by then, functioning as a diocesan priest. It was under Monsignor Zabler from 1888 to 1905 that St. Martin's reached its peak. The imposing school facing the church across Gray Street arose. The church building itself was expanded, and an impressive set of stained-glass windows from the Royal Bavarian Art Glass Institute in Munich were installed. A new pipe organ, called "one of the finest examples of nineteenth century organ building in the country," provided

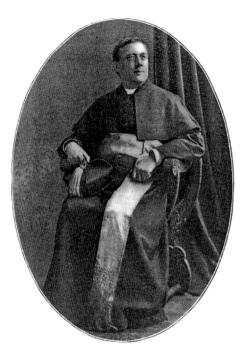

Monsignor Franz Zabler was the third pastor of St. Martin of Tours Church. *Courtesy St. Martin of Tours Church.*

music. One of the best-known treasures of St. Martin's, the relics of the Roman martyrs Saints Magnus and Bonosa, was acquired in 1901 and placed under the side altars.

The fourth German ethnic parish in Louisville was St. Peter's Church, founded in 1855, the year of the Bloody Monday riots. This was an extension southward from St. Mary Church, located at Seventeenth Street and Southgate (Garland) Avenue in what was called the California neighborhood. Called "the most beautiful church in the city in the Romanesque style," St. Peter's had as its first pastor the diocesan priest Martin Beyhurst. However, in 1860, the parish was placed in the care of the Conventual Franciscans with the appointment of Father Bonaventure Keller, OFM, Conv. These friars continued to supply priests for St. Peter's until the parish was closed in 1973. The parish was served by the Ursuline Sisters beginning in 1868. One of the more active lay organizations was the Knights of St. John, with St. Michael Commandery located in the parish from 1889. Among the active members of the parish were the Huber, Gottbrath, Heitzman, Wolpert, Goetz and Wittenauer families.

Initial steps were taken by Bishop Spalding in 1864 to found a fifth German parish, that of St. Joseph, in Butchertown under Leopold Walterspiel, a native of the Grand Duchy of Baden. A site was chosen on the south side of Washington Street between Adams and Webster Streets for a combination church and school building. Dedication of this structure was carried out on January 6, 1866.

The following year, the Ursuline Sisters were requested to assume responsibility for the parish school, with two sisters teaching 236 children in grades one through six. In 1875, at the request of Bishop McCloskey, the

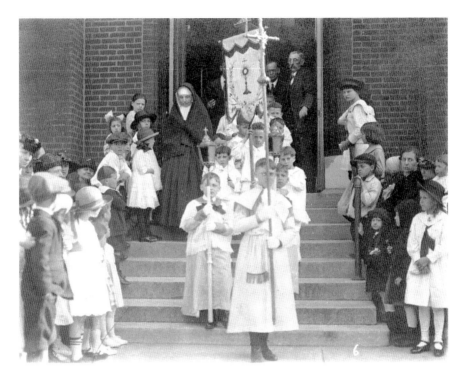

A first communion procession at St. Peter's Church, about 1940. *Authors' collections.*

Franciscans assumed responsibility for the parish, with Father Gottbehoede moving from St. Boniface's to set the parish on a firm foundation.

Initially, the parish included a significant Irish minority, but in 1876, this group organized its own parish of St. Columba, so St. Joseph's existed as a German ethnic parish until after World War I. Work began on the present church building in 1883, with the cornerstone laid on October 21 and the new church consecrated on September 12, 1886. The "twin steeples"—the tallest twin spires in Louisville, rising 175 feet—were completed in 1905 and 1906, with a one-thousand-pound bell installed in the west steeple.

Among the many who contributed to the development of St. Joseph Parish, mention might be made of the Oertel, Schindler, Lichtefeld, Zoeller and Liebert families.

Daughter parishes, spun off from the original five, include St. Anthony (1867–2011), St. Vincent de Paul (1878–1996), St. Francis of Assisi (1884–present), St. George (1898–1997), St. Elizabeth of Hungary (1906–present) and St. Therese of Lisieux (1908–present), all of which retained some

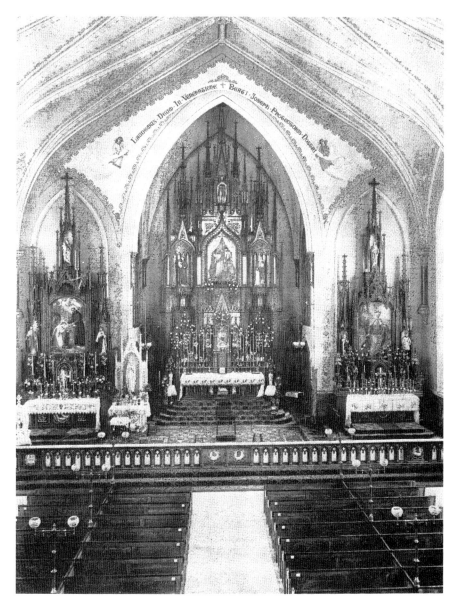

The interior of St. Joseph Church, about 1900. *St. Joseph Church Centennial Volume, 1966.*

German identity until after World War I. St. Mary's was abandoned in 1933, and St. Peter's in 1973. Today, there are no German ethnic parishes in Louisville. The greatest cause of this change was the impact of the two world wars. As a consequence of those struggles, Catholics of German descent

chose to emphasize their American identity. After World War I, the practice of preaching, publishing parish newsletters and bulletins and teaching classes in the schools in German ended. Probably the longest-lingering use of German was in the confessional, where some older parishioners did not feel comfortable in English as late as the 1960s. In addition, more and more people moved to the suburbs in ethnically mixed neighborhoods, abandoning the historically German areas.

4.

FRANCISCAN FRIARS

BY FATHER ADAM BUNNELL, OFM, CONV., AND FATHER CAMILLUS GOTT, OFM, CONV.

The Catholic bishops of the Ohio Valley were not prepared for the influx of Catholic immigrants beginning in the 1820s and increasing throughout the century. But the wave of Germans who came was a particular challenge because they did not speak English.

To their credit, the bishops of the Ohio Valley felt a responsibility to provide for the pastoral care of all the new Catholics. The first attempt in almost every case was to find a diocesan priest who could speak the language of the newcomers. An associate for St. Louis Church (now the Cathedral of the Assumption) with German skills could not meet the demand. Eventually, St. Boniface's was founded as a German-speaking diocesan parish. Rapid growth, however, called for more rigorous measures.

Eventually, the bishops turned to religious order priests to supplement the need. This was not an easy decision for a bishop. Religious orders at the time would take a parish mostly "in perpetuity," which meant that the local bishop had only minimal administrative and financial control. Women's religious orders were more welcome than religious order priests because they founded and staffed schools, hospitals and orphanages. Men's religious orders (other than priests), such as the Xaverian Brothers from Belgium, also were welcomed because of their service in the schools.

Yet the bishops' sense of pastoral need overcame everything else, and they knew that they needed help to adequately minister to a growing flock of German immigrants. The religious orders they turned to, however,

had their own issues to confront. All had faced a wave of secularization in Europe even before the American and French Revolutions.

The Franciscans survived better than most, but they themselves were divided. They were splintered into several groups, all claiming to be the "Original" Franciscans of the thirteenth century. Vocations in the German-speaking world were growing slowly, and as in every century, new recruits were of a mixed lot. Too often those who were sent as "missionaries" were among those who were hard to place at home. In addition, Franciscans had not traditionally seen themselves as called to staff parishes—that was diocesan territory.

One of the reform branches of the Franciscans (OFM) had already made this transition in Cincinnati and was staffing parishes there. Its headquarters were in South Tyrol, then part of the Austrian empire. Members of this order agreed to come to Louisville and in 1849 took over St. Boniface's, the first German Catholic church established here. They were to remain in Louisville and actually expanded their reach to St. Martin of Tours Church and St. Joseph Church, and occasionally, a German-speaking Franciscan would serve as an assistant in other parishes. The OFM (Brown) Franciscans did not leave St. Boniface's until 1997 and did not leave St. Joseph's until five years after that.

The other group of German Franciscans that arrived, the Conventuals, came from New York State. The Conventuals were connected to the Basilica of St. Francis and the Sacro Convento in Assisi, owned by the pope but served by the Conventuals since the thirteenth century. Originally referred to as "Greyfriars," the color of their habit was black when they arrived in America, and they came to be known as the "Black Franciscans." Some early Conventuals had gone to Texas but then had transferred to the East Coast with the new wave of immigrants. They were in New York and New Jersey and expanding to places as far away as California and Wyoming.

In Louisville, the Conventuals settled into St. Peter Church and St. Anthony Church. Eventually, they staffed St. Paul Church, the successor of St. Andrew

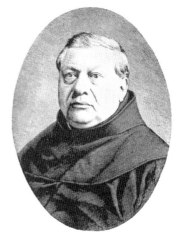

Father Otto Jair, OFM, was the first Franciscan pastor of St. Boniface Church. *St. Boniface Church Centennial Volume, 1937.*

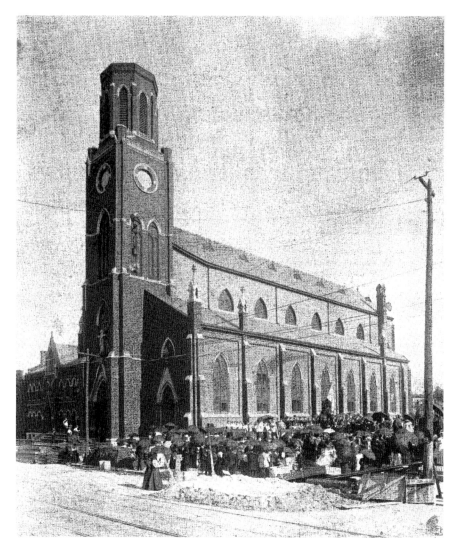

St. Anthony Church, 1887. *St. Anthony Church Centennial Volume, 1967.*

Church, which had been founded in 1851 in Jefferson County outside Louisville with mostly German but also some French and Irish parishioners. They also had accepted parishes in Clarksville and Terre Haute, Indiana, and founded a formation community on Indiana farm property known as Mount Saint Francis. Beginning in 1950, the Conventuals also provided a significant percentage of teachers for Bellarmine College, founded by the Archdiocese after World War II.

In many ways, this "holy gamble" turned into a blessing for the religious orders that came to Louisville. Parish histories indicate the large number of men and women who came from these parishes to become sisters, brothers and priests (mostly Franciscan priests). Louisville was good to both Franciscan groups, and the orders reciprocated.

The two Franciscan groups threw themselves into the task with gusto. It was culture as well as language that brought success. The rivalry between various German groups is hard to miss. One of the great accomplishments of the friars—but more especially of the parishioners they served—was that they were able to mold together those various "Germanies" into a cohesive whole in a parish that had a real sense of unity. (One must also mention the key role of the religious sisters, especially the Ursulines, who were the "silent" partners in building a strong community.)

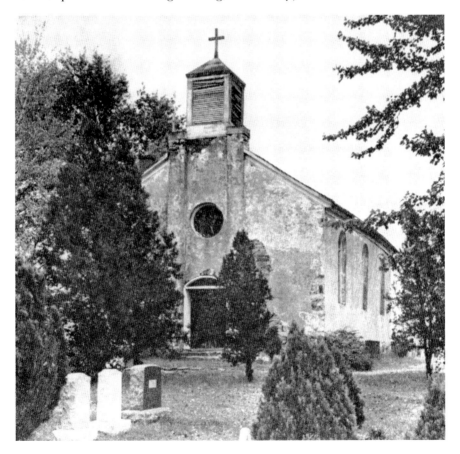

St. Andrew Church and Cemetery. *Courtesy Archdiocese of Louisville Archives.*

Some of this, of course, was unity necessitated by a hostile environment. Although America was a nation of immigrants, later generations developed an amnesia about the value of immigrants and a blind spot about what had happened to both the indigenous and slave populations. Consequently, there were waves of hostility to newcomers. Established citizens seem to have both wanted and not wanted these new citizens, who both contributed to and drained local resources. This was especially true when these immigrants were Roman Catholic in a country founded without an established religion but that nonetheless considered itself Christian—Protestant Christian.

The Germans were mostly of the proletariat class: farmers, craft workers, shopkeepers. They were as prejudiced as the next group about skin color, but they had an inherent mistrust of an economic system of slavery that was being debated throughout this time. This would be significant in Kentucky during the Civil War era.

Last, but certainly not least, in a country that witnessed waves of religious revivals, hostility to those who had not found Jesus in the revival tent was strong. And the growing temperance movement was moving toward outright prohibition. Beer and schnapps were, of course, German staples.

This is a context that needs to be set out to understand what can only be seen as a major achievement of the Catholic Germans of Louisville: people and priests and religious women created a cohesive cultural system. This was a system that would last through the addition of numerous newcomers, a divisive Civil War in their adopted country and, finally, two world wars fought against Germany. In this latter time, the German language disappeared, but the cohesion did not.

With strong leadership in its pastors and not only a German but also a Roman Catholic identity, community was forged. The pastor's word was law on issues well beyond the theological. This extended to the word of the bishop and that of the pope. It was the American Catholic loyalty to papal primacy that shored up, often with money, the claims of the popes in the nineteenth century. This was not true back in the German world, where most of the laboring classes were turning to socialism.

In seeming contradiction to this, however, Franciscan pastors, although "absolute," were not in any way permanent. A close examination of the lists of pastors—most noted as "beloved" or passed over in silence with a registration of their dates of service—reveals that ten years was a long time. Unlike diocesan priests, who could become "pastor for life," Franciscans cycled through in a relatively short time. This actually gave the trustees of the

parish (invariably "sober," pious and prosperous businessmen) considerable power to influence. And they used it.

In parish histories, much of the record is filled with building churches and schools and social halls. Sometimes architects are named. Mostly construction companies are named since the pastor and the trustees did most of the "architecting." They were all Catholic, of course. What isn't mentioned is the large number of parishioners who came with hammer and saw, sewing needle and cleaning rag to both build and maintain these buildings, which were powerful and proud symbols not only of their piety but of the strength and wealth of their community.

Another noticeable thing in all of the parish histories is the large number of groups formed around everything—from bingo to bowling, from sewing to cleaning the church. There were even youth groups where good Catholic boys could meet good Catholic girls. This was a "total society" from birth in a Catholic hospital to burial in a Catholic cemetery by Catholic undertakers. The world outside the parish seemed scarcely to exist.

Today, this cohesiveness is but a shadow, but it is still a shadow that shapes the Catholic Church in Louisville and the city of Louisville itself.

5.

URSULINE SISTERS AND CATHOLIC SCHOOLS

BY SISTER MARTHA JACOB, OSU

The city of Louisville in 1850, with a population of 43,194 people, was the fourteenth-largest city in America. Its location on the Ohio River was a major factor in its growth in the early nineteenth century. The opening of the Portland Canal around the nearby falls in 1830 greatly improved Ohio River traffic and brought about an economic boom in tobacco, hemp, livestock, distilling, commercial sales and warehousing.

But Louisville was a city of contrast. Many prosperous merchants supported the arts and participated in both local and national politics but were not particularly interested in education, organized religion or healthcare. The more recent arrivals, German and Irish immigrants, were seeking refuge, acceptance and jobs. The 1850 census lists 7,502 German and Prussian immigrants and 3,105 Irish immigrants. These newer arrivals met prejudice, as most arrived poor, continued to speak their own languages, practiced their ethnic customs and established their own neighborhoods. Also the Know-Nothing political party was quite strong and aimed to keep Catholics and those who were foreign-born from holding public office, even seeking to prevent them from voting. In addition, Catholics could not teach in the public schools. The tension escalated into violence on August 6, 1855, with the anti-immigrant Bloody Monday riots that took over twenty lives, the majority being Catholic.

Three Roman Catholic nuns, two just twenty-six years old and the third in her fifties, arrived on this scene on October 31, 1858. The three Ursuline sisters—Mother Salesia Reitmeier, Mother Pia Schoenhofer and Sister

Maximilian Zwinger—came to serve the German families in the city at the invitation of Louisville Bishop Martin John Spalding. ("Mother" was the title given to sisters who were in positions of authority.) The sisters' first home in Louisville, a small frame house consisting of two rooms and a garret, was a striking contrast to the large, beautiful convent they had left in Bavaria. During the first winter, especially, the sisters suffered loneliness, heartache and even want, but these heroic souls never looked back.

Bishop Spalding, who was concerned for the education of Catholic children, sent Father Leander Streber, a Franciscan priest and pastor of St. Martin of Tours Church, to Bavaria to seek sisters to teach at St. Martin School. The three volunteers came from the Ursulinenkloster in Straubing, Bavaria. They and the women who joined them to become Ursuline sisters were to launch, administer and staff the Catholic school system of the Diocese (later Archdiocese) of Louisville, along with sisters of several other orders, for more than one hundred years.

In the 1850s, of the thirty-three churches in Louisville, seven were Roman Catholic and had been established for language groups. St. Boniface's (1837) was the first for the German-speaking population, followed by two others: St. Mary's in 1845 and St. Martin of Tours in 1853. The Ursuline Sisters played a major role in the schools of the three parishes, as well as in many other churches and schools in Louisville.

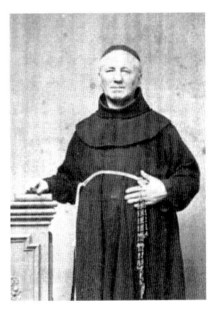

Two weeks after their arrival, Mother Salesia and Mother Pia began teaching fifty children in the space set up by the people of St. Martin of Tours Church. The subjects taught were Christian doctrine, grammar, arithmetic, geography, writing, reading, spelling, singing and "fancy-work." Sister Maximilian was busy with preparing meals and performing other household tasks in the convent.

Mother Salesia saw a further need to educate girls beyond the elementary level (usually to eighth grade) and, after a few months, began planning for such an education. In order to further the

Father Leander Streber, OFM, was the first pastor of St. Martin of Tours Church. *Courtesy Ursuline Sisters of Louisville Archives.*

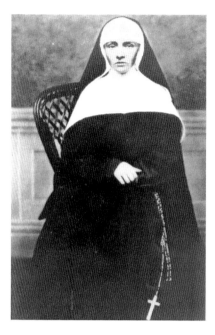

Mother Salesia Reitmeier was the first superior of the Ursuline Sisters. *Courtesy Ursuline Sisters of Louisville Archives.*

education of young girls, she decided to enlarge the sphere of her activity by opening a girls' boarding school where they might receive not only an elementary education but also an opportunity of pursuing a high school curriculum.

As soon as it was announced that Ursuline Academy of the Immaculate Conception was opening and boarders would be accepted, six little girls entered. The six were Mary Disher, Josephine Wahl, Josephine Hutti, Matilda Woltring, Cecilia Schweri and Amalia Issert. A day school was soon added, and the enrollment rose from the original six to twenty-two for the 1860–61 year, thirty-two in 1861–62, thirty-eight in 1862–63 and fifty-nine in 1863–64.

Mother Salesia had managed to pay the traveling expenses of the three sisters from New York City to Louisville and "build a convent," having only the $22.50 she received upon the sisters' departure from Straubing. She continued to find ways to finance the expansion of physical facilities to meet the needs of ever-increasing enrollments at both Ursuline Academy and St. Martin School. Despite the obstacles of lack of personnel and of finances, Mother Salesia was able to have erected, at a cost of $3,700, a two-story brick building of about twenty rooms, which was to serve as a convent and as a temporary residence for the Ursuline Academy boarders.

Then, in 1863, the sisters purchased for $1,225 two plots of land joining the academy and a third piece on the west side of the convent for $1,025. In addition, in 1865, they answered the need for more space for St. Martin School by erecting a two-story building on Kellar (Gray) Street at a cost of $10,000. The sisters suffered a loss in 1882 when they sold this building to the parish for $6,500.

In 1861, the sisters were asked to staff a second parish school, St. Mary's on Eighth Street, and Sisters Martina Nicklas and Xavier Wurm traveled

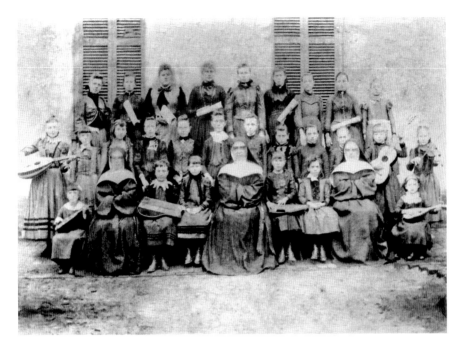

Ursuline Academy Students, 1889. *Courtesy Ursuline Sisters of Louisville Archives.*

back and forth daily from East Chestnut Street to the school. This was during the Civil War, and Sister Martina wrote of one day's experience:

> *We were semi-cloistered in those days and to get to school we rode in a closed carriage lent us by a wealthy friend. Suddenly a mounted soldier dashed up and demanded that our driver turn the horses over to him. Our driver protested—they were fine horses, I can tell you. We sat trembling in the closed carriage. Suddenly we heard a shout and saw the angry soldier pointing his gun at the driver's head.*
>
> *But the soldier caught sight of our guimpes and veils. In an instant he dismounted, stuck his head in at the carriage window, seized my hand in both of his and cried, "Oh! Forgive me, Sisters, you saved my life in the hospital when I lay wounded and dying. I am only a rude soldier. Dear Sisters, I shall conduct you wherever you are going." And we rode off with a soldier for a military escort!*

Thus began the ministry of administering and staffing schools of German Catholic parishes: St. Joseph's in Butchertown in 1867, St. Peter's

in 1868, St. Boniface's in 1898 and St. Anthony's in 1899. The Ursuline Sisters were able to staff these parish schools while also operating their own schools because their way of living and their works attracted young women from Bavaria and from German families in Louisville. The first five new members were received in September 1860. They were Johanna Nicklas, Sophia Wurm and Anna Merkel from Straubing and Cecilia Schweri and Amalia Issert from Louisville.

They were followed by a total of sixty-five German women who transferred from the founding house of the Louisville Ursulines in Straubing, Bavaria, or arrived as candidates to join the Ursuline Sisters of Louisville between 1858 and 1911. Young women from Louisville German families also continued to enter the religious community. When the Ursuline Sisters celebrated 125 years in Louisville in 1983, they were serving, or had served, in sixty-two locations in the Greater Louisville area.

On June 25, 1868, the sisters suffered a great loss on the death of their founder and leader, Mother Salesia, age thirty-six. One of the German-language newspapers of that time reported:

> *M. Salesia was held in highest esteem by all friends of education of every denomination. Her teaching ability, her motherly manner of dealing with students had won over victoriously all who were prejudiced against religious persons so that the academy under her leadership, in a very short time, enlarged with rising attendance, even with non-Catholics who openly acknowledged it to be the best educational establishment for girls in the city.*

When Mother Salesia died, the membership of the Ursuline Sisters of Louisville was twenty professed sisters and eleven women in the formation process. Her death interrupted the construction of the first convent chapel on the corner of Chestnut and Shelby Streets, but it was completed and dedicated on December 26, 1868.

The Ursuline Sisters also began serving in another German parish, St. Peter's at Seventeenth and Garland Avenue in west Louisville in 1868. The two sisters who arrived that year, whose names have been lost, were the first of a long line of Ursulines to labor at that parish.

Upon Mother Salesia's death in 1868, twenty-nine-year-old Sister Martina (Johanna) Nicklas, who had arrived in Louisville from Ratisbon (Regensburg), Bavaria, in 1860, became the second Mother Superior. She served as head of the Louisville Ursuline Sisters for thirteen years (1868–81) and then continued to teach in schools, the last one being St. Joseph School

in Butchertown during the early 1900s. She died at the age of ninety-seven on June 24, 1936.

In 1877, Mother Martina purchased ten acres of land on Workhouse (Lexington) Road as the location for a second convent and a school for children in that rural area east of Louisville. At first for day students, the Academy of the Sacred Heart soon accepted boarders (until the 1940s), and the campus grew to over forty acres. The Motherhouse (headquarters) of the Ursuline Sisters moved there in 1917. Additional schools were established: Sacred Heart Junior College in 1921, which grew into Ursuline College for women in 1939 and merged with Bellarmine College in 1968; Sacred Heart Model School (kindergarten through eighth grade); Sacred Heart Pre-School (children age two through prekindergarten); and Sacred Heart School for the Arts (open to all ages), which, along with Sacred Heart Academy for young women, are thriving in the twenty-first century.

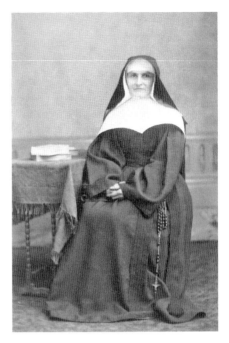

Mother Martina Nicklas, second superior of the Ursuline Sisters. *Courtesy Ursuline Sisters of Louisville Archives.*

The Ursuline Sisters took on a new mission on December 28, 1897, when 122 orphans arrived at St. Joseph Orphans Asylum on Frankfort Avenue and met the 16 sisters. The home was founded in 1849 by a group of men from the two German Catholic parishes, St. Boniface's and St. Mary's, to establish a home for the many German Catholic children orphaned by the cholera epidemic of that year and was first staffed by the Sisters of Notre Dame of Milwaukee. The Ursuline Sisters continued to staff the home as teachers and childcare workers until 1972.

In 1898, the Ursulines replaced the Sisters of Notre Dame at St. Boniface parish school at the invitation of the Franciscan friars who administered there. In the early years, the sisters taught boys and girls in grades one and two but only girls in the upper grades; the Xaverian Brothers taught the older boys. Later, the Ursuline Sisters served as principals and taught all eight grades of girls and boys.

In 2008, as they marked the 150th anniversary of their arrival in Louisville, the Ursuline Sisters erected a Kentucky Historic Marker on the Shelby Street side of their chapel as witness to their presence in, and contributions to, Louisville since 1858.

6.

PROTESTANT CHURCHES

BY REVEREND GORDON A. SEIFFERTT

Germans established communities on the eastern shores, especially in Pennsylvania, beginning before 1700 and through the decades, often escaping from state-sponsored churches and persecution. They brought with them their religious convictions: free thinkers, nonreligious, antireligious and the children of the sixteenth-century Reformation, including Lutherans, Reformed and Anabaptist descendants. By 1800, in eastern Pennsylvania, American Methodist influences on the Reformation traditions had produced the Evangelical Association and several Brethren groups. In the same area in the 1830s, American Baptist influence produced German Baptists. William Nast, born in Stuttgart, became a Methodist pastor and began the first German Methodist church in Cincinnati in 1837. In Prussia in 1817, Kaiser Friedrich Wilhelm, seeking to bring to fruition Lutheran and Reformed efforts toward unity dating back to Luther, began the Evangelical movement, which spread to other principalities. All of these German denominations were present in Louisville. Very brief histories of some thirty congregations are offered. The churches followed the immigration of Germans into Louisville and then into their new neighborhoods.

The Germans in the east followed the westward migration toward Louisville. Christ Lutheran Church began in 1789 in Brunerstown (now Jeffersontown). In that community, a historical marker indicates the location of a "Cemetery of the German Reformed Presbyterian Church 1799–1909." According to historical records, such a congregation began in 1792. While there were German Presbyterians in other areas, this may be the one

and only church with such a name, but it was consistent with the arrival of both Scots and Germans at that time. It had disappeared by 1819. There is evidence of a United Brethren congregation at Doup's Point (Taylorsville and Bardstown Roads) by 1811.

In 1830, Louisville's population was 10,000, which would have included scattered Germans. By 1850, the population was about 43,000, of whom at least 7,500 were German-born. Some of these Germans migrated from the early East Coast colonies while others arrived at East Coast ports and immediately came west, and many came through the port of New Orleans and up the Mississippi and Ohio Rivers. New Orleans was the primary port of entry for the Evangelicals.

The first German neighborhood in the 1830s, Uptown (now Phoenix Hill), was bounded approximately by Main Street on the north, Brook Street on the west, Broadway on the south and Shelby Street on the east. The first German Protestant church, organized in 1836, was St. Paul Evangelical Church. After meeting in several locations, it settled on the east side of Preston Street near Green (Liberty) in 1840–41 and built a magnificent sanctuary in 1860. The congregation relocated to Broadway at Brook in 1907. Its 1860 edifice was extremely impressive in comparison with the other Protestant buildings of the era. Under its second pastor, Karl Daubert, it had one thousand communicant members by 1848, and in the 1860s, it was offering two Sunday services in German and two in English. The congregation merged with Bethel Church in St. Matthews in 1995.

Die alte Kirche.
The old Church

The original St. Paul Evangelical Church. *St. Paul Evangelical Church Seventy-Fifth Anniversary Volume, 1911.*

In 1841, the First German Methodist Church (also known as "Zion" or "Clay Street") organized and shortly thereafter built on the west side of Clay Street between Market and Jefferson. When it moved to Market and Hancock Streets in 1880, it was called "Market Street." The congregation relocated to the suburbs in the 1990s.

St. John Evangelical, greatly assisted by Daubert, organized in 1843 and built on Hancock Street on the same block as the German Methodist Church. In 1867, it moved to its Market and Clay Streets corner, where members continue to gather for worship in its magnificent Gothic sanctuary.

Zion Reformed Church began in 1849 on Green Street between Clay and Shelby. In 1863, it built new facilities on the west side of Hancock Street, between Madison and Chestnut. It moved to 536 East Broadway near Brook in 1906. Zion merged with two daughter congregations, Milton Avenue and Faith, and built off Eastern Parkway at Burnett and Minoma Avenues in 1950. The congregation continues at that location.

The second German neighborhood was bounded approximately by Main Street on the north, Seventh Street on the east, Broadway on the

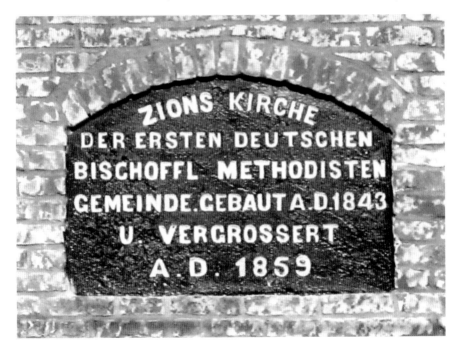

The inscription above the door of the original German Methodist Church. *Authors' collections.*

Die Alte Kirche an der Hancock Strasse,

The First Church.

The original St. John Evangelical Church. *St. John Evangelical Church Sixtieth Anniversary Volume, 1903.*

south and Twentieth Street on the west. A congregation organized in 1847 and, after several name changes, became St. Peter Evangelical Church. It built on Grayson Street, east of Eleventh in 1850 and then relocated to Jefferson Street at Thirteenth in 1895. In recent years, with the guidance of an African American female pastor, St. Peter's is again ministering to its neighborhood's inhabitants.

In 1856, St. Peter's pastor and a number of its members withdrew to form a congregation that became St. Luke Evangelical Church. The new congregation built close by at Thirteenth and Green Streets before moving to two locations, first on Jefferson Street east of Nineteenth and then west of it. St. Luke's merged with Sunnydale Reformed Church

FIRST CHURCH.
Green Street, between Clay and Shelby.

The original Zion Reformed Church. *Zion Reformed Church Fiftieth Anniversary Volume, 1899.*

to become St. Stephen United Church of Christ in 1964 and built on Farnsley Road in Shively.

In 1848, a German Methodist congregation began at Market and Twelfth Streets. It relocated several times before becoming the Jefferson and Seventeenth Street Church. It took the name Second German Methodist Episcopal Church when it merged with the Eighteenth Street Mission at Eighteenth and Ormsby Streets in 1906–07.

In the Uptown neighborhood, the first German Baptist church organized in 1856 and was located on Hancock Street near Chestnut. Members organized the German Baptist Orphan's Home in 1871. Over the decades, it was located at four different addresses on Broadway. It ceased to exist in the early twentieth century.

The First Evangelical Association Church (Zion) organized in 1864 and was located at 418 East Walnut Street and then 918 East Walnut before relocating to Hepburn and Edward Avenues in 1922. It ended in the 1990s.

Beyond present-day Iroquois Park, at Manslick and Palatka Roads, another St. John Evangelical Church began in 1851. It became Lynnhurst Reformed Church early in its history.

While several of the above Evangelical and Reformed churches would associate briefly with a Lutheran Synod and several of those churches did include "Lutheran" in their names, Lutheran churches were not among the earlier churches that lasted. On the second Sunday in May 1843, Reverend William E. McChesney delivered a discourse before the "First English Evan. Lutheran Church" on the "Doctrines, Practices and Government of the Evan. Lutheran Church in the U. States." But this apparently did not nurture an ongoing congregation because the First English Lutheran Church was established in 1872 on Broadway, where it is still located.

The First German Evangelical Lutheran Church (now Concordia) was organized in 1878. It initially met in a Presbyterian chapel at Clay Street and Broadway until 1880, when it bought the German Methodist Church building on Clay near Market Street. In 1892, the congregation moved to Broadway near Barret Avenue, where it still gathers today.

As Germans moved into new neighborhoods, new churches began. Salem Reformed Church was founded by Zion in 1867, a few blocks south of Broadway on Prentice Street near Dixie Highway in what is called the "California" neighborhood. Its first building was erected in 1876. The congregation moved to Newburg Road in 1965. As it closed in 2011, it gave its property and building to Brooklawn Child and Family Services (now Uspiritus).

The Evangelical Association West End Mission (Trinity) organized in 1872 at Nineteenth and Duncan Streets in Portland.

Breckinridge Street German Methodist, later known as "Third," is listed in the 1877 *City Directory* at the corner of Clay Street. It disbanded in 1927, and its members united with the related churches.

First English Lutheran began Second English Lutheran in 1877 at Walnut and Eighteenth Streets. It relocated to 2115 West Jefferson Street in 1902. Its first pastor, Reverend Harlan K. Fenner, served until his death in 1929. Second became Fenner Memorial.

First English Lutheran also began Third English Lutheran in Butchertown in the early 1880s. It was built on Story Avenue in 1887 and moved to Frankfort Avenue in 1931.

The pastor of St. John Evangelical and a number of members withdrew to form Christ Evangelical in 1879. Worshipping first on Garden Street (now the eastern extension of Chestnut), it erected its sanctuary on Barret Avenue at Breckinridge in 1901. The Highland Community Ministries moved into the building in 2014.

An Emmanuel Evangelical appears briefly in the 1880s at Grayson and Twentieth Streets.

First German Lutheran began Second German Lutheran (now Redeemer) in 1884 at Twenty-second and Madison Streets. Over the decades, the congregation had at least three other locations in that neighborhood before moving to Thirty-seventh Street and Del Park Terrace in the 1920s.

In 1885, St. Peter Evangelical Church began a Sunday school in a rented school building on Market Street near Forty-first. This led to the organization of West Louisville Evangelical Church in 1916.

In 1889, several Evangelical churches helped establish St. Matthew Evangelical Church on St. Catherine Street at Hancock. Its history states that the reason for the location was that there were no other German Protestant churches in the neighborhood. It was a faithful servant to the neighborhood until its closure in 1999 and continues to serve, having given the building to House of Ruth for its AIDS ministry.

Bethlehem Evangelical Church began in 1891 on Seventh Street between Magnolia Avenue and Hill Street. It moved to Sixth and Hill in 1913. It continues a reinvigorated ministry at that location today.

In 1898, the pastor and a number of members withdrew from St. John's to form Immanuel Evangelical Church. They wanted to maintain the German language. Its first building was at Bardstown Road and Transit (Grinstead Drive) Avenue. This congregation moved to Taylorsville Road

near Bardstown Road in 1925 and constructed a modernistic hyperbolic paraboloid sanctuary in 1961. It continues to thrive today.

Evangelical congregations began Westermann Memorial Evangelical Church in the Clifton neighborhood in 1903. It began as German speaking but, within a few years, became English speaking and took the name Clifton Evangelical. Before 1920, it had withdrawn from that denomination and is today part of the Unitarian Universalist Association.

Zion Reformed established Milton Avenue Reformed in 1906. Although it was located in Schnitzelburg and served Germantown as well, its initial language was English. It merged with its mother church and moved to Burnett and Minoma Avenues in 1950.

In the 1890s and following, a number of mission churches existed for a few years. New Salem Evangelical Association existed in the early 1890s at Mercer and Grayson Streets and then at 952 South Twenty-fourth Street. A "United Brethren in Christ" appears in the 1891 *City Directory* at 212 Cabel Street in Butchertown. A German Methodist Mission church appears in the 1891 *City Directory* at 2115 South Eighteenth Street and took that street name. A German Baptist Mission existed at 1019 Christy Avenue in 1900.

Moving from the past toward the present, the older congregations held on to at least some German worship services; however, World War I greatly diminished them, and World War II ended them. They had daughter and granddaughter congregations through the decades, but these were much more part of the melted and merged pot of American society than German institutions.

During the twentieth century, other changes occurred. The German Baptists became the North American Baptist Conference with no congregations in Louisville. The English Lutherans are part of the Evangelical Lutheran Church in America. The German Lutherans are part of the Missouri Synod Lutherans. The Methodist Central German Conference merged with the English-speaking Methodist Episcopal denomination in 1933. With similar heritages, the Evangelical Association and the United Brethren merged in 1946 and were absorbed into the United Methodist Church in 1968. The German Evangelicals and German Reformed united in 1934 and then merged with the Congregational Christians in 1957 to become the United Church of Christ—still the only denomination in the United States to bring together strands with differing historical roots.

7.

PROTESTANT AND SECULAR SCHOOLS

BY VICTORIA A. ULLRICH

The education of their children was very important for German immigrants. The desire to have instruction conducted in German, as well as English, led to the establishment of schools outside the Louisville public school system, usually by churches or children's social service organizations. The first German school, the Freie Bürgerschule, was founded in 1852 to serve the growing German population. The first school in Louisville's Butchertown neighborhood was the German American Civic School, which opened in 1854.

Several German Protestant churches established schools soon after the founding of their congregations. The first German Protestant church, St. Paul Evangelical Church, was founded in 1836 and immediately opened a parochial school that remained until 1900. Reverend George Brandau, the pastor, was the first instructor. St. John Evangelical Church, founded in 1843, established its school in 1849 with Carl Grosz as instructor. The day school closed in 1882 as English became the more prominent language and students joined the public school system, although the German language was taught in a Saturday school for several more years.

The First German Evangelical Lutheran Church (now Concordia), founded in 1878, started a Christian Day School in 1883 under the guidance of its pastor, Reverend F.W. Pohlmann, who was the sole teacher. Pilgrim Lutheran Church, founded in 1927, established a Christian Day School in 1931, which merged with the Concordia school in 1952. The school facility

at Concordia closed in 1957, when the consolidated school relocated to a new building next to the Pilgrim Church.

As the First German Evangelical Lutheran congregation grew and expanded westward, Pastor Pohlmann saw the need for another church. The Second German Evangelical Lutheran Church (now Redeemer) was founded in 1884 and established its own Christian Day School in 1889. A newly ordained pastor, Reverend Otto Luebke, took over the leadership of the Second Lutheran Congregation and became its schoolteacher as well. Enrollment grew sufficiently to require the hiring of a full-time teacher, Theodore Weseloh, in 1892. Nearly one thousand children were educated there until it closed in 1972.

Reverend Karl Daubert, the second pastor of St. Paul Evangelical Church, was instrumental in the founding of a Protestant orphanage to care for children of German descent who had been orphaned by the cholera epidemic in the 1840s. The German Protestant Orphan Asylum (later Brooklawn, now Uspiritus) opened in 1852. A school was

Concordia Lutheran Church and School, 1928. *Courtesy University of Louisville Photographic Archives.*

established for the orphan residents and boarding school students, and it became highly regarded as one of the best orphanage schools. Mr. and Mrs. J. Schenk of Cincinnati were hired as the house parents with Mr. Schenk serving as teacher.

Another notable German innovation to the Louisville school system was the introduction of kindergarten programs patterned after the philosophy of German educator Friedrich Fröbel. Louisville had one of the first ten kindergarten programs founded in German communities in the United States. It was established by William Hailmann, a native of Glarus, Switzerland, at the German-English Academy in 1865. Hailmann was a progressive educator as

William N. Hailmann. *Courtesy Special Collections, Charles E. Young Research Library, UCLA.*

well as being highly educated himself. He studied in Zurich and then at the Louisville Medical College and was awarded a doctorate from Ohio University in 1885. He was director of the German-English Academy until 1873, when he left Louisville to pursue deeper involvement in the early education movement. His wife, Eudora Lucas of Louisville, developed an equally passionate belief in the kindergarten system and was his associate in fostering kindergartens throughout the United States. Hailmann translated Fröbel's *Education of Man* into English and became the first chairman of the National Education Association kindergarten division and president of the Froebel Institute of North America.

Initially, the kindergarten movement in Louisville did not survive the loss of the Hailmanns. In 1887, it was rejuvenated by a group of women working with poor and immigrant children at the Holcombe Mission on Jefferson Street near city hall. They saw early childhood education as a means to avoid the poverty and ignorance pervasive in the immigrant community. These dedicated ladies formed the Louisville Free Kindergarten Association and established programs throughout the city. The association's ten kindergartens, under the direction of Patty Smith Hill, developed a national reputation for outstanding education. Patty Hill was principal of the St. John German Evangelical Church School in the 1880s. Along with her musically talented sister, Mildred, Patty composed a book called *Song Stories for the*

Kindergarten, which contained a cheery song, "Good Morning to You," to give the young students a positive start to their school day. In subsequent years, the song's lyrics were changed to "Happy Birthday to You." Thus, the educational accomplishments of the Hill sisters were dwarfed by their fame as the composers of the universally recognized song of birthday wishes!

The most notable student of the German-English Academy was Louis Dembitz Brandeis, the son of German-speaking immigrants from Prague. Brandeis had an illustrious law career that was capped by his appointment to the United States Supreme Court in 1916. The University of Louisville Brandeis School of Law is named in his honor.

By 1854, German-language instruction was included in the curriculum of the public schools and was taught at Boys and Girls High Schools by 1872.

As the immigrant students became assimilated into the local culture and became more comfortable with the English language, the need for bilingual instruction diminished, even though German was still spoken in many homes. Indeed, the children, as with immigrants today who speak other languages, often served as interpreters or translators for their German-speaking parents.

GERMAN CHRISTIAN ORPHANAGES, HOSPITALS AND ELDER CARE

BY REVEREND GORDON A. SEIFFERTT

Jesus taught his followers to care for the orphan, heal the sick and provide for the widow. German Christians in Louisville responded to Jesus's example and instruction. The city had the title "Graveyard of the West" due to the many stagnant ponds and polluted air, which contributed to several cholera outbreaks. Deaths of many parents led to the establishment of orphanages.

The St. Joseph German Roman Catholic Orphan Society was organized by the city's two German parishes, St. Mary's (Father Karl Boeswald) and St. Boniface's (Father Otto Jair, OFM), and their members in 1849 following several years of orphan care by the Sisters of Charity. The first location of the St. Joseph Orphans Asylum was on Green (Liberty) Street near Eighth Street, next to St. Mary's. In 1858, it moved to a site across from St. Boniface's. In 1886, the home moved to its present location on twenty-four acres of wooded parkland one mile east of the city limits between Brownsboro Road and Shelbyville Pike (Frankfort Avenue). Preceding the present board of trustees, the home was staffed and governed by the Notre Dame Sisters and then the Ursuline Sisters. A picnic begun in 1851 to support the ministry still occurs each year. St. Joseph Children's Home continues to expand its facilities and now offers three core services: a Residential Treatment Program for abused and neglected children, a Therapeutic Foster Care and Adoption Program and a Child Development Center.

The German Protestant Orphan Asylum came into existence to serve children. There already were German Roman Catholic homes and English-

speaking homes. Reverend Karl Daubert, pastor of the Evangelical Church (St. Paul), led the efforts to organize this home in 1851. He galvanized not only Evangelical churches but also other German organizations. The first location was a three-story home on Jefferson Street between Nineteenth and Twentieth Streets purchased in 1852. The first orphan, Elisabeth Reister, whose parents had died en route from New Orleans, was accepted immediately. In addition to care, the home also provided schooling. In 1903, the home moved to a Bardstown Road location (now Mid-City Mall) and in 1961 to Goldsmith Lane along the Watterson Expressway, taking the name Brooklawn. From 1940 to 1983, annual Turtle Soup Suppers at Brooklawn were cherished events. The Presbyterian Bellewood Home for Children was founded in Louisville in 1849 by members of four churches and originally called the Louisville Orphans Home Society. It moved to Anchorage in 1875. Brooklawn and Bellewood merged in 2012, producing much-expanded services and the new name Uspiritus.

The German Baptist Orphan's Home (originally called Der Bethesda-Verein) was founded by the single Louisville German Baptist church in 1871; its pastor, Andreas Henrich; and member J.T. Burghardt. It moved to Hanan Garden between East Broadway (Cherokee Road) and Cave Hill Cemetery

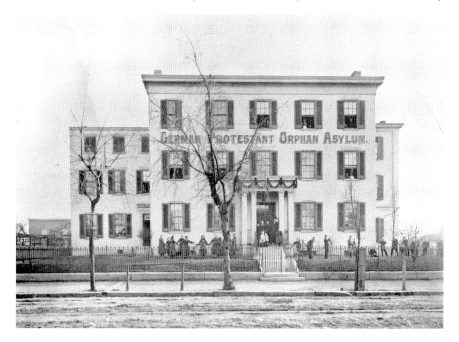

German Protestant Orphan Asylum, about 1889. *Courtesy University of Louisville Rare Books.*

German Methodist Deaconess Hospital. *Courtesy University of Louisville Photographic Archives.*

by 1878. In the city directories of the era, it described its policy as "Receives orphan children and other children in needy circumstances, regardless of religious denominations." As the orphanage approached other German Baptist churches (mainly north of Louisville) for support, its nonsectarian approach, coupled with its southern location and being locally owned and controlled, produced much friction within the denomination. The issue was contentiously debated over several decades until the ministry was given to the denomination. In 1916, German Baptist orphans' care moved to St. Joseph, Michigan, where a home opened in 1919. During recent years, the former orphanage building has housed the Highlands Community Ministries' childcare program.

The German Methodist Deaconess Hospital was founded in 1895 by pastors and members from the four Louisville Methodist churches and those in Jeffersonville and New Albany, Indiana. By 1898, the John P. Morton estate on Eighth Street near Chestnut had become its home. In 1933, the German denomination merged with the Kentucky Methodist Episcopal Conference, and the hospital had wider support. But finances continued to

be a major challenge even as it continued to train nurses and provide good care, revealing "truly a hospital with a soul." When the hospital closed in 1951, the leadership was already pursuing a new venture.

The Methodist Evangelical Hospital grew out of the demise of Deaconess Hospital. The Evangelicals had begun a number of hospitals throughout the Midwest. In the early 1900s, a Deaconess organization in Louisville had begun to provide care for the ill. In 1909, an Evangelical Deaconess Hospital Association formed. In 1922, the name was shortened to Evangelical Hospital Association, which immediately conducted a major fundraising program generating $165,000. Property was purchased near Shelby Street and Eastern Parkway. In 1933, restrictions on loans due to the Great Depression bank holiday interrupted the building plans, and the organization sensed that its Louisville population was too small to underwrite such an endeavor. But it continued, and conversations about a site with the Methodists were conducted in the 1940s. The Evangelicals had accumulated $440,000. The two groups merged their efforts in 1948 to build a new hospital. Several sites were considered with the decision finally made to build on Broadway at Preston Street. The Methodist Evangelical Hospital was dedicated on September 4, 1960. Through the years, the facility has become part of Norton Healthcare. The building is now the Norton Healthcare Pavilion.

St. Anthony Hospital, dedicated on April 29, 1902, was founded by the order of the Sisters of St. Francis of Perpetual Adoration. The order was founded by Maria Theresia Bonzel of Olpe, Westphalia, in 1863. (Mother Bonzel was beatified on March 27, 2013.) The bishop of Fort Wayne, Indiana, invited the order to America, and Mother Theresia and other sisters arrived in Lafayette, Indiana, on December 14, 1875. By 1902, the order had established several hospitals, as well as academies and orphanages. The order's hospitals, including St. Anthony's, ministered without distinction as to creed, nationality, sex, condition, race or economic status. St. Anthony's Nursing School offered training to hundreds over many decades. Louisville was blessed by Sister Alwinia Heinemann, who was born on April 21, 1908, in Kickenbach, Germany. She entered the order in 1931 and came to America three years later, training as a nurse in Fort Wayne, Indiana. She was assigned to St. Anthony's, and for twenty-nine years, she excellently personified the best of loving care and professional innovation by her presence at fifty-seven thousand births and by opening labor rooms to fathers in 1956 and delivery rooms in 1962. Her innovations with respect to the care of newborns and the presence of fathers and siblings were emulated by other hospitals. Even as she lost her sight, she continued to be the "White

St. Anthony Hospital, 1920s. *Courtesy University of Louisville Photographic Archives.*

Tornado," performing miracles of care. Even with the sisters' loving care and remarkable innovations, by the early 1990s, St. Anthony's was losing more than $5 million over three years. It closed at midnight on March 14, 1995. Vencor, now Kindred Hospital, took over the facilities at 1313 St. Anthony Place, and palliative care is now offered.

The Louisville Protestant Altenheim began in 1906 after several years of planning and preparation by Miss Mary Rothenberger and her Good Will Circle at St. John Evangelical Church, the preeminent German Protestant congregation of the era. The Steward home and property on Barret Avenue south of Breckinridge Street was purchased, and the first residents arrived in 1907. Miss Mary served as matron from 1909 to 1934. The Good Will Circle was still providing assistance during the fiftieth anniversary celebration, as was the Ladies Aid Society, which dated back almost to the founding. While begun by St. John's, support was offered from other Evangelical churches and later Reformed churches and from the wider German and Louisville communities. Fundraising suppers and picnics continued into the 1960s.

Arthur P. Stitzel (who died in 1947), noted distiller—along with his father, uncle and wife, Florence (née Koch, who died 1953)—having no children, left a sizable estate to the Altenheim, which built the Stitzel Memorial Wing, a twenty-two bed addition, in 1955 and continues to assist residents to this day. The Stitzels were married at St. John's in 1900 in the presence of hundreds of friends. Perhaps Florence was in the Good Will Circle. They were probably close to Miss Mary and the Altenheim until their deaths. Members of the staff continue "to serve their Master in serving old and homeless men and women" through a range of care from independent living to personal and immediate care to nursing home beds.

These ministries to the orphan, the sick and the elderly were founded by German Christian churches and their laity, clergy and sisters. They have served faithfully and well with the support of a host of dedicated volunteers from the churches and the wider community, as well as caring, competent nurses, doctors and hospital staff.

9.

JEWISH COMMUNITY AND SYNAGOGUES

BY CAROL A. ELY

The first Jews on the American frontier moved west in advance of the formation of towns as merchants and traders. As early as 1781, Richmond merchants Jacob Cohen and Isaiah Isaacs (from Oberdorf and Frankfort-am-Main), looking to expand west, hired Daniel Boone to survey Virginia's Kentucky region.

Nineteenth-century Germany's various provinces and independent cities had varied laws restricting Jewish occupations, marriages and travel. Most Jews spoke Yiddish and were employed in trade, peddling goods in the countryside and running small stores. Germany offered young Jews an insecure future.

But their familiarity with a "middleman" role in the economy in bringing manufactured consumer goods to rural areas and their ability to take advantage of niche markets and opportunities were valuable skills when transferred to the developing areas of the American Midwest and South.

Frontier life challenged Jews because of the lack of a community to provide the conditions for a religiously observant life: services, burial and kosher food. The first historian of Kentucky Jews, Ludwig (Lewis) Dembitz, wrote: "Whoever came, came singly, found no one to pray with, and what is more, no one to mate with."

It took several decades of settlement for Jews to gather and form a community. The Hyman brothers, from Berlin, were the first long-term settlers to maintain Jewish family life and foresee the possibility of an organized Jewish community. In 1829, they opened the Western Coffee

House, or "Hyman's Altar," on the south side of Market Street between Fourth and Fifth Streets.

They became community leaders, helping form the Israelite Benevolent Society in 1832, a charitable and mutual aid organization. Local Jews joined those who worked at similar occupations (dry goods, clothiers) near each other. Rather than work for outsiders, they formed partnerships.

Migrants arrived from south Germany in the 1830s. Dembitz writes, "These, and nearly all those who came after them, remained in their faith." Around 1838, religious services were first held at Abraham Tandler's Market Street boardinghouse, with a Torah scroll brought from Germany. Five years later, Louisville's first Jewish congregation received a state charter as Congregation Adas Israel, "according to the form and mode of worship of the German Jews in Louisville."

Joseph Dinkelspiel from Munchausen, Bavaria, served as rabbi, even though he was not ordained. As the only congregation, Adas Israel served Jews from a variety of backgrounds, with English and Hebrew used in services. By 1849, the growing congregation had built on Fourth Street a "Synagog," the first in Kentucky.

During the 1840s, radical changes seen as "reforms" to Jewish practice, originating in Germany, arrived in America. Adas Israel "resolved to conduct the business…in the German language," showing the rise of the reformist faction who were fiercely proud of their language and culture and wanted to bring progressive German values of liberalism and rationality to America.

In 1851, a new congregation, Beth Israel, was established by those who thought that the reforms went too far. Thirty years later, Brith Sholom, doctrinally between the two existing congregations, built a synagogue chartered "according to the form and mode of worship of the German Israelites." When Adas Israel built a new synagogue in 1866, the building's striking design and its location on Broadway reflected the growing wealth and confidence of the city's German Jews.

Immigrants from the Austro-Hungarian Empire included sophisticated middle-class merchant families of Vienna and Prague. The failed European revolutions of 1848 disillusioned those who believed that a democracy with equal rights was possible in their homeland. Jewish and non-Jewish Forty-Eighters left for America.

Economically, German Jewish immigration in the mid-nineteenth century is the story of the pack peddler walking the backcountry, establishing a small store and later moving to the city to set up a flourishing dry goods establishment.

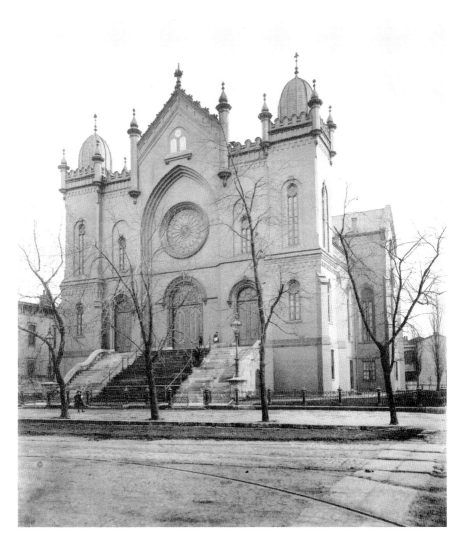

Temple Adas Israel, about 1889. *Courtesy University of Louisville Rare Books.*

For example, the brothers Isaac and Bernard Bernheim were from southern Baden. Isaac's passage to America was paid for by an uncle who gave him credit for peddling stock, including needles, thread, handkerchiefs and ladies' stockings. Setting off through rural eastern Pennsylvania, where many of the farmers spoke a familiar German, he was successful and added a horse and a wagon. Ultimately, in Kentucky, the Bernheim brothers would found a distilling dynasty.

Moritz Flexner, whose sons made significant careers in medicine and education, came from the Bavaria/Bohemia border. As a peddler covering the Kentucky countryside, Moritz returned to Louisville for religious holidays. On a visit to the city, he met his wife, Esther, a fashionable seamstress from Paris, and together they established a store.

The Flexners maintained traditional Jewish practices but did not teach Judaism to their children. Their son Simon remembered that his mother always celebrated the Sabbath: "It was a beautiful sight to see her…burning the candles…Just what the custom signified was never explained." According to son Abraham, "We began to be affected by the rationalistic spirit of the time…they saw us drift away into streams of thought and feeling they did not understand."

A similar split in religious attitudes characterized the extended Brandeis family, who came from an upper-middle-class milieu in Prague. Politics drove them out as they were active in the 1848 revolutions. In Louisville, Adolph Brandeis opened a prospering grain business, Brandeis & Crawford. The Brandeis family adopted the views of the most secularized, humanistic German Jews: Judaism meant morality, justice and high values, not ritual. The family was outspoken against slavery even at the cost of social alienation from the leading families of Kentucky. Louis Brandeis wrote: "My early training was not Jewish in a religious sense…my people were not so narrow as to allow their religious beliefs to overshadow their interest in the broader aspects of humanity." His uncle Lewis Dembitz, on the other hand, embraced traditional Judaism, which Brandeis also respected and admired.

Justice Louis D. Brandeis. *Courtesy Library of Congress.*

Liberation from Jewish law was a relief for people who faced practical conflicts in maintaining observances such as the Sabbath. How could business owners afford to close on Saturdays, the main shopping day? How could employees ask for Saturday off, a regular working day? Reform Judaism gave Jews permission to adapt.

The late nineteenth century was a booming time in retail, with "ready-

Isaac Rosenbaum and Sons, 1933. *Courtesy University of Louisville Photographic Archives.*

to-wear" clothing and new methods of merchandising. By the 1870s, Jewish merchants had moved on from peddling to become operators of considerable businesses with a citywide clientele. German Jewish retail businesses included Levy Brothers clothiers, Kaufman-Straus department store, Herman Straus's department store and Lee Loevenhart's men's store; wholesalers included Ullman & Company and Bamberger, Bloom. Other merchants included Charles Rosenheim (the "King of Queensware"), Nathan Bensinger and many more.

In distilling, the Bernheim Brothers and Grabfelder & Company were on Main Street's "Whiskey Row." Louisville was also a center for the fur, hide and wool trade, with several Jewish-owned firms on Market Street, including Isaac Rosenbaum, Goodman & Sons, Dinkelspiel & Company and the Tasman Company.

The Fleischaker family transferred their business skills intact from Germany. Generations of Fleischakers (whose name means "meatpacker") were master butchers in Merchingen. In Louisville, they continued as meat cutters and packers, operating a slaughterhouse business in Butchertown.

German Jewish immigrants included very few physicians because German medical schools had severely restricted Jewish enrollment. The next generation, American-born, was able to train in professions such as medicine, pharmacy and law. Louisville's most famous jurist was Louis Brandeis, who said, "My uncle, the abolitionist [Dembitz], was a lawyer, and to me nothing else seemed worthwhile." He became the first Jewish justice of the Supreme Court in 1916.

In the 1880s, a flood of immigrants from Eastern Europe transformed the community, with thousands of Russian and Polish Jews, religiously traditional and very poor, joining the relatively comfortable German Jews, who (after some initial embarrassment) rose to the challenge of providing the social services and support needed by the impoverished newcomers.

The most lasting civic effort by the German Jewish community was the establishment of Jewish Hospital in 1905. Although the hospital's second-generation founders were wealthy, successful men, the patients they wanted to serve were poor—mainly Russian and Orthodox—with needs, such as kosher meals and Jewish chaplains, that were not met at local hospitals, where Jewish doctors could not even practice.

The Young Men's Hebrew Association (YMHA) helped to bridge the social gap between the city's German and Russian Jews. One Russian remembered that "they took a lot of poor Jewish kids, we didn't know nothin' about paying to go into the YMHA, we just went, and we were treated as a member."

When America entered World War I in 1917, there were no organizations to support Jews in the armed forces. Camp Zachary Taylor was the temporary home of many immigrant Jewish soldiers with language, dietary and ritual needs that were foreign to the army. Louisville's World War I hospitality program became a national model for the effort that was required again in the 1940s.

By the 1930s, Louisville Jews were aware of the dire situation of Jews in Germany. In an oral history interview, Irv Lipetz recalled, "Rabbi Solomon Bazell…literally was screaming about what was happening in Germany." Restrictive immigration legislation of the 1920s made it difficult for European Jews to get United States visas. In an effort to get every Jew possible out of Europe, a Jewish Refugee Committee helped to find housing and jobs, and the YMHA offered English classes. About four hundred refugees from Germany, Austria and other parts of Europe were resettled in Louisville before the war.

Distiller and philanthropist Isaac Bernheim, in his nineties, used his fortune to try to buy freedom for European Jews held in the internment

Young Men's Hebrew Association, 1915. *Courtesy University of Louisville Photographic Archives.*

camps of Vichy, France. He sponsored about 350 refugees by posting bonds guaranteeing that they would not be a financial burden to the United States. But many others were beyond the reach of even his fortune and influence, tied up in red tape in Europe and stopped by the refusal of the United States to authorize visas.

The Louisville community protested the mass murder of the European Jews during the war. In May 1943, a Service of Intercession was held as a memorial for the Jews massacred by the Nazis. Those present passed a resolution demanding the release of European Jews and the opening of Palestine.

The entry of the United States into World War II mobilized the entire Jewish community. There were up to three thousand homesick soldiers at Fort Knox and Bowman Field Airport to be supported. In 1944, Charles Morris said: "We have a good community—generous, tolerant, and strong— an old community, proud of its traditions, walking with dignity through the chaos and confusion of these dreadful times."

Postwar, the Jewish Welfare Federation took the lead in refugee resettlement, assisting about five hundred displaced persons. Local survivors of the Nazi Holocaust who have told their stories publicly include Ernie Marx, who survived on the run in Occupied France; Ilse Meyer, the only one in her family to get a visa to America after surviving Kristallnacht; and many others.

In the 1950s, Jewish families relocated from the deteriorating downtown. The congregations followed, with the more traditional moving to the Highlands and the two reform congregations, Adath (formerly Adas) Israel and Brith Sholom, merging to form The Temple on Brownsboro Road.

Old divisions between Germans and Russians were disappearing. Al Erlen wrote: "Before 1903, it was considered almost a calamity for a German family if a son or a daughter married someone from Eastern Europe…But then Eastern European Jews also became more financially viable, which took another generation…just as it did with the German Jews."

Louisville's German Jews had created a legacy of thriving businesses and civic and social welfare organizations, such as the Jewish Hospital and many others, that now serve all of Louisville, merged with and indistinguishable from those established by their fellow citizens.

NEWSPAPERS

BY KEVIN COLLINS AND KATHLEEN PELLEGRINO

Using extant copies, contemporary advertisements and the fallible memory of man, to date twenty-eight Louisville German-language publications have been identified, spanning the years 1841 through 1938. Unfortunately, records of most of those papers are missing. Additionally, more than 60 percent, eighteen in number, seem to have published for a year or less, making accurate information difficult. At least two, Wilhelm Weitling's paper (1852?) and a possible offering by German Romantics planning Oregon's colonization, *Die Weltlaterne* (1840s?), may not have survived mere conception.

The established newspapers were the *Louisville Anzeiger*, including its weekly magazine, *Deutsch Amerika*, (1849–1938), eighty-nine years; the *Katholischer Glaubensbote* (1866–1923), fifty-seven years; the *Louisville Volksblatt* (1862–82), including its Sunday edition, the *Omnibus* (1867–1910), and the *Omnibus*'s successor, the *Germantown News* (1910–18), fifty-six years; the *Louisville Argus* (1892–1918?), about twenty-six years; and, the *Beobachter am Ohio* (1844–1856), twelve years.

Two publishing eras can be identified, with only the *Anzeiger* spanning both. The first, 1841 to 1856, accounted for fourteen newspaper titles. The second, 1859 to 1938, produced another fourteen titles.

The German-speaking population these papers served ranged from a few thousand in the 1840s to more than seven thousand Louisvillians by 1850. The Civil War years to the turn of the century saw this local newspaper market balloon to fifteen thousand and more. The following forty years saw

a gradual and then a precipitous decline in local native-speaking Germans. By 1938, with the extinction of the *Anzeiger*, that audience numbered about two thousand.

Many Louisville publications expressed special subject matter interests. There were five religious publications. The *Louisville Adler* (1852), the *Katholischer Glaubensbote* and the *Louisville Argus* were Catholic. The *Seebote* (1862–?) and the *Waisen-Freund* (1894–?), the latter a publication about orphanages, were Baptist. The *Deutsche Geflüge-Zeitung* (1879–82) was an agricultural semi-monthly. Humor and literary interests were featured in the *Eulenspiegel* (1848–50?), the *Westliche Blätter* (1859) and the *Omnibus*. Educational interests had the *Amerikanische Schulzeitung* (1870–73). The *Kentucky Colonist* (1883?–1885?) was a state publication written to attract immigrants to Kentucky.

Some newspapers aligned themselves with political parties, often out of sincere conviction but also for financial support. One well-traveled editor, Ludwig Fenner von Fenneberg of the *Herold des Westens* (1853), arrived in Louisville with a reputation ridiculed for changing allegiances according to which party paid the best. Like so many of the newspapermen of that time, he moved on to other cities to pursue his publishing interests.

Parties, in turn, gained added political influence. Abraham Lincoln in 1860, for example, co-owned a German newspaper in Illinois. Louisville had two papers identified as Democratic, the *Adler* and the *Louisville Bote* (1848). Three were Republican, the *Staats-Zeitung* (1859?), the *Kentucky Courier* (1894?–1895?) and the *Volksblatt*. The *Anzeiger* and the *Beobachter* had changing political allegiances over time.

Ideologically, at least five publications were Communist or Socialist or just radical: Weitling's unnamed paper, the *Beobachter*, the *Herold des Westens*, *Der Pionier* (1854) and the *Neue Zeit* (1877?–1878?). Their positive contributions were farsighted, if excessively belligerent and idealistic. They advocated revolutionary changes more recognizable to the twentieth century, including direct elections, equality of women and minorities, free trade, just labor laws, privacy rights and social security. Although all German papers were antislavery, in slave-holding Kentucky, radical voices were stentorian. Radical ideology, however, particularly against capitalism, slavery and religion, also incited the kind of violent reactions that culminated in the massacre of Louisville's Bloody Monday on August 6, 1855. Many native-born Americans perceived German arrogance and superiority inherent in ideologies that attacked "the American way of life."

Weitling, Anton Eichoff, Karl Heinzen, Bernard Domschke and Gustav Fernitz all spent time in Louisville advancing their ideals. The now largely forgotten Weitling—a self-educated, charismatic, pre-Marxian Utopian Communist—was a man of great influence in his day. He visited Louisville in 1852 and contemplated a newspaper here. It is unknown if he actually published, but he wrote for the *Beobachter*. His New York *Republik der Arbeiter*, with a circulation of four thousand, was posted to Louisville and other American cities. Eichoff, a radical editor of the *Beobachter* in the early 1850s, biliously advocated the hanging of capitalists and clergy. Heinzen, perhaps the most famous radical, edited the *Herold des Westens*, which was quickly torched. He then founded *Der Pionier*, which also had arson problems. After a short presence in Louisville, the paper relocated to other cities before finding a permanent home in Boston, Massachusetts, in 1859. It published for twenty-five years. Heinzen also wrote the historic *Louisville Platform*, a progressive manifesto critical of many aspects of life and government in the United States. It was first published in German in *Der Pionier* in March 1854 and subsequently printed in English in about thirty newspapers around the country. The *Platform* was viewed by many as too radical and was widely criticized in papers throughout the country. Domschke assisted Heinzen in Louisville before making his mark in Milwaukee. Fernitz edited the *Neue Zeit* to advance the Socialist views of the Louisville Workingmen's Party.

Georg Walker, an intellectually gifted and experienced publisher, produced the first frontier Louisville newspaper, remembered as either the *Volkstribüne* or the *Volksbühne* (1841–42). A congenial, pipe-smoking, beer-drinking, well-traveled Lutheran ex-seminarian, Walker employed a hand-held wooden press with insufficient type and muddy ink impressing random-sized paper. Publishing a few times a week on a whimsical schedule, his enterprise lasted ten months. After publishing failures in Cincinnati, his second Louisville effort, the *Patriot* (1847), also failed in months.

The intelligentsia was well represented in the German newsmen. Examples abound. Walker graduated first in his University of Tübingen theology studies. Wilhelm Albers, of the *Locomotive* (1846), was a medical doctor, as was Dr. Lange of the *Staats-Zeitung*, who published many books of poetry. Lewis Dembitz, uncle of Louisville's future Supreme Court justice Louis Dembitz Brandeis, commanded a dozen languages, including Sanskrit and Arabic. His German translation of *Uncle Tom's Cabin* appeared in the 1853 *Beobachter*. He subsequently enjoyed a preeminent legal career in Louisville.

The *Omnibus*, with its famous masthead of a traveling stagecoach emblazoned with a different witty remark each week, was the creation of Carl Wilhelm

The *Omnibus* masthead, January 6, 1867. *Courtesy University of Kentucky Libraries.*

Krippenstapel. Upon his death in 1896, his son, George W., took the reins. Suffering from tuberculosis, George died in 1910, and the *Omnibus* became the *Germantown News*, published from the Krippenstapel residence at 720 East Oak Street until 1914. Thereafter, H.H. Moore of the German Printing Company on Shelby Street published the *Germantown News* until 1918.

The *Katholischer Glaubensbote*, a Roman Catholic weekly, was an early advocate for teaching German in schools. A complete newspaper, it reported on the Franco-Prussian War, World War I, cultural events in Germany, American politics, immigration, the Catholic faith and more, as its motto proclaimed, "for the edification and instruction of the People."

The *Louisville Anzeiger* was both the longest lived and the most widely circulated of the Louisville German papers. It was founded in 1849 by Georg Philipp Doern and Otto Scheefer, who bought its predecessor *Eugenspiegel*. Its founding coincided with the unsuccessful European uprisings of 1848 that resulted in the emigration of a large number of Germans, often referred to as the Forty-Eighters.

One was Ludwig (Louis) Stierlin, who fled Germany to avoid arrest on charges of violating the press laws while editor of the *Westphalia Gazette*, and who became the second editor of the *Anzeiger*. First published on February 28, 1849, the *Anzeiger* began as a semiweekly and became a daily on May 8, 1849. At that time, the publishers wrote that the "events in our old fatherland keep the feelings in constant agitation…therefore each one will wish to read the latest reports every morning." Indeed, when Stierlin was offered the editorship of the newspaper on February 11, 1851—the day after his initial arrival in Louisville—he protested

The *Katholischer Glaubensbote* masthead, April 14, 1866. *Courtesy University of Kentucky Libraries.*

that he knew too little of American conditions to take over. Scheefer, who had been the paper's first editor, assured him that "at present, nothing of importance was happening in this country and that the readers would much prefer to read about conditions in Europe, especially Germany," according to Stierlin's 1873 account of the history of Germans in Louisville.

Stierlin speculated that Scheefer actually wanted to shed the job of editorial writing because of the sharp attacks that came from competing editors—a common practice among the German newspapers. What Stierlin called the "strange idea of the conditions of the press" had become apparent on his first day in Louisville when he saw that the front page of the *Anzeiger* displayed a picture of a jackass that was labeled Anton Eickhoff—the editor of the rival paper *Beobachter am Ohio*. On another occasion, an *Anzeiger* editor played a trick on the editor of the rival *Omnibus*, Krippenstapel, by creating a false dispatch that said the czar of Russia had been murdered. The *Omnibus* editor ran the dispatch, only to learn later that the murder had occurred twenty years before.

In its early days, the *Anzeiger* office was located on Jefferson Street near Third Street in a long bare room over a blacksmith's shop. The office, print shop and composing room were separated only by planks, and an acrid odor permeated the premises when the blacksmith shod a horse. At first, there were no reporters, and the editor did everything by himself.

As Stierlin recalled, the editor wrote about local news "relying on events reported by some accommodating person or other." All other events were reported a day late after they could be translated and paraphrased from the English-language papers. It was only when the Civil War broke out that the *Anzeiger* accessed the telegraphic news so that it was no longer delayed.

The first issue of the *Louisville Anzeiger*, February 28, 1849. *Authors' collections.*

When Stierlin left Louisville to return to Germany in 1889, the announcement in the *Courier-Journal*, headlined "He Will Write No More," described him as "one of the foremost German writers and practical newspaper men of the country."

The largest single issue of a German paper in Louisville was the *Anzeiger*'s fiftieth anniversary edition, published in 1898. At 164 pages, it claimed to be the largest paper printed in the world up until that time.

During the war years of 1917–18, reacting to anti-German sentiment, the *Anzeiger* included a patriotic statement in its masthead: "A Loyal

Richard J. Schuhmann was the last owner of the *Louisville Anzeiger*. *Courtesy John J. and Mary Jo Schuhmann Burns.*

Patriotic Newspaper, Published Solely in the Interest of American Ideals and Principles." Its editorials were required to be submitted in advance of publication to Jefferson County officials.

Over the years, ownership changed a number of times. Doern, who had sole ownership for twenty-eight years, incorporated the paper as the Louisville Anzeiger Company in 1877. Martin Borntraeger took over as president upon Doern's death in 1878. George S. Schuhmann took over in 1892, followed by the paper's final owner, Richard J. Schuhmann, in 1910.

The format also changed. By 1855, the *Anzeiger* had daily, semiweekly and weekly editions. Toward the end, it was published weekly. The last daily issue appeared in 1933, after the *Anzeiger*, then located at 321 West Liberty Street, declared bankruptcy due to declining circulation and advertising. *Deutsch Amerika*, the weekly rotogravure magazine, was published until March 4, 1938. In announcing the end of the eighty-nine-year-old newspaper, Schuhmann said, "We'd rather not have a big funeral" for the paper. He said readership had declined because "after all, we are all Americans."

11.

BREWERIES

BY CONRAD D. SELLE AND PETER R. GUETIG

About two hundred breweries have operated in Louisville since 1808 at more than sixty-five sites. The majority of them were owned by German-speaking immigrants. The early breweries were small and probably similar to the breweries of small cities and villages in Europe, typically with fewer than ten men making two to four thousand barrels of beer annually. Before the 1880s, brewers typically had to make their own barley malt, and the malt house was the largest building at the brewery. Before refrigeration, malt could be made only in cool weather. Making malt was not possible from late April to late September. Barley was spread out on the floor to a depth of several inches, and had to be turned with a shovel twice a day. It took about a week to sprout sufficiently. The malt was then roasted in a kiln. Early breweries were often idle in the summer. Mechanization, refrigeration and rail shipping made large breweries possible. Kentucky was only fourteenth among the states in beer production in 1902, but by far the largest producer among the southern states. Most of it was produced in Louisville.

Early brewers worked ten to twelve hours a day, six days a week, and sometimes a half day on Sunday. Most workers lived at the brewery or in boardinghouses nearby. One benefit was free beer. Workers typically consumed eight to ten pints a day. The Louisville breweries were unionized about 1902, and hours were reduced. In 1917, the Louisville Brewery Workers Local No. 110 contract stipulated a nine-hour day with a one-hour lunch break, six days a week. A German text was included, as it was in many brewery-related publications of the time.

As the technology of brewing advanced in the United States, there were publications in both English and German, such as the *Der Amerikanische Bierbrauer* (1868), *The Western Brewer* (1876), *Handbuch für den Amerikanischen Brauer und Mälzer* (1897) and the *American Handy Book of the Brewing, Malting, and Auxiliary Trades* (1902).

In 1887, the Master Brewers Association of America was formed to meet in Chicago and conducted its meetings in German.

The first beer brewers in Louisville were mostly English, Scottish and Irish immigrants. The first recorded brewery in Louisville was operated by Elisha Applegate in 1808. Applegate was born at Sullivan's Station in Jefferson County. McMurtrie's *Sketches of Louisville* lists two breweries in Louisville in 1819. There were three breweries listed in the first city directory, published in 1832. One brewer, Joseph Metcalfe from Yorkshire, England, had the largest brewery west of Pittsburgh, making "porter, ale, and beer." Another was the Scottish poet Hew Ainslie, who operated small breweries in Louisville, Shippingport and New Albany for a few years.

By 1848, three of the five breweries in Louisville had Swiss or German proprietors: Andrew Nicholas, proprietor of the William Tell Brewery, located at the later site of the Fehr Brewery, on Green (Liberty) Street; Jacob Fischer's Brewery at the corner of Twelfth and High Streets; and Adolph Peter on the south side of Jefferson Street near Wenzel. Shortly afterward, William Armbruster opened the Washington Brewery (later the Christ Brewery) next to Adolph Peter's Brewery, and John Luetzelschwab opened the Jackson Street Brewery across from the William Tell Brewery. Most of Luetzelschwab's employees were Swiss, with others from Baden or Württemberg. The Swiss included members of the Kaelin and Eberle families, who later had the first Falls City Brewery in Louisville (the first of three by that name). In 1850, there were six breweries in Louisville, employing thirty persons and producing $108,000 worth of beer, about eighteen thousand barrels at the prices then current. All except Metcalfe were operated by German-speaking immigrants. In 1853, Joseph Metcalfe leased property adjacent to his brewery to open "Metcalfe's Bier-Haus." An 1855 advertisement in the *Louisville Anzeiger* lists his products as "pale and dark ale, Clay ale, cream beer, lager beer, and bock beer...all of my own manufacture." He employed "Fred. Dithmer, a brewer of great repute, from Philadelphia." Peter Noll is believed to have introduced lager beer to Louisville when he acquired the old City Brewery, on Sixth Street between Water and Main, in 1852.

Joseph and Kaspar Zoeller opened the Bavaria Brewery in Portland in 1836 and had a saloon on Third Street between Market and Jefferson. In 1884, Heinrich Nadorff, from Hanover, opened a brewery on Portland Avenue near Seventeenth Street.

The growth of the German immigrant breweries ran afoul of the temperance movement, which had gained a large following by the 1840s. It was also a target of the antiforeign, anti-Catholic Know-Nothing Party. On Bloody Monday, August 6, 1855, rioters burned Armbruster's Washington Brewery. Attempts to burn Adolph Peter's Brewery were unsuccessful.

As Louisville grew, local brewery production was insufficient to meet the demand. In 1865, in partnership with Philip Zang and Philip Schillinger, Gottfried Miller, from Hohenzollern, designed and built the Phoenix Brewery and beer garden. In 1869, Peter Weber, from Alsace, became a partner. Weber had operated a brewery in Madison, Indiana, since 1863, shipping most of his product to Louisville. In 1877, the Phoenix Brewery was the largest in Kentucky, producing 17,364 barrels.

Conrad Walter's brewery opened on Clay Street in 1858 and was operated by his sons until Prohibition, making only common beer.

John Zeller opened the Shelby Street Brewery in 1861. Charles Schaefer and Adolph Meyer acquired the brewery in 1882 and moved to a large modern brewery on Logan Street in 1890, making "Pilsener, Extra Pale, XXXX Ale, and Berliner Weiss Beer."

In 1865, Franz Rettig opened the "Brauerei im Butchertown," which was later operated by Charles Hartmetz and bought in 1892 by John F. Oertel, who built a large modern brewery there in 1903. When the Oertel Brewery burned on March 24, 1908, Oertel arranged to make cream beer at the Phoenix Brewery from March 28 until the rebuilt Butchertown Brewery was reopened in April 1909. The Phoenix Brewery made "Phoenix Common Beer" for years afterward. Oertel's survived Prohibition to become one of the three major breweries in Louisville. Although it was famous for its "Oertel's '92" lager beer, introduced in 1936, the brewery also was noted for making "cream beer," a dark, light-bodied ale especially popular in the summer time and unique to the Louisville area. Most other breweries in Louisville, Jeffersonville and New Albany made this style of beer, but the *Louisville Anzeiger* in 1909 declared that "the best common beer in Louisville is the Cream Beer of the Butchertown Brewery." Cream or common beer was the old term for a low alcohol, summer beer usually made, kegged and served within a week or two. The usual ingredients were malt, corn grits, hops and caramel and/or dark malt. In 1913, Oertel's

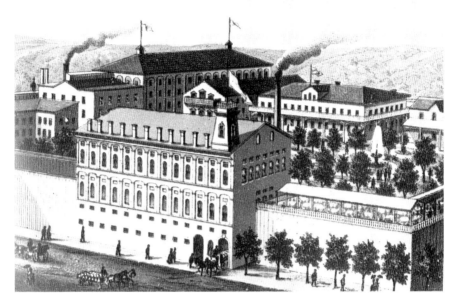

Phoenix Brewing Company and Phoenix Hill Park. *Courtesy University of Louisville Photographic Archives.*

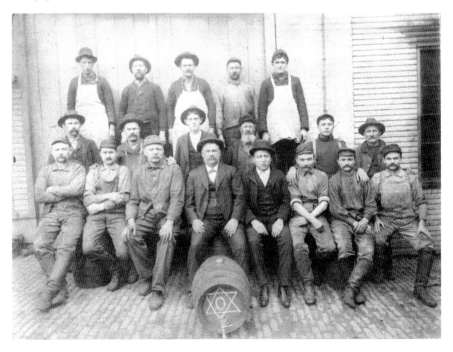

Brewery workers, about 1895. *Authors' collections.*

built a bottling plant and brewed its first batch of lager beer in 1915. It survived Prohibition by making soft drinks and near beer and thrived for decades afterward, closing in 1967.

Frank Senn and Philip Ackerman opened Senn and Ackerman Brewing Company at 1710–20 West Main Street in 1877. Senn came from Mechtersheim, Bavaria, in 1853, Ackerman, from Nassau in southern Germany in 1861. Both worked as coopers initially. Their company was a large modern lager beer brewery making Export Lager, Old English Stock Ale and porter, producing over fifty thousand barrels annually. Senn was a partner in the Kentucky Malting Company, which made malt for local breweries and distilleries.

Frank Fehr, from Zinsweiler in Alsace, came to America in 1862 and worked at breweries in Chicago, Cincinnati and Madison, Indiana, before moving to Louisville in 1868 to manage the Phoenix Brewery. Frank Fehr and Otto Brohm acquired the old William Tell Brewery in 1872. Brohm soon left the partnership. When the brewery was destroyed by fire, Fehr built the City Brewery on the site, with a capacity of 12,000 barrels and expanded

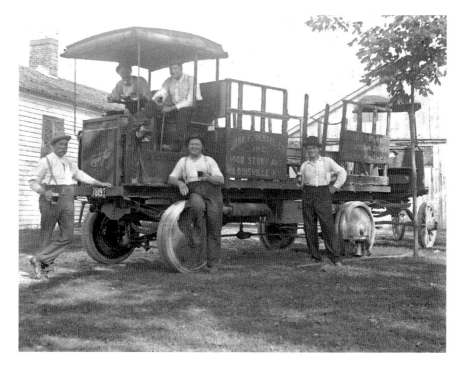

John F. Oertel Company delivery truck, early 1900s. *Courtesy University of Louisville Photographic Archives.*

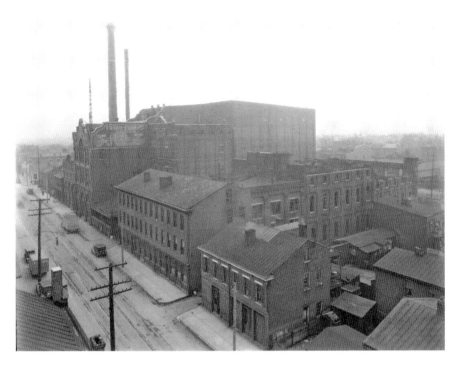

Frank Fehr Brewing Company. *Courtesy University of Louisville Photographic Archives.*

to 20,000 barrels the following year. Fehr was the first in the area to install an ice machine in 1878. In 1883, he introduced FFXL (Frank Fehr's Excellent Lager), a beer made with barley malt and rice. A large bottling plant was built in 1896. By 1903, the capacity of the brewery had been increased to 120,000 barrels, by far the largest brewery in the area. In 1901, Fehr's combined with Senn and Ackerman, Schaefer-Meyer, Phoenix and Nadorff to form the Central Consumers Company, having at the time a practical monopoly of lager beer production in Louisville. The Stein and Christ breweries were the only other lager beer producers. Central Consumers products, especially FFXL beer, were shipped by rail throughout the south, which had few breweries. Only Fehr's reopened after Prohibition, finally closing in 1964.

The Central Consumers monopoly did not suit many of the local saloonkeepers and grocers. In those days, saloons typically sold the products of only one brewery, and breweries often owned the saloons, leasing them to operators to sell their beer. In 1904, Ben Schrader, a son of German immigrants, formed the Falls City Brewing Company, Inc., with other

investors. The board selected a site at Thirtieth Street and Broadway and built a 75,000-barrel plant. Otto Doerr, longtime brew master at Schaefer-Meyer, was hired as brew master. The brewery opened in 1906. A bottling plant was built in 1907. The brewery produced many interesting products in its early years, including Salvator (a strong lager), Extra Pale, Cream Beer and Berliner Weiss. Falls City operated as Falls City Ice and Beverage, making soft drinks and near beer during Prohibition and expanded to 750,000-barrel capacity in 1948, making it the largest brewery in the state. It introduced aluminum cans and produced the ill-fated Billy Beer in 1977 before closing in 1978.

The Union Brewing Company on Franklin Street was organized by the Louisville Brewery Workers Local No. 110 as a result of the lockout of all members by local breweries. By 1902, the Louisville breweries were unionized, and most of its stockholders returned to their old jobs.

In a list of Falls City employees in 1916, only about half had German names. Louisville Union contracts in the early twentieth century were published in English with a German translation included.

The Germans in Jeffersonville and New Albany also had breweries. The largest was the brewery operated by Paul Reising of Hoerstein, Bavaria, who acquired the New Albany City Brewery in 1857, moving to Fourth and Spring Streets in 1862. The City Brewery, renamed the Main Street Brewery, was operated by Martin Kaelin of Einsiedeln, Switzerland, until 1872. The Reising Brewery eventually became the Southern Indiana Ice and Beverage Company, finally closing in 1935. Another City Brewery operated in Jeffersonville at the corner of Graham and Maple Streets from 1875 to 1899. It made lager beer, cream beer, ale and porter.

Of the businesses associated with local brewing, it is worth mentioning the Kentucky Malting Company, founded in 1861 by John Engeln. Returning from the Union army, E.W. Herman joined the company in 1865. Frank Senn was a later partner. In 1880, the capacity was increased to 500,000 bushels of malt. In 1881, local malt houses had twenty-six employees, working fourteen hours a day, and produced 680,000 bushels, then worth $510,000. Kentucky Malting made malt for both brewing and distilling. Ferdinand Lutz operated the City Malt House at Rowan and Twelfth Streets. It eventually had a capacity of 250,000 bushels. A bushel of malt would make about a barrel of beer. The Southern Malting Company, founded by Nicholas Bohn in 1888 and acquired by Gottlieb Layer in 1890, made malt on what is now Lexington Road, near the present Irish Hill Park. Southern Malting produced about 50,000 bushels of malt. It had closed by 1910.

Elizabeth Bauer's Franklin Street Brewery produced a few thousand bushels of malt as the Falls City Malt House.

Philip Sengel, from Alsace, operated the Gambrinus Cooperage works on Mason Street. The company made large wooden fermenting tanks, each with a capacity of up to six hundred barrels, for aging and storing beer, as well as beer barrels. Until the 1930s, wooden barrels were the principal beer containers, and most beer was sold on draft, not canned or bottled. One reason so few breweries operated after Prohibition was because their vats were ruined by years of idleness, and capital for new vats was scarce in 1933.

Early breweries did not bottle their own beer. Thus, Adam Bez bottled Fehr's beer in 1880 and then later bottled beer for Drexler and Immohr and Drexler and Krieger. Phoenix Brewery beer was bottled by Louis Weber, who operated the Phoenix Hill Park. That changed after the crown cap and mechanized bottling were introduced in the 1890s, which, with pasteurization and refrigeration, made large breweries practical.

After 1942, there were only three breweries in Louisville, but they produced far more beer than the small breweries combined. In the 1950s, Oertel's, Fehr's and Falls City, along with Wiedemann in Newport and Bavarian in Covington, produced more beer than Kentucky consumed and were major local employers.

SALOONS AND BEER GARDENS

BY CONRAD D. SELLE AND PETER R. GUETIG

The first edition of the *Louisville Anzeiger*, February 28, 1849, lists advertisements for a number of saloons: Jacob Matheus's "deutsches Wein und Bierhaus" and Schrodt and Laval's wine and drink establishment, both on Market Street; Friedrich Meier's Wenzel Street Tavern; Daniel Kensten's Walnut Street Tavern near the Woodland Garden; Jackson Street Tavern, boasting "my bar is furnished with the best and purest drinks and my table with the most agreeable dishes"; Anton Bader's Portland Exchange "Kost und Wirtshaus"; Georg Besser's Kentucky Hall; Michael Dies's Kentucky Tavern; and Henry Fischer's "deutsches Bierhaus" on Market Street.

Louisville city directories listed 56 saloons in 1858, 355 in 1875, 748 in 1885 and 840 in 1895. About nine-tenths were operated by Germans. Many early breweries had saloons on premises to sell their product. Large breweries owned several. The Central Consumers Company, a combination of five large breweries including Fehr's, owned about a third of the saloons by 1910. These were leased to operators who sold their beer.

By the 1890s, there usually was a saloon or two on every street corner. A common type of business in the Louisville area was a grocery store and saloon combination, often a two- or three-story corner building. Sometimes it also had a stable and feed store in the back. The saloon was a mostly male establishment—respectable women could buy their beer on the grocery side of the premises. A considerable amount of beer was bought in buckets for consumption, and often children were sent to fetch

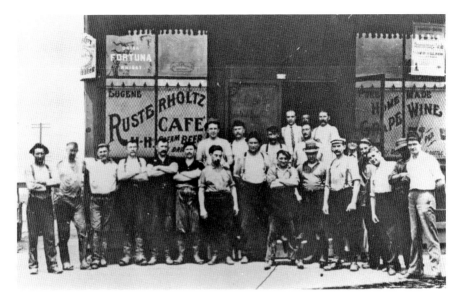

Rusterholtz Saloon in Butchertown. *Courtesy University of Louisville Photographic Archives.*

the beer. Kegs of beer were highly carbonated, but the opened beer would go flat and stale if it was kept overnight; so, the emptying of the keg often determined the closing hour. Most of a saloon's customers lived an easy walking distance from the place.

Saloons and beer gardens were a target of the temperance movement, which gained momentum in the early twentieth century. In 1906, a Sunday closing law was enacted. Most men worked ten, twelve or even fourteen-hour workdays, six days a week. Sunday was the only day the family could relax together so that was the day when beer gardens did the bulk of their business. According to an article in the *Louisville Daily Journal* dated July 4, 1868, Phoenix Hill Park sold 1 keg a day during the week and 30 on Sunday. Sales from the twelve breweries were estimated at 3,500 hundred kegs a week (about twenty-eight thousand gallons). Total sales at other establishments were estimated as follows: Woodland Garden, 1 keg a day, 12 on Sunday; the Löwengarten (Lion Garden), 2 kegs a day, 30 to 35 on Sunday; Smith's Garden, 7 kegs a week; Hanauer Garten, 7 kegs a week; and the Louisville Garden in Shippingport, 10 kegs a week; Otto Brohm's Empire Saloon (Fourth Street between Main and Market), 50 kegs a week; Phillip Bruckheimer (west side of Third Street between Market and Jefferson), 65 kegs a week; the Eldorado

Frank Bott's Saloon in Shippingport, about 1909. *Authors' collections.*

(northwest corner of Jefferson and Third Streets), 40 kegs a week; Beck's Hall with Hesser's Garden (north side of Jefferson Street between First and Second), 30 to 35 kegs a week; H. Driesman (west side of Third Street between Main and Market), 35 kegs a week; Turner Hall (north side of Jefferson Street between Preston and Jackson), about 21 kegs a week; and Schad's Saloon (west side of Third Street between Market and Jefferson), about 50 kegs a week.

Before Louisville's park system was established in the 1890s, beer gardens were an important source of recreation. They were usually located outside the city where the air was cleaner. Since people lived in close quarters in most of the city, with privies behind most dwellings, they enjoyed the trip to the countryside. The main features of the typical beer garden were shade trees, fellowship, music and entertainment, as well as beer and other beverages.

There were many beer gardens in Louisville before Prohibition. The Woodland Garden, located between Main and Market Streets past Wenzel, opened in 1827 but had passed into the hands of German operators by the 1850s. It had abundant trees and flowerbeds, and in 1834, a miniature railroad was built around it, offering rides for five cents.

In 1870, the proprietor was Bernard Strube, and the Liederkranz Society held promenade concerts at the large hall. Zoeller's band gave concerts there, and the trees were fitted with gaslights for night illumination. The Phoenix Brewery and Phoenix Hill Park—designed and built by Gottfried Miller, a stone mason and architect from Hohenzollern, and opened in 1865—had a park of a couple acres, occupying the area between Baxter Avenue, Barret Avenue, Hull Street and Rubel Avenue, with a commanding view of downtown and the Ohio River. Miller's partners were Philip Schillinger and Philip Zang. The brewery was bought by Peter Weber in 1869. Weber, from Alsace, had been operating a brewery in Madison, Indiana, for some years. His brother, Louis Weber, was the proprietor of the park. Phoenix Hill Park had extensive picnic grounds, a large dance hall, a bowling alley, a "card room (guns checked at the door)" and a 111-foot bar. There were many band concerts and sometimes the Liederkranz Society sang there. Political rallies were often held, and among the speakers were Theodore Roosevelt, Charles Evans Hughes and William Jennings Bryan.

The Löwengarten was located on Preston Street near Kentucky and had a dance hall, music stand and bowling alley. The Elm Tree Garden was located in Shippingport. Later called the Louisville Garden, it closed about

Woodland Garden. New York Daily Graphic, *April 29, 1875.*

1869. Phillip Eisenmenger had a beer garden at Thirty-fourth and Market Streets. Philippine Heser operated a beer garden on the narrow-gauge railroad in Prospect, also advertised in the *Louisville Anzeiger* as the Shooting Park; she also operated Schardein's Farm, off Seventh Street a mile or two south of Broadway.

Other beer gardens included Swiss immigrant John Buechel's Garden at the intersection of Baxter Avenue and Bardstown Road, near Cave Hill Cemetery. Visitors could ride the streetcar close to there by 1874. Buechel sold his establishment to Dominick Zehnder, another Swiss immigrant, about 1880 and opened the White Cottage Tavern in the part of Louisville now named for him. Zehnder's Cherokee Park Tavern was noted for its immense beer garden, known as Zehnder's Summer Garden. There were eleven saloons and four beer gardens between Zehnder's and Phoenix Hill Park in 1892, about a three-fourths-mile distance. Louis Will had a smaller beer garden across the street from Zehnder's. Sebastian Bott's Brewery at Eighteenth and Lexington Streets, which opened in 1865, also operated a beer garden called California Park. The beer garden had closed by 1905, when the brewery was greatly enlarged. The Family Garden of George Montz was located on Third Street near the Masonic Widows and Orphans Home. In 1892, it appeared as the Third Street Garden.

The German community proposed a beer garden at Iroquois Park, "which would be a splendid place for summer night celebrations, with concerts by the Liederkranz Society for example on sultry summer evenings, with fireworks and so forth, if not for the most repulsive sort in our lives, the Temperance clique with their sanctimonious hypocrisy did not put their veto on it!"

Prohibition was an economic disaster for Louisville's German community. As the editor of the *Louisville Anzeiger* warned in 1909: "Are the fanatical prohibitionists aware of what they want to destroy, millions in capital… without paying one cent of compensation?" The proprietors and employees of breweries and distilleries, saloons, beer gardens, cooperages, equipment manufacturers, warehouse workers, liquor dealers, shippers and others lost employment. Prohibition was not a sudden thing. Dry laws enacted in states and counties reduced alcohol sales. Sales at Oertel's Butchertown Brewery declined from 76,048 barrels in 1914 to 30,107 in 1919. Falls City and Fehr's experienced similar declines. Nationally, beer sales declined from 47 million barrels in 1910 to 7 million in 1919. Most of the country was already dry by the time the Eighteenth Amendment was enacted.

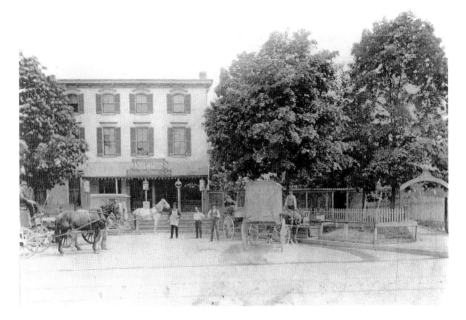

Zehnder's Cherokee Park Tavern, late 1890s. *Authors' collections.*

Prohibitionists blamed the saloons for a variety of social ills, including gambling and prostitution. But when Prohibition closed them, they were replaced with speakeasies where vices flourished to a greater degree, the liquor was frequently poisonous, where women and teenagers joined the men at the drinking establishments in a nation of lawbreakers. Prohibition undermined respect for law and government that has never been fully recovered and is a good measure of what cannot be attained by force of law.

During World War I, prejudice against German Americans was widespread. Saloons, along with the brewing and distilling industry, where German Americans were heavily involved, were called a German plot by the Kaiser to undermine American morals. The Ku Klux Klan had a resurgence about this time, and it campaigned against alcohol, Germans and Catholics, in addition to supporting racism.

Republican support for Prohibition was a disaster for the party. When a report in 1931 defended Prohibition, satirist and poet Franklin P. Adams wrote in the *New York World*, "It's filled our land with vice and crime, it don't prohibit worth a dime, nevertheless we're for it." It was repealed in 1933 after the Republicans lost the election.

After Prohibition, legal drinking was resumed in a society that was much changed. Many businesses were licensed to sell alcohol, but they were no longer called saloons. German language and customs were far less prevalent then, and most of the German community was English-speaking and heavily integrated with the rest of the population. Private drinking of bottled beer had become prevalent. Movies were more popular than live entertainment. While outdoor entertainments were often held, the Sunday closing law ensured the virtual extinction of the old-style beer gardens.

13.

SINGING SOCIETIES

BY GARY FALK

As Germans immigrated to Louisville beginning in the 1820s and 1830s, they formed social organizations as a way of sustaining and promoting the culture of the home country. As late as 1900, there were sixty-nine German clubs and societies in Louisville. Most of these organizations had a central theme based on either music or athletics.

The first known musical society in Louisville was the St. Cecilia Society, formed in 1822. This orchestral group was active intermittently until about 1835. The earliest choral group was the Mozart Society, organized about 1845.

The best-known singing society in Louisville was the Liederkranz (a name meaning "wreath of songs"). In the United States, Liederkranz societies had their earliest organizations in Baltimore and New Orleans.

The Liederkranz in Louisville began with a meeting in February 1848, although there had been interest in starting such a group as early as the 1830s. The group was modeled closely after a similar organization in Newark, New Jersey. Its first regular meeting place was the Mozart Hall at Fourth and Jefferson Streets.

From its founding, the Liederkranz became an important part of the fabric of the city of Louisville. In 1849, members joined similar groups in Cincinnati for the first Sängerfest organized by the newly formed Nord-Amerikanischer Sängerbund (NASB). The chorus at that gathering was under the direction of Fritz Volkmar, the founder of the Liederkranz. Louisville and the Liederkranz were hosts to National (NASB) Sängerfeste

Liederkranz Society, 1865. *Courtesy Filson Historical Society.*

[handwritten annotations: "Against Know Nothing Party Bloody Monday Riots"; "German and Irish"]

in 1850, 1866, 1877 and 1914, and they participated in at least eleven others from 1849 to 1927.

In the mid-1850s, the anti-immigrant, anti-Catholic Know-Nothing Party gained a foothold in Louisville. Its antipathy culminated in the Bloody Monday riots, which took place on August 6, 1855. This event represented a threat to the German community and to the Liederkranz organization, but after several years, the ideas promoted by the Know-Nothings were largely discredited. After the Civil War, the Industrial Revolution brought about important economic changes, which were reflected in the various expositions that became part of the local landscape. Thus, the late nineteenth century became the period of greatest success for the Liederkranz.

In 1873, the Liederkranz built its first hall on Market Street between First and Second Streets. Twenty-three years later, a new hall was built at Sixth and Walnut (Muhammad Ali Boulevard) Streets. The meeting hall and adjacent theater remained extant until it was demolished in 1976.

Throughout most of its history, the Liederkranz in Louisville was a singing society; however, there was a period starting in 1893 when there was a Liederkranz chorus and orchestra. When this union was formed, it was under the leadership of Karl Schmidt.

Thirty-fourth National Sängerfest, Nord-Amerikanischer Sängerbund, 1914. *Courtesy Filson Historical Society.*

During World War I, because of negative sentiment, the Liederkranz suspended its activities until 1921. Exacerbated by two world wars, interest in the group had begun to wane by the early 1950s. The Louisville Liederkranz disbanded after the death of its last director, Fred O. Nuetzel, in 1959.

Besides the Liederkranz, other German singing societies were important to the city, at least one of which remains active today. Those which existed only briefly include the Mozart Society (1845–60), the Mendelssohn Club (1867–73), the Beethoven Society (1870s), the Arion Society (1870s–87), the German Baptist Singing Association (1880s) and the Harmonia Männerchor (1882) and Singing Society (1890s).

The best-known and longest-lived musical societies were (are) as follows:

Orpheus Choral Society: The Orpheus Society was founded in 1849 with Carl Bergstein and Professor Glagan as directors. The society participated in National Sängerfeste in 1869 and 1870 but went out of existence in the 1870s.

Frohsinn Society: The Frohsinn organized about the same time as the Liederkranz but had disbanded by the late 1880s. Members participated in National Sängerfeste in 1869 and 1870.

Concordia Singing Society: The Concordia Society was founded in 1855 and held rehearsals at St. Boniface School Hall with Professor George W. Nahstoll as director. Members participated in six National Sängerfeste from 1870 to 1927. They disbanded in the 1930s.

Alpenrösli Singing Society: The Schweizer Männerchor, a Swiss men's singing society, was founded on January 8, 1878. The group became

a mixed chorus in 1882 and renamed itself the Alpenrösli Society. Its members were active until the 1930s. When first formed, the society rehearsed weekly at Beck's Hall under the direction of Professor E. Scheerer. The Alpenrösli participated in three National (NASB) Sängerfeste in the 1890s and hosted the 1909 Sängerfest of the Swiss-American Central Sängerbund.

GERMAN-AMERICAN CLUB GESANGVEREIN: First known as the Sozialer Männerchor, the organization was founded on November 10, 1878, at Beck's Hall on Jefferson Street by Louis Vormbrock. Its first director was Otto Schuler. Members gave their first concert in Beck's Hall in June 1879. The group located to a permanent home at 318 South Jackson Street in 1942 and renamed itself the Social Male Chorus. In 1965, because of urban renewal, it moved to its present location at 1840 Lincoln Avenue. Still in existence, the society has participated in numerous Sängerfeste, beginning in 1880 and continuing through the present. It hosted the 1989 National Sängerfest, attended by 1,725 singers from fourteen states. The Social Male Chorus changed its name to the "German-American Club Gesangverein" in 1993.

THE TURNERS

BY GARY FALK

The term "Turner" is derived from the German *turnen*, meaning to perform gymnastic exercises. The original Turners were primarily athletic in scope but later developed political overtones. When they were founded, the Turners were known as being quite liberal. After organizing in the United States, they were opposed to slavery and promoted women's rights.

The founder of the Turner movement was Friedrich Ludwig Jahn (1778–1852). He was a German gymnastics educator and nationalist who believed that the development of physical and moral powers occurred through the practice of gymnastics. He organized the Turners in Germany in the early nineteenth century, when the country was occupied by Napoleon. After the European revolutions of 1848, the Turner movement was suppressed in Germany, and many Turners immigrated to the United States. As noted in *The American Turner Movement: A History from Its Beginnings to 2000*, "Many Turners saw it as their duty in their new homeland to continue fighting for democracy, liberty and fraternity as they had done in Germany." Many Turners became soldiers in the Civil War, even forming several of their own regiments.

Shortly before the Civil War, the Turners found a friend in Carl Schurz (1829–1906). Schurz had been active in the movement to promote democracy in Germany but immigrated to the United States in 1852. He campaigned for Abraham Lincoln in the 1860 election, fought in the Civil War and was the first German immigrant elected to the U.S. Senate in 1868

(Missouri). Schurz, like Lincoln and the Turners, was opposed to slavery. In addition, the Turners became a part of the American public education process and were involved in organized labor. They became active in events that surrounded President Lincoln and were proud American citizens. So it must be said that the Turner movement embodied principles of physical fitness and health, moral responsibility and social activism.

The oldest *Turnverein* (gymnastics club) in the United States is the Cincinnati Turngemeinde, which began on November 21, 1848, the same year that an organization was founded in New York. Before long, the Turners were in most cities along the eastern seaboard and into the Midwest. At a convention held in Philadelphia on October 4–5, 1850, a national Turner organization, the Vereinigte Turnvereins Nordamerika (United Turner Societies of North America), was created to bring about a closer union of the various groups and to provide unity to the individual societies. The next year, the organization was renamed Socialistische Turnerbund von Nord Amerika (Socialist Turner Federation of North America) to reflect the liberal political outlook of the group at the time. To further advance the cause of the Turner movement nationally, periodic

Männer Turnverein Vorwärts, 1887. *Courtesy Filson Historical Society.*

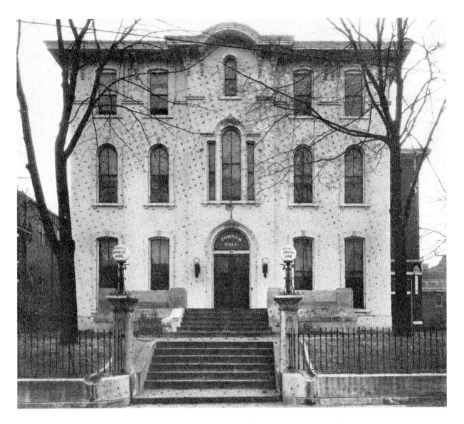

Turner Hall. *Official Souvenir and History, Thirty-Third National Turnfest, American Turnerbund, 1926.*

Turnfeste were organized in which selected athletes of participating organizations were chosen to display various aspects of physical training. Although the official language of the Turners was German, this gradually changed, and by World War I, the language requirement had been abandoned.

The Louisville society of the Turners was organized on September 2, 1850. William Vogt, a prominent local citizen, along with Charles Franke and Wilhelm (William) Staengel, was instrumental in organizing the society. In 1851, the Turners moved into their first hall, ostensibly the first gymnasium built in the city of Louisville. By 1854, a permanent home for the society was built on Floyd Street between Market and Main Streets. In the 1850s, the Turners were the victims of the infamous Know-Nothing Party, which had been able to influence local politics and represented a threat to newly arrived German and Irish immigrants. Two years later, a fire destroyed the Floyd

Street hall. In 1858, a former Catholic church building was purchased on Jefferson Street near Preston. The church was remodeled into a hall suitable for the activities of the Turners. During the Civil War years, some thirty-five members of the Turners enlisted into the war effort. From 1861 to 1864, the hall was used as a hospital to treat hundreds of wounded soldiers. In 1875, the Ladies Auxiliary of the Turners was started.

In 1887, the Louisville Turners split over a resolution condemning the Chicago judges who sentenced seven German immigrants to be executed for their involvement in the Haymarket Square Riot. Liberal members of the Turners left to form their own organization, the Männer Turnverein Vorwärts. Although Vorwärts included some of the best gymnasts from the Turners, the organization lasted only twelve years.

By 1911, the Turners were able to purchase the site of Turner Park along the Ohio River near Zorn Avenue. When the Turners outgrew the downtown hall, they purchased the boyhood home of Supreme Court justice Louis D. Brandeis at 310 East Broadway. They added a gymnasium to the rear of the building and occupied it in 1917. In 1926, the Louisville Turners were hosts to the thirty-third National Turnfest. In 1984, the Broadway site was sold, and the Turners built a new building and gymnasium on the site of Turner Park, where they now reside.

By the early 1900s, the Turners were open to all U.S. citizens regardless of racial, ethnic or religious background. Today, there are fifty-three Turners societies in twelve districts. They have annual national competitions in gymnastics, golf, bowling, softball, volleyball and cultural activities. While the Turners retain elements of their German heritage, they have adopted American ways while striving to respect their founding principles. The official name of the Turners in the United States is now the "American Turners," and their corporate headquarters are located in Louisville.

15.

BUTCHERTOWN

BY EDNA KUBALA-MOTT

Butchertown is a neighborhood located just east of downtown Louisville. It is bordered by the Ohio River on the north, Interstate 65 on the west, Main Street on the south and Mellwood Avenue and Beargrass Creek on the east. As early as 1796, a gristmill was built there, and the first house was erected in 1802. The area was annexed by the City of Louisville in 1827. The history of Butchertown is closely tied to the wave of German immigration to Louisville beginning in the 1830s.

In the nineteenth century, Louisville faced a large and ever-growing urban population to feed. With only twelve butchers in town in 1832, they were in great demand. As Germans with a mastery of the butchering trade immigrated to the United States and settled in the Midwest, they were the natural fit to heed the midcentury call. In Louisville, the only question was where. With the generally messy process of butchering livestock banned in the city center, the just-removed area upriver, east of downtown, also happened to be the intersection of Shelbyville Turnpike, Workhouse (Lexington) Road and Brownsboro Road, all prime routes to transport livestock into town from the surrounding farm country. Also, the nearby Beargrass Creek was a convenient place to dispose of animal remains (a practice long since abandoned).

A large influx of experienced butchers emigrating from Germany following the European revolutions of 1848, combined with the then suburban location and proximity to Beargrass Creek, quickly established Butchertown as a bustling early German neighborhood in Louisville. By

1865, Louisville was home to two hundred master butchers, 80 percent of them in Butchertown. A typical Louisvillian of the time would buy cleaned, butchered meat from one of the many Germans employing the skills and experience brought over from the strong Metzger culture of Germany. Names such as "Kleisendorf, Leibold, William and Gottlieb Kriel, Casper and Henry Schmitt, Bremacher, Weis, Ulmer, E. Kirder, F. Butterweck, Conrad Schoefel, Frank Hammer, Charles Rehn, and Fred Leib" turned animals into dinner during the antebellum and Civil War eras in Louisville.

In the mid-nineteenth century, the Germans who immigrated to the United States were, for the most part, refugees from the political strife that embroiled the German states prior to Bismarck's unification (in contrast to the Irish famine immigrants). In the United States, the areas settled by Germans became humming towns and villages with the efficient specialization of labor typical of Germany. This was true of Butchertown with its natural geographic features, manmade infrastructure and nearby city requiring products and food. The industriousness of the newcomers and the urban proximity and transportation advantages of the neighborhood brought about a host of complementary commerce, the likes of which also took advantage of German experience and expertise. Becoming a veritable German workshop to the city's immediate east, cooperages (making barrels to ship meat and other products), Louisville's largest woolen mill, breweries, inns, tanneries, bottle makers, candle makers and soap-making factories began to emerge to support the rapid growth following the Civil War. Catering to farmers heading back to the country after selling their animals were feed stores, such as the Knopf Brothers and the William Gnau Feed Store, and fertilizer and dry goods stores near the Stock Yards.

The Bourbon Stock Yards was established in 1834 along developing railroad lines in the neighborhood. With the completion of the Louisville-Cincinnati-Lexington Railroad in 1851, driving livestock along turnpikes from the Bluegrass was rendered obsolete. By 1869, the Stock Yards was enlarged, and the Metzger Verein (Butchers Union) was formally organized and led by President John M. Letterle. The Metzger Verein developed a presence in the neighborhood and began sponsoring community events, such as parades and picnics. With the meat-processing industry scaling up to meet the growing demands of Louisville and German immigrants pouring in, Butchertown became Louisville's *Mittelstand* (enclave of small- and medium-sized enterprises) on the banks of Beargrass Creek. Numerous German meatpackers, such as Henry Fischer, Herman Vissman and Louis Bornwasser, were based in Butchertown.

An image of the Bourbon Stock Yards with a horse-drawn wagon in front, 1936. *Courtesy University of Louisville Photographic Archives.*

While blending some sensible North American styles where practicable, newly immigrated Germans left their mark on the lasting architectural heritage now contained in the Butchertown Preservation District. The feel and mixed-use nature of Butchertown is somewhat reminiscent of German villages and small towns with varying types of houses, industrial businesses, churches and small shops. This is in contrast to other areas of Louisville, even Germantown, which are generally more residential in nature. Employing thrifty practices learned at home, Butchertown residences were generally humble in nature, such as the many small shotgun, townhouse and duplex homes, interspersed with larger brick mansions built by wealthy butchers. An interesting example of identical housing is a row of shotgun cottages along Mellwood Avenue between Main Street and Frankfort Avenue, which were built by Charles Stecker, a German immigrant who owned a tanning business, as rental properties between 1912 and 1915. They were occupied by a variety of renters, ranging from railroad employees who walked across the street to work, to tallow plant and pork house workers. Another notable section of the neighborhood is the 1600 block of Story Avenue. Straddling

prominent turnpike intersections and Beargrass Creek, the block included mixed-use properties (residence in front, butchering out back), tanneries, candle makers and taverns. It remains today a cohesive block example of the density of Butchertown's prime.

Perhaps the most famous home in Butchertown is the Heigold House, built between 1857 and 1865 on Marion Street by German-born stonemason Christian Heigold. Started following the Bloody Monday riots of 1855, it was decorated with patriotic busts of Presidents George Washington and James Buchanan, as well as patriotic symbols and phrases such as "The Union Forever," "Hail to the Union, Never Desolve It" and "Hail the City of Louisville" in an effort to prove loyalty. Tolerance and respect afforded to the early industrious Germans would ebb and flow throughout the decades, with Germanness and heritage deemphasized or altogether hidden during anti-foreign riots and two world wars. Threatened with demolition, the Heigold House façade was first moved in 1953 to Thruston Park before being moved in 2007 to its current location at the gateway to Butchertown at the intersection of Frankfort Avenue and River Road.

Where there are Germans, there is beer. In order to wash down all the pork produced by the neighborhood, beer was a necessity. German immigrants established and frequented breweries in Butchertown, such as the Butchertown Brewery, established by John Oertel of Mühlheim, Germany, in 1891 (later renamed Oertel's), as well as Steurer, Franklin, Clifton and Union Breweries. The brewery density of Butchertown at the time rivaled that of the homeland. Also, Germans brought beer garden traditions to Louisville and frequented the local Woodland Garden at Market and Johnson Streets or Schwab's Grove (later known as the Third Woods), accessible on Mellwood Avenue via the Market Street car line. Woodland Garden advertised "bowling alleys, Merry-go-round, shooting gallery, swings, excellent food, good wines, Refreshing beer, Lively music and spacious dance floor." Germans worked hard and liked to relax in beer gardens with their families and enjoy their time off, even though Louisville natives were somewhat scandalized by the attendance in beer gardens on Sunday.

Community and civic duties were important in Butchertown, and clubs were founded and met at outside venues or at the Delmont Club (now the Vernon Club, the third-oldest bowling alley in the country). Among these were a *Gesangverein* (singing society), a Turnverein, a baseball team and, of course, bowling leagues.

Heigold House, about 1904. *Courtesy Janice K. Hellmann.*

Oertel Brewing Company, 1942. *Courtesy University of Louisville Photographic Archives.*

Schools and churches in Butchertown also were influenced by the resident Germans. The German American Civic School began in 1854. St. Joseph Catholic Church and its associated school were founded in 1866 to serve the German Catholic population. The present large brick Gothic Revival church was completed in 1883. Its 175-foot-tall twin spires, added in 1905–06, make it easily identifiable from the distance. The church has been central to the neighborhood since it was built.

As in the rest of the country, industries in Butchertown, such as butchering, have become centralized and dominated by large conglomerates. The age of German-led butchering as the lifeblood of the neighborhood has long passed. Interstate highways and floodwalls have done further damage to the neighborhood. However, the strong neighborhood foundations laid by early German immigrants to the Louisville area remain in the no-nonsense, stout architecture; the ideal location, close to the city and transportation outward; and the creative and mixed-income residents who know the value of a day's work. Though distant relatives of their past heydays, butchering, brewing and cooperage remain. Current businesses, especially those continuing past industrial traditions, are distant but descendant from much of the work done by early Germans in Butchertown. The neighborhood's convenience and proximity to the city, put to such good use by the Germans who were instrumental in developing the area, remain appealing today.

16.

GERMANS IN THE MEXICAN WAR AND THE CIVIL WAR

BY JOSEPH R. REINHART

On May 17, 1846, just four days after the U.S. Congress declared war on Mexico, the First Regiment Kentucky Volunteers Foot (infantry) mustered into federal service at Louisville. Among its ten companies were two companies of German immigrants from Louisville (C and F). Notably, Captain Florian Kern, a native of the Grand Duchy of Baden, led Company C, and Captain Conrad Schroeder, from Hessen, commanded Company F. Both captains had previously served in the National Guards, a local German militia company formed in 1840. Several other Germans from Louisville who had served in the cavalry in Germany fought in Colonel Humphrey Marshall's First Regiment Kentucky Volunteers Cavalry.

The First Regiment Kentucky Volunteers Foot, also known as the Louisville Legion, participated in the Battle of Monterrey in Mexico (September 21–24, 1846). Soldiers were garrisoned in the city of Monterrey and scouted and guarded supply trains during their year of service. Of the 129 Germans in companies C and F, 10 died, 21 were discharged for disabilities, 2 were captured and 1 was missing. Private Jacob Ruckstuhl, a Bavarian Rhineland native, was seriously wounded at the Battle of Buena Vista, fighting with Colonel Humphrey Marshall's cavalry regiment. Germans maintained several local militia companies after the war ended, but the anti-foreigner Know-Nothing movement caused their dissolution in the late summer of 1855.

Louisville's German-born population nearly doubled during the 1850s and totaled 13,374 persons in 1860. If their immediate offspring born in

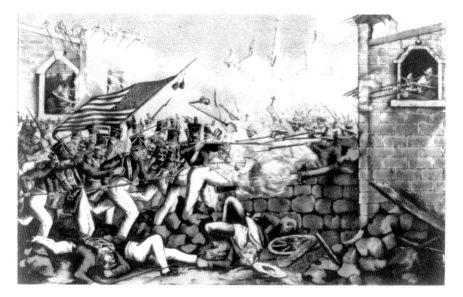

The Battle of Monterrey, September 21–24, 1846. Courtesy Library of Congress.

Louisville or elsewhere in the United States were added, persons who were culturally German (and considered Germans by Anglo Americans) exceeded 20,000 persons, representing 33 percent of Louisville's white population and 30 percent of its total population. (Anglo Americans are defined here as persons born in the United States and descended mainly from colonial-era English and Scots-Irish colonists).

Louisville's Germans, like the rest of America's 1.3 million German-born immigrants in 1860, were not a monolithic group and were divided by many issues. Even though they were all German speaking, they were set apart by differences in idiom and dialect, class, religion, political views, region of origin and time of emigration. They had come from Baden, Bavaria, Prussia, Hessen, Oldenburg and numerous other political entities that were, or had been, independent kingdoms, duchies or principalities with their own political and tribal histories, which had sometimes warred against each other. In 1860, most Germans in America identified themselves with the state of their birth rather than with Germany because, until 1871, there was no country or nation called Germany, only a geographical area in Central Europe. Anglo Americans lumped all these Teutonic newcomers together and called them all Germans or, disparagingly, "Dutch" or "Dutchmen." "Dutch" was a corruption of the German word "Deutsch,"

meaning German. Historian Christian B. Keller notes, "German-born immigrants…were struggling to define themselves within American society as an ethnic group and sort out internal differences that kept them strongly divided." Despite these differences, "a spirit of 'Deutschtum' or 'pan-German consciousness' began to sweep across the country as the 1850s progressed." Army service brought together many Germans from different places, raised their ethnic consciousness, and increased ethnic solidarity. As described later in this chapter this "spirit of Deutschtum (Germanness)" increased both during and after the Civil War.

Louisville's Germans voted overwhelmingly for Democrats because the Democracy welcomed foreigners into the party, spoke out for their political rights, and opposed Puritanical temperance and Sabbath laws fostered by Anglo American Protestant reformers. In the 1860 presidential election, Republican candidate Abraham Lincoln received only ninety-three votes in all of Louisville. Some of the ninety-three votes for Lincoln likely came from German Forty-Eighters and Turners who supported the Republican Party because of its abolitionist element. The *Louisville Anzeiger* reported that Louisville's Germans disliked slavery and opposed its spread to the territories but were not in favor of a sudden unprepared emancipation because they feared the economic and social disruptions this would cause.

While a large majority of the city's population opposed Kentucky's secession from the Union, the city's Germans were virtually unanimous in their opposition to secession. They believed their best interests lay within the Union. The *Anzeiger* declared in bold print on April 18, 1861, "Union für Immer!! (Union Forever)." Germans enthusiastically participated in pro-Union rallies before war broke out, and soon after Confederate guns fired on Fort Sumter in Charleston Harbor on April 12, 1861, they enlisted in Home Guard units authorized by Louisville's General Council for local protection. Several German companies were organized (the National Guards, Thurston Guards and Franklin Home Guards), and Germans also enlisted in mixed companies with Anglo Americans and other ethnic groups. Many of the Home Guards later joined the Union army. Ultimately, more than 1,225 German-born men from Louisville served in the Federal army. On the other hand, only a few local Germans can be found in Confederate army muster rolls.

Two-thirds of Louisville's German-born enlistees joined predominately German companies, and the remaining one-third served in mixed companies predominated by Anglo Americans or other nationalities. Many Germans chose German companies because they lacked skills in English or wanted to serve

among and under men of their own culture. Some feared nativist hostility in the ranks of Anglo American units while others responded to an appeal from German leaders to stick together to raise the visibility of Germans' participation in the war. Still others saw a better opportunity for advancement than in predominately Anglo American companies. A Civil War company mustered in with 84 to 101 officers and men; a captain and 2 lieutenants led each company. Infantry regiments normally consisted of 10 companies and a small headquarters (headed by a colonel, lieutenant colonel and a major). Cavalry regiments usually contained 12 companies and a headquarters.

Lieutenant Robert A. Wolff, 32nd Regiment, Indiana Volunteer Infantry. *Courtesy Library of Congress.*

Kentucky's entry into the war was preceded by a period of self-declared armed neutrality beginning on May 20, 1861, and ending on September 18. During this uncertain and distressing period, Louisville Unionists traveled to Indiana and Ohio to join or organize Union regiments. In July 1861, hundreds of Louisvillians entered Camp Joe Holt near Jeffersonville to join the Union army. Approximately two hundred Germans from Louisville were among this group forming Company E of the 5th Kentucky Volunteer Infantry Regiment and the future Company C of the 6th Kentucky Volunteer Infantry Regiment. Captain August Schweitzer, a machinist born in Bavaria, led Company E, and Captain Joseph Haupthof (German birthplace unknown) headed future Company C. The 6th Kentucky officially began organizing in Louisville shortly after Kentucky declared for the Union and ultimately contained four companies of Louisville Germans, the most in any Kentucky regiment. Company K of the 22nd Kentucky Volunteer Infantry Regiment consisted principally of Louisville Germans. Sufficient numbers of the city's Germans served in various companies of the 28th Kentucky Volunteer Infantry, 34th Kentucky Volunteer Infantry and Louisville Provost Guards for each of those units to have formed a separate German company. Louisville Germans also joined various other Kentucky

regiments and units from other states, such as the predominately German 32nd Indiana Volunteer Infantry and 9th Ohio Volunteer Infantry.

Local Germans fought in the cavalry, too. The 4th Kentucky Volunteer Cavalry Regiment contained three German companies from Louisville. Mexican War veteran Jacob Ruckstuhl served as lieutenant colonel of the 4th Kentucky Volunteer Cavalry. A wound received in July 1862 caused Ruckstuhl to resign his commission at the end of April 1863.

Lieutenant Colonel George W. Barth of the 28th Kentucky, Major John F. Gunkel of the 4th Kentucky Cavalry and Jacob Ruckstuhl served as field officers. Close to thirty Falls City Germans served as company officers (captains and lieutenants), mostly in German companies. Four officers in the 6th Kentucky sacrificed their lives for the Union: Captain Peter Marker and Second Lieutenant Friedrich V. Lockmann were killed at the Battle of Chickamauga in Georgia, Captain Friedrich Nierhoff was slain during the Atlanta campaign and Captain Peter Emge died in Louisville from disease. Several other German-born officers resigned because of physical disabilities.

The 5th and 6th Kentucky Volunteer Infantry Regiments, which fought in many of the major battles in the western theater, such as Shiloh, Stones River and Chickamauga, suffered the second- and third-highest number of combat-related deaths of all of Kentucky's regiments respectively, and their German officers and enlisted men shared in the sacrifice. In these two regiments, approximately fifty Germans were killed in action or died from wounds, and nearly forty-five died from disease and other causes. Civil War graves of local Germans who gave their lives for the Union can be found in Alabama, Georgia, Kentucky, Louisiana, Maryland, Mississippi, Tennessee and Virginia.

On the homefront, German American civilians and organizations helped the soldiers in the field in various ways. Ladies made clothing

Captain Adolf G. Metzner, 32nd Regiment, Indiana Volunteer Infantry. *Courtesy Library of Congress.*

Captain William Urlan, 32nd Regiment, Indiana Volunteer Infantry. *Courtesy Library of Congress.*

and sent tobacco, cigars, preserved fruit and other useful items to soldiers. Men and women (including Pauline Barth, Ida Beckman and Rosa Volkmar) raised money for the Soldiers Fund and Monument Fund, and Germans worked in local military hospitals. The wives and children of soldiers suffered from the absence of their husbands and fathers, and many lost their loved ones forever.

The participation of Louisville's German immigrants in the War with Mexico and in the Civil War demonstrated their willingness to fight for their adoptive country in its times of need.

Unfortunately for the Germans, joining the battle to save the Union did not extinguish the anti-German prejudices so prevalent in the mid-1850s. Captain William Staengel, a founder of the Louisville Turnverein and one of the Louisville residents who joined the 9th Ohio Infantry, wrote in a letter published in the *Anzeiger* in January 1862: "You have no concept at all how deep Know-Nothingism is rooted in all layers of American society…I have never seen the hate of foreigners, especially toward the Germans, appear so openly as during this campaign [in western Virginia]." The irate Forty-Eighter then revealed his own strong Teutonic pride and prejudice by stating: "Jealousy may well have much to do with it because as conceited as the American is, he cannot accept that the German is a much better soldier." Similarly, in March 1864, the *Anzeiger* published a letter from Private Gottfried Rentschler of the 6th Kentucky Infantry, stating: "As a rule, the German has to wade through the mud, while the American walks on the dry road. The German…is, if not despised, is disrespected, and not regarded or treated as an equal." Like Captain Staengel, Private Rentschler also proclaimed German soldiers to be superior to Anglo American ones. Obviously, pride and prejudice ran both ways.

American nativism manifested against Germans during the Know-Nothing crisis, followed by nativists' actions against Germans during the

Civil War, caused America's Germans, in Keller's words, "to unify against the nativist threat and protect their own." They remained on guard even after the crisis passed in case the threat might rise again. The war caused Germans to change their conceptions of their ethnic identity and of their place in American society, and after the war they constructed a national German American ethnic identity. This separate identity was based on cultural values, and with help from postwar immigration, it lived on until finally shattered by the anti-German hysteria of World War I.

17.

MANUFACTURING

BY GARY FALK

Emigrants from throughout Europe came to the United States in large numbers beginning in the early 1800s. As they worked their way westward across the nation, many settled in Louisville and Southern Indiana.

These groups brought with them the cultures of their native countries. Many settlers were from Germany. By 1850, Germans in Louisville numbered about seven thousand five hundred, which was about 20 percent of the total population. With this new population, many skilled trades emerged that helped the city grow and prosper. These skilled artisans represented a broad spectrum of talents, including carpenters, brick masons, painters, metalworkers, furniture makers, food processors, brewers and distillers.

Tradespersons in the 1800s were associated with their craft and the style of work that originated in their home country. Starting in the early 1900s, these talents began to be assimilated into the population. As a result, certain skills became less identifiable as to the country of origin. From small tailor shops and shoemakers to the captains of large industry with as many as several thousand employees, German names were pervasive in the landscape of Louisville and southern Indiana.

German workers, shops and industries began to experience great difficulty in the mid-1800s with the growth of the political Know-Nothing Party, which was anti-immigrant and anti-Catholic. The infamous Bloody Monday riot that occurred in Louisville in August of 1855 was a flash point for this reactionism.

Fortunately, after the Industrial Exposition of 1872 (Exposition Center at Fourth and Chestnut Streets) and Southern Exposition from 1883 to 1887, Louisville citizens were mainly concerned with the development of the city and showing the world the many resources they had to offer. The negative feelings were, for the most part, dispelled until the outbreak of World War I, when many industries, banks, churches and social groups purged themselves of any identifiable link to the "homeland." This represented a sad chapter for German business and trade locally, one that would remain through World War II. By the 1950s, most of the animosity had waned, and Louisville became an industrial power that did not decline until the late 1970s. The downturn this time had nothing to do with immigration, politics or religious intolerance. The world was beginning to change in ways going beyond nationality. New terms such as "outsourcing," "globalization" and "downsizing" emerged. The manner and means of production was changing. Computer control and robotics were the new modes of manufacturing, eliminating the need for much of the manual labor that early immigrants provided. Many products that formerly were crafted from wood and metals were made instead from plastics, epoxy resins and new composite materials. There would be no going back. Global trade agreements would emerge to further change the way that products were made and marketed.

Examples can be given of many Louisville businesses and industries whose beginnings were rooted in first- and second-generation German immigrants. Many of the fruits of these German artisans and tradesmen are evident today in the architecture and ornamentation of the many homes in what is referred to as "Old Louisville." The ornamental ironwork embodied in the many storefronts and industrial buildings along Main and Market Streets are testimony to this craftsmanship. It would be impossible to chronicle the precise number of companies that were managed by any nationality, and certainly it would be beyond the scope of an effort such as this. There are many examples, though, that are important in the development of commerce and growth in this city and its environs. The following paragraphs describe some of the major players in Louisville manufacturing with German roots.

THEODORE AHRENS

Plumbing and Manufacturing

Theodore Ahrens's parents, Georg Andreas Theodor and Maria Christine (Lohmann) Ahrens, were German immigrants who came from Hamburg to Louisville by way of Baltimore, where Theodore Jr. was born in 1859. Theodore Sr. was a skilled plumber who formed a partnership with Henry Ott, also a practical plumber. They did extensive brass work and general plumbing. Theodore Jr. was a visionary who built on the experience of his father, combining it with nine other businesses, each representing a specialty in the plumbing trade that formed what became known as the Standard Sanitary Manufacturing Company. This company ultimately employed many thousands of workers in the various manufacturing plants that dotted the city. The building that housed the main plant at Seventh and Shipp Streets still stands, as does the company headquarters building at Campbell Street and Broadway. Theodore Ahrens's stature extends beyond plumbing, however. He literally changed the industrial landscape of this city, creating a huge

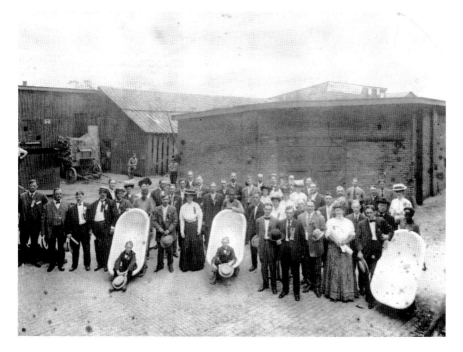

Ahrens & Ott Manufacturing Company, about 1880. *Courtesy Filson Historical Society.*

vocational school for all of the important building trades. He also supported the Standard Sanitary Orchestra that performed at important music functions throughout the city. Following World War I, Standard Sanitary merged with the American Radiator Company of Ware, Massachusetts, to become the American Standard Company. Ahrens died in 1938 and is buried in Cave Hill Cemetery.

Vogt Family

Ice Machines, Gate Valves, Boilers, Lawn Mowers and Heavy Equipment Manufacturing

Johannes (Johan) Vogt and his wife, Barbara Schlatter, emigrated from Freinsheim, Bavaria, in 1861. Two of their children, Amelia and Jacob, came with them from Germany. Two sons, Henry and Adam, were born in the United States. The Henry Vogt Machine Company, a giant facility that occupies some twenty acres in the industrial corridor just west of downtown Louisville near Eleventh and Ormsby Streets, and the Vogt Brothers Manufacturing Company at Fourteenth and Main Streets stand today as

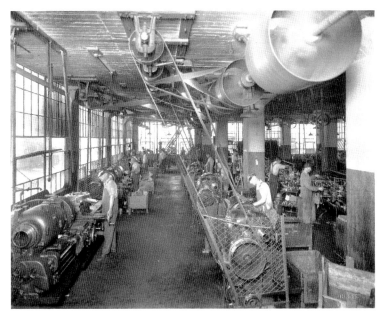

Henry Vogt Machine Company, 1930s. *Courtesy Lewis A. Meyer.*

silent reminders of the size and scope of the various industrial enterprises that came about through the efforts of the two brothers Henry and Adam. Vogt was best known for manufacturing giant gate valves and fittings and ice and refrigeration machines. It also made boilers for large ships and factories, electric lawn mowers and fire hydrants (some of which are still in use in the city). It built steam-generating equipment and petroleum refinery and chemical plant equipment as well. Clarence Vogt (1891–1973), the son of Adam Vogt, worked for the Vogt Brothers Manufacturing Company for a time, but became famous as an inventor of many products, including the Votator (1926), a device still in use for emulsifying and aerating products within the food industry. The Votator was built for many years by the Girdler Corporation in Louisville.

CHARLES C. MENGEL JR. AND CLARENCE R. MENGEL

Wooden Boxes, Shipping Containers, Furniture, Aircraft and Auto Bodies

Charles C. Mengel Jr. and his brother Clarence R. Mengel founded C.C. Mengel & Brother Company in 1877. The brothers were natives of Gloucester, Massachusetts, and sons of Charles C. Mengel Sr., an emigrant from Gera, Saxony. A third brother, Herbert W. Mengel, joined the company in 1890. Before it ceased operations in 1960, the Mengel Company employed over six thousand persons in its various divisions. The brothers started building wooden boxes for the tobacco and distilling industries but quickly expanded their operations to include furniture and car bodies for the Durant automobile company of New York. This company was the major force behind the development of the C-76 Caravan, an all-wooden cargo plane developed by the Curtiss-Wright company, located on Crittenden Drive during World War II. At one point, it maintained a fleet of steamships to bring in specialty woods from overseas. Mengel also had a company town named Mengelwood, located in Tennessee, for its sawmill and logging operations.

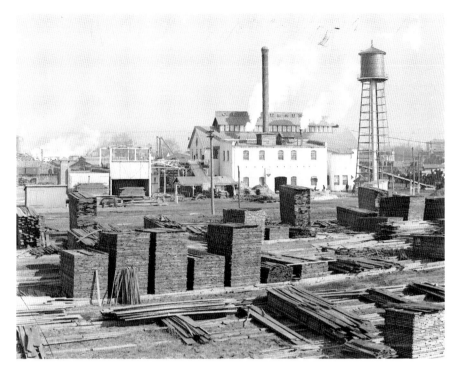

C.C. Mengel & Brother Mahogany Mills, 1910s. *Courtesy Library of Congress.*

MATHIAS POSCHINGER

Ice Machines, Hydraulic Elevators and Custom Wood Products

The American Machine Company opened in 1898 at 510 East Main Street (Main and Jackson Streets) in a building nearly a city block square. It operated at least into the 1920s. The company made castings, did custom machine work, built elevators and manufactured ice machines. It was a support industry to other companies. The president of the company was Mathias Poschinger (1849–1916), an emigrant from Passau, Bavaria. Part of the building still stands. At some point, the building was occupied by the Vermont American Company. Today, city officials and others (erroneously) refer to the building as the Vermont American Building.

GUSTAV SCHIMPFF AND FRANK A. MENNE

Confectioneries

frank A. Menne Candy Co.'s Fabrikanlage,
die größte in den Vereinigten Staaten.

Wir sind soeben nach unserem neuen Gebäude, Ecke Wenzel und Mainstraße, umgezogen. Dieses Gebäude wurde unter unserer persönlichen Aufsicht gebaut und ist die vollständigste Candy-Fabrikanlage in diesem Lande. In der Fabrikation von Zuckerwerk haben wir stets mit der Zeit Schritt gehalten, und da wir die bedeutendsten Zucker-Ankäufe in diesem Landestheile machen, so sind wir im Stande, die niedrigsten Preise auf unsere Fabrikate anzusetzen.

❧ "Eagle Brand." ❧

Unser completes Waarenlager dieses berühmten Brands bietet hinreichende Garantie für unsere Geschäfts-Methoden. Dieser Brand bedeutet stets beste Qualität, volles Gewicht und volle Zahlung.

Die Zunahme unseres Geschäfts.

Im Jahre 1882 war der ergründeten Eigenthümern gegründet, betrug die Fabrikation täglich, 300 Pfund; 1885—1,600 Pfund; 1890—1,000 Pfund; 1891—6,000 Pfund; 1892—30,000 Pfund; 1898—75,000. Sämmtliche Aufträge, ob groß oder klein, werden prompt ausgeführt.

FRANK A. MENNE CANDY CO., Louisville, Ky.

Frank A. Menne Candy Company. *Authors' collections.*

There were many Germans involved in the candy trade. Gustav Schimpff was one of eight children of Magdalene Schimpff, a widow, who emigrated from Bavaria in the 1840s. Gustav and his brothers started the Schimpff confectionery business in the 1850s on Preston Street in Louisville. They later moved the business to 347 Spring Street in Jeffersonville, where it still resides.

Frank A. Menne's father was from Prussia and his mother from Bavaria. He founded the Frank A. Menne Candy Company, a manufacturer of chocolates under the name "Eagle Brand," around 1882. It occupied a building that covered a city block on Main Street at Wenzel Street. The building is now occupied by the Plumbers Supply Company of Louisville. Candy output was measured in *Pfunde* (pounds), and as many as seventy-five thousand were produced in 1898. Much of the company's advertising was in German. It was said to have been the largest candy factory in the world at that time. The company eventually became part of National Candy Company (Fourteenth Street and Broadway) of which Menne was vice-president.

HENRY FISCHER

Meat Processing

Henry Fischer, born in Germany in 1875, came to the United States at the age of seventeen. He first worked in a coal mining operation in Pennsylvania before moving to Louisville, where he worked for Ahrens and Ott plumbers.

He started in the meatpacking trade in 1904 and built the Fischer meatpacking house ("the bacon makin' people") in 1909 on Mellwood Avenue as a wholesale meat business for pork and beef. Peak employment in Louisville reached 675 in 1988. Although there is no processing operation in Louisville today, the company remains in business. Fischer died in 1973 and is buried in Cave Hill Cemetery.

Many others of German descent were involved in the meat processing business, including Louis Bornwasser (Corn Blossom Hams), Herman F. Vissman (C.F. Vissman Company), John M. Letterle (pork) and Theodore Klarer (pork products and sausage).

John Nepomuk Shymanski

Clothing

John Shymanski; his wife, Helene Moetki; and their two sons, William and Frederick, emigrated from Germany in the 1880s. John had trained in Germany to become a tailor. They first lived in New York City and came to Louisville in 1895. In 1904, he opened the manufacturing company Shymanski & Sons at 227 South Sixth Street and later expanded into several floors of the Snead Building at 815–27 West Market. Its brand was "Churchill Clothes," a line sold in Louisville and across the United States. At its peak, the company employed some five hundred cutters and tailors. Ultimately, the Shymanskis changed the family name to Sherman, becoming Sherman & Sons, Inc. In spite of labor unrest and the Depression, they managed to stay in business until the early 1950s.

Cyrus Adler

Piano and Organ Building and Radio-Phonographs

Cyrus Adler was born in Chicago in 1865. His father, Louis Adler, and mother, Mary Schram, both came to the United States from Bohemia. Cyrus had worked in the lumber trade in Chicago before he opened a lumber plant in Lyons, Kentucky. In 1903, he joined with R.S. Hill, a piano expert who had

been with the famous Mason and Hamlin Piano Company in Boston, to start a new company in Louisville named the Adler Manufacturing Company. Their initial product was pump-reed organs, mostly for home use, marketed under the names "Adler," "Loreto" and "Southern Grand." They later produced radio-phonographs under the name "Adler-Royal Radio-Phonographs." The size and scope of their operation in their forty-five years of existence at Twenty-ninth and Chestnut Streets in Louisville was quite impressive with some 260,000 square feet and 650 employees. At its peak, the company produced five thousand organs, five thousand pianos and twenty-five thousand radio-phonographs annually. The operation closed in 1948.

Gustave Bittner

Furniture Making and Steamboat Trim

Gustave Bittner (1829–1895) came to Louisville from Pratzan, Schlesien. He worked for a number of furniture builders before opening his own shop at 13 East Street (now 415 Brook Street) in 1854. Bittner produced much of the ornamental woodwork for steamboats on the Ohio River. Little did he realize that he would create a legacy of one of the few continuously operating manufacturing companies in Louisville, one that would serve furniture and cabinet building to the present day.

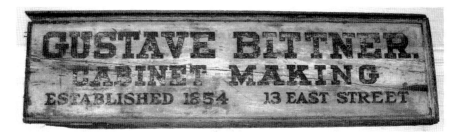

Gustave Bittner Cabinet Making. *Authors' collections.*

John Henry Wrampelmeier

Furniture, Wood Products and Church Pews

John Henry Wrampelmeier was born in Prussia. He opened the Wrampelmeier Furniture Manufacturing Company at Fifteenth and Rowan Streets and the showrooms at 544–50 South Fourth Street in Louisville in 1852. The five-story factory building still stands today. There, 150 employees made cabinets and bedroom and living room furniture. They also built bank and office furniture, store fixtures and church pews. The factory closed in 1895.

Wrampelmeier Furniture Manufacturing Company. *Authors' collections.*

Karl Bernhard Grahn

Brick Manufacturing

Karl Bernhard Grahn (1845–1922) came to the United States in the 1860s from Hanover, Germany. He was involved in the mining business, reinvesting the profits to purchase around six thousand acres, much of it in Carter County. In 1886, he discovered flint and fire clay on his property and opened what became known as Grahn's Mines. He shipped these materials to many states. Most of them were used in the boilers for railroad engines. In 1889, he opened the Louisville Fire Brick Works Inc. in Highland Park. The company is still in business at that location. The firebrick plant in Carter County still operates. The town was originally named Fireclay but was renamed in honor of Grahn in 1909.

JOHN FREDERICK HILLERICH AND VALENTINE UHRIG

Woodworking and Baseball Bats

At least two Louisville bat-manufacturing companies have German roots. J. Frederick Hillerich (1833–1924) was born in Darmstadt, Hessen, and emigrated with his family from Baden-Baden to Baltimore in the late 1830s. They moved to Louisville and set up a woodworking shop in 1855. By 1864, they were involved with the manufacture of many wood products. The baseball connection is largely credited to his son John Andrew "Bud" Hillerich, who was an amateur baseball player and a lover of the sport. By company tradition, he made his own bats at first but gained recognition when he began making bats for baseball star Pete Browning. In 1911, Frank Bradsby joined the company, and in 1916, it became known as Hillerich & Bradsby. Today, Hillerich & Bradsby is owned by Wilson Sporting Goods Company and operates from a modern factory located at 800 West Main Street in Louisville.

Valentine Uhrig was best known for barrel plugs known as "bungs," but like Hillerich, he "turned" many products, including vinyl posts, dumbbells, clubs, ten pins and baseball bats. His company was established in 1861 and was located at 417 East Jefferson Street.

ALBERT FINK

Railroads and Bridge Building

Albert Fink (1827–1897) was born in Lauterbach, Hessen, where he received much of his education. He attended private and polytechnic schools at Darmstadt and graduated in engineering and architecture in 1848. He came to the United States the following year. He first lived in Baltimore, working for the Baltimore and Ohio Railroad in the engineering department. He was largely involved with bridge and depot construction and developed a bridge truss design that bears his name. After eight years, he moved to Louisville to become chief engineer and superintendent of the Louisville & Nashville Railroad (L&N) and ultimately became its vice-president. While at the L&N, he did a research study on

Fourteenth Street Bridge, about 1906. *Courtesy Library of Congress.*

the cost of railroad transportation. That study has been referred to as the foundation of American railway economics. It became a standard for many years for cost analysis on railroad projects.

Albert Fink had many successes. He was responsible for the design and construction of the Fourteenth Street Bridge, which was completed in 1870, crossing the Ohio River between Louisville and southern Indiana. At that time, it was the longest iron bridge in the United States. He also served as the chief engineer and architect for the completion of the Jefferson County Courthouse (1858–60). He was affiliated for a time with the Louisville Bridge and Iron Company (in business from 1865 to 1986). Fink died in 1897 in New York. He is buried in Louisville's Cave Hill Cemetery.

AUGUST FREDERICK VOSS

Wood Fireplace Mantels and Related Wood Products

August Frederick Voss was born in Germany in 1855. In 1885, he started the A.F. Voss Mantel Company in Louisville. Its offices and showrooms were located at the corner of Sixteenth Street and Arbegust Avenue (828–40 South Sixteenth Street) on around two acres of land. The company made mantels from oak, cherry, birch and mahogany woods with a capacity of between four thousand and five thousand mantels annually. The company had a work force of around sixty employees, having regional sales representatives that covered a wide portion of the United States. Today, many websites dedicated to antique furnishings stress the quality of Voss mantels, which reflect Old World craftsmanship and precision manufacturing. Voss also manufactured hall racks, settees, mirrors, costumers chevals, tables and other furniture products. A.F. Voss died in 1908 and is buried in Cave Hill Cemetery. He was succeeded in the business by his son Louis C. Voss. From 1914 to 1923, the company was known as the Voss Table Company.

FERDINAND PFINGST, JOHN AND BASIL DOERHOEFER AND EDWARD KESSLER

Tobacco Products and Plug Tobacco

The National Tobacco Works was established in Louisville in 1879. Pharmacist Ferdinand J. Pfingst (1835–1901), a native of Hofgeismar, Hessen, joined with tobacconist brothers John (1849–1903) and Basil (1850–1923) Doerhoefer, from Wellbach, Nassau, and pharmacist Edward F. Kessler (1848–1895), who emigrated from Oberlistingen, Hessen. They jointly created a company that was said to be the fastest-growing and most profitable concern in the tobacco trade. Pfingst used his chemistry expertise to mix the sweetening for plug tobacco using champagne, licorice and other flavorings. The company's plug tobacco brands included "Punch," "Newsboy," "Battle Ax" and, their great leader, "Piper Heidsieck." This business had at least five factories throughout Louisville, including the headquarters and tobacco-processing plant in the 1800 block of West Main Street and the stemmery and drying house in the 2400 block of West Main Street with five hundred employees. In February 1891, it became the first tobacco manufacturer acquired by the newly formed American Tobacco Company.

18.

AGRICULTURE AND FOOD INDUSTRIES

BY CARL E. KRAMER

For generations, Germans had a profound influence upon the development of many sectors of Louisville's economy. But perhaps their greatest impact occurred in the production, processing, marketing and sale of food and other agricultural products. Louisville was still young when native Germans and the descendants of earlier immigrants to the East Coast began planting farms in and around the rural precincts and villages of Jefferson County.

In the late eighteenth century and early nineteenth century, the Jeffersontown area, originally known as Brunerstown, attracted many settlers descended from the original German immigrants to colonial America. Among these were Abraham Bruner and John Funk from Maryland, Abraham Hite and William Goose from Pennsylvania and Nicholas Blankenbaker from Virginia. Other early settlers included John Bechtold and Morris Stephens, who were emigrants from Germany. Blessed with fertile soil and ample water from Floyd's Fork, Chenoweth Run, Pope Lick Run and other streams, these pioneers made Jeffersontown the center of a thriving agricultural area that produced vegetables, corn, fruit, grain, flax and tobacco. Several raised dairy cattle and hogs and operated small agricultural businesses, such as dairies, tanneries and gristmills.

During the early 1800s, descendants of some Jeffersontown settlers opened farms in other parts of Jefferson County. In the 1830s and 1840s, they were joined by a new wave of German immigrants. Some had crossed the Atlantic to the East Coast and then traveled down the Ohio River to

Louisville while others took a southern route to New Orleans and then up the Mississippi and Ohio Rivers to the Falls City. In the 1850s, many settled in the emerging Germantown neighborhood, where some began cultivating vegetable gardens and operating dairy farms.

Farther out in the county, the Funk family expanded into the Seatonville neighborhood, where A.H. Funk built a gristmill. Paul Disher, a native of Baden, and Frederick Baringer, son of immigrant Jacob Baringer, established farms in the Highlands. Germans in the Fern Creek and Buechel areas operated cattle and poultry farms and fruit orchards. In the late nineteenth century, German and Swiss farmers in the St. Matthews area, including Henry Holzheimer, Daniel Rudy and Henry Nanz, began growing potatoes. By 1910, St. Matthews claimed the title "potato capital of the world," a status it maintained until 1946, when suburban development began transforming farms into subdivisions and shopping centers. Immigrants, such as Adam Hildebrand, began farming in the vicinity of Brownsboro Road and the present-day Watterson Expressway. At various times, the Hildebrand family specialized in watermelons, turnips, Irish potatoes and sweet potatoes.

To the west, Germans drained the fertile, boggy soil and established successful farms in the triangle created by the Louisville & Nashville Railroad's Southern and Cecilian branches. Along the Ohio River, in

Potato harvesting in Jefferson County, 1940. *Courtesy Library of Congress.*

communities such as Valley Station, Pleasure Ridge Park, Cane Run and western Louisville, Germans with names such as Kahlert, Schmitt, Thieneman, Dohn and Garr raised dairy cattle and cultivated truck gardens that produced vegetables for local and regional markets.

The post–World War II period witnessed a wave of suburban development that absorbed much of Jefferson County's farmland. But some German families found ways to remain in agriculture. Four generations of the George Deutsch family, for example, operated a dairy farm in the southern part of the county until the 1990s, when they sold it for development and began raising fruit and vegetables on a new farm in Spencer County. During the late 1940s, Paul Thieneman, whose family had operated truck farms in the Campground Road area for many years, opened a retail vegetable operation on Barret Avenue; it expanded into Paul's Fruit Market Inc. during the 1960s and remains a thriving purveyor of fruit and vegetables. One of Paul's suppliers is Dohn & Dohn Gardens, a family business that has grown mint and general herbs since 1930. Dohn & Dohn supplies about one thousand pounds of mint to Churchill Downs for the Kentucky Oaks and the Kentucky Derby.

As the center of a large farming region, Louisville emerged as a hub for processing and marketing commodities produced by area farms. Numerous Germans engaged in such enterprises. German brew masters converted Kentucky wheat, barley and hops into beer at Armbruster's Washington Brewery, the Frank Fehr Brewing Company, Senn & Ackermann Brewing Company, the Falls City Brewing Company and the Oertel Brewing Company, among others. German distillers Isaac and Bernard Bernheim and Philip and Frederick Stitzel played prominent roles in the whiskey industry.

Germans also played leading roles in the floral industry. Immigrant horticulturalist Henry Nanz Sr. opened a greenhouse on Third Street south of Breckinridge Street in 1850. His son-in-law, H. Charles Neuner, entered the firm in 1872, and it became Nanz & Neuner. By 1880, the company had moved to St. Matthews, and Henry Nanz Jr. assumed control after his father's death in 1891. He was joined later by his brother-in-law Edward A. Kraft Jr., whose grandson assumed control in 1958, when the business took its present name of Nanz & Kraft Florists. Others followed in their steps. Jacob Schulz opened a florist on East Broadway (Cherokee Road) near Cave Hill Cemetery in 1873 and operated there for many years. Alsatian immigrant Victor Mathis established a florist business in Portland in 1896, and it has been family owned for four generations. By 1925, the city boasted

approximately two dozen German florists. Germans also made significant contributions in the dairy, baking and confectionery industries.

Perhaps no other agricultural industry was more dominated by Germans than meatpacking. The center of the industry was Butchertown, where several roads to Louisville's hinterland converged. In the 1820s and 1830s, many German butchers built houses facing Story Avenue and erected backyard slaughterhouses along Beargrass Creek. Farmers drove their livestock into the city and transferred them to a slaughterhouse operator. After the animals were killed and processed, the meat was packed in barrels and shipped to Pittsburgh, New Orleans and other ports.

Expansion of the railroad network spurred the meatpacking industry's westward growth after the Civil War. But Louisville remained a regional packing center, and family-owned German firms continued to dominate the industry. Herman F. Vissman established a company in Butchertown in 1875; it became the C.F. Vissman Company when his son took control in 1890. The Vissmans were joined in Butchertown by the John M. Letterle Pork House; the Louis Bornwasser Company, producer of Corn Blossom hams; and smaller operations owned by residents with names like Koch, Pfaffinger and Henzel. Meanwhile, Theodore Klarer began producing sausage and other pork products in 1876 in a plant on Amy Avenue in the West End.

By the early twentieth century, small packers faced stiff competition from Swift, Armour and other national giants that applied mass production techniques to killing and packing. But Bornwasser, Pfaffinger, Rausch & Ruger, Vissman, Klarer and other local companies remained strong competitors. In 1909, German immigrant Henry Fischer began grinding sausage in his backyard on Mellwood Avenue, thus founding Fischer Packing Company. Six years later, Joseph Emmart joined Klarer in forming Louisville Provision Company, and in 1921, Emmart established Emmart Packing Company. By midcentury, Fischer, Klarer, Vissman, Emmart and Louisville Provision were major regional packers.

Economic and technological changes during the 1950s and 1960s drove many smaller firms out of business, and others merged with larger firms to survive. Louisville companies were not immune to these trends. In 1955, the city boasted at least thirteen packers; by 1970, the number had dropped to eight. Meanwhile, Vissman and Emmart merged with Klarer, which then sold out to Armour in 1969. The same year, Wilson & Company, a national giant, bought Fischer Packing Company. The economic situation stabilized somewhat during the 1970s, and in 1980, the city still had six packers, including four with German roots: Fischer, Hoerter & Son,

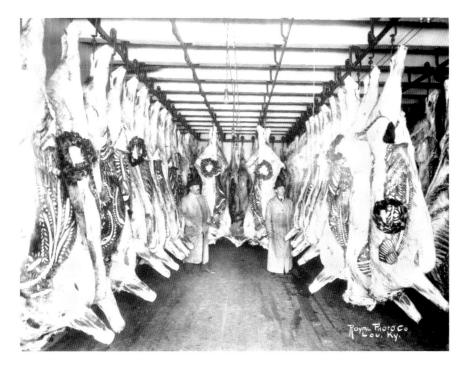

Bornwasser Packing Company, about 1915. *Courtesy University of Louisville Photographic Archives.*

Dawson Baker and Koch Beef Company. Over the next three decades, a series of international mergers and labor difficulties forced most of the city's remaining packers out of business. Fischer Packing Company survived locally until 2002, when new owner Premium Foods Group of northern Kentucky closed the Mellwood Avenue plant and consolidated its production operations with those of other subsidiaries. Today, the JBS Swift plant at 1200 Story Avenue is the city's only packer still in business.

Germans also made their mark in other agricultural businesses. Future meatpacker Herman F. Vissman owned the Bourbon House and Stock Yard in Butchertown during the mid-1850s as it evolved into the Bourbon Stock Yards, and during the following century, numerous livestock buyers and commission merchants of German descent conducted operations there. The produce business at the Haymarket, originally located in the block bounded by Jefferson, Liberty, Floyd and Brook Streets, was dominated by Italian and Lebanese purveyors, but several German fruit and vegetable growers operated stands there. During the early twentieth century, the Hyman Pickle Company advertised "Hyman's Oyster Hot Tomato Catsup, Made on Our

Farm" in the *Louisville Anzeiger*; Henry Fruechtenicht bought and sold hay, grain and mill products at the Big Four Elevator & Warehouse, located at 211 North Hancock Street; and Basil Doerhoefer was one of the city's leading tobacco manufacturers.

In addition to producing and processing food and fiber, Germans were deeply involved in providing them to the consumer as wholesale and retail grocers. A. Engelhard & Sons Company commenced business in 1855. J. Zinsmeister & Brother Wholesale Grocery started business in the Fort Nelson Building at Eighth and Main Streets after the Civil War and dealt in provisions and staple and fancy groceries well into the next century. During the early twentieth century, wholesaler J.W. Horstman Fancy Groceries handled California wines, fine Kentucky whiskies and imported and domestic beers, as well as groceries, at First and Green (Liberty) Streets. At the same time, George A. Landenwich operated a produce exchange at Beck's Hall at 113 West Jefferson Street.

The late nineteenth and early twentieth centuries witnessed rapid growth and dispersion of neighborhood retail groceries as proprietors moved closer

Louisville Haymarket, about 1910. *Courtesy University of Louisville Photographic Archives.*

George F. Korfhage & Sons Food Market, 1935. *Courtesy University of Louisville Photographic Archives.*

to their customers. By 1925, Louisville boasted nearly 1,100 grocery stores, about 400 operated by Germans. Many were located at neighborhood intersections, and proprietors occupied living quarters within their store buildings. Surging automobile ownership and the emergence of regional chain groceries reduced the number of neighborhood groceries during the next twenty-five years, and the number had declined to about 850 by midcentury, about one-third of them with German proprietors. Large chains, such as Kroger, Winn-Dixie and A&P, captured a growing proportion of market share while local chains, such as Pic-Pac, Convenient Food Mart, Key Market and Nite-Owl, gained a significant share of neighborhood business during the next twenty-five years.

By 1975, the number of retail groceries had dropped to about 290, approximately 75 of which were either local or regional chain outlets. Almost all of the German neighborhood stores had disappeared, with Burger's Super Market at 1105 Ray Avenue in the Highlands, Germantown Food Mart at 1357 Texas Avenue and Paul's Market at 2020 Duncan Street

in Portland being notable exceptions. By the early twenty-first century, only Burger's remained in business, and it closed in 2013. Its demise, along with the passing of the meatpacking industry and the loss of farmland to suburban development, symbolically ended a long history of direct German involvement in local agriculture and food industries.

WHISKEY INDUSTRIES

BY MICHAEL R. VEACH

German Americans played an important role in the development of Louisville's whiskey industry. Many early Kentucky settlers were of Germanic origin, and they brought stills into the west with them as they settled in Kentucky. These include such families as the Wellers and Beams. Jacob Böhm (Jim Beam) came to Kentucky in the 1790s and was making whiskey by 1795. Daniel Weller and his family came to Kentucky in 1796 and were making whiskey by 1800. This early whiskey was an unaged corn whiskey made in pot stills and usually stored in jugs that could be used as barter in a cash-strapped frontier west.

As the state became more populated, Louisville, with its position at the Falls of the Ohio River, grew to become the center of transportation. The Ohio River was the main highway for goods leaving the state for markets downriver, such as St. Louis and New Orleans. The city quickly became the center of business and transportation for the state as goods were shipped to market from Louisville. Whiskey and tobacco were the state's major exports in the nineteenth century, and "Whiskey Row" quickly grew along the wharf on Main and Market Streets. Most of the businesses along Whiskey Row were sales offices, as distillers had their main sales offices in Louisville, but their distilleries were located elsewhere.

In 1849, William LaRue Weller and his brother, Charles D. Weller, formed the firm W.L. Weller and Brother in Louisville. The 1851 *City Directory* lists their address as the "East Side of Eighth Street between Jefferson and Green (Liberty) Streets." They were not a distillery but simply whiskey wholesalers.

Their inventory included spirits, both domestic and foreign. They probably were selling whiskey made by their father, Samuel Weller, in LaRue County. The city had very few distillers within its borders, but there were many merchants dealing in spirits before the Civil War. The Weller business grew in this period but met with tragedy during the war. Charles was collecting money in Clarksville, Tennessee, when he was robbed and murdered. William partnered with a man named Buckner until the end of the war. After the war, William's sons joined the firm, and it became W.L. Weller and Sons. They prospered, and as the business grew, they gave back to the community. William became a founding member of the Louisville Baptist Orphan's Home.

It was after the war that the city of Louisville experienced a growth in the whiskey industry, with Whiskey Row expanding along Main and Market Streets from Brook Street in the east to Tenth Street in the west. The city also had several large distilleries located within its borders. These distilleries became possible because of improvements in technology that included the column still that allowed whiskey to be made in an inexpensive manner. These distilleries were supported by the railroads that allowed grain to be brought to the distillery and whiskey to be shipped to distant markets. Steam powered the mills that ground the grain and heated the stills. It also could be used to heat the warehouses in the winter while maturing the whiskey. German Americans were part of this growth.

Stitzel Brothers opened a distillery at Twenty-sixth Street and Broadway in 1872, making Glencoe and Old Fortuna bourbons and rye whiskeys. It used this new technology but also contributed to the technology of aging whiskey when, in 1879, Frederick Stitzel patented a system of barrel racks for warehouses that allowed for easy movement of the barrels while improving air circulation and reducing the amount of "musty" whiskey created during the aging process. This system is still used in the aging of bourbon. In 1877, Stitzel Brothers sold its distillery and brands to the firm of Hollenbach and Vetter. The Stitzels continued to run the distillery for the new owners until Prohibition. In 1903, Arthur Philip Stitzel, the son of Philip Stitzel of Stitzel Brothers, opened his own distillery on Story Avenue and became associated with W.L. Weller and Sons as their distiller.

Other German Americans were involved in the whiskey industry as rectifiers—that is, they were not the owners of distilleries but instead hired others, such as the Beams and Dants, to be their distillers. After the Bottled-in-Bond Act of 1897 was passed, many of them purchased their own distilleries and sold bonded whiskey.

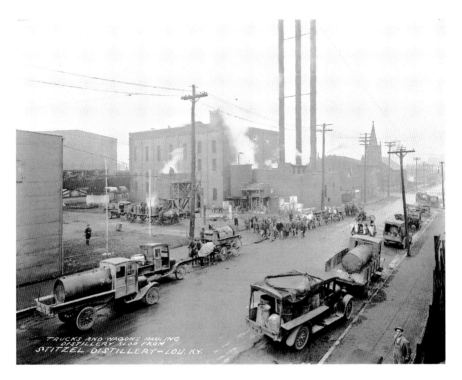

Stitzel Distillery, 1931. *Courtesy University of Louisville Photographic Archives.*

After the Civil War, the growth along Whiskey Row was fed mostly by spirits merchants and rectifiers. Many of these were German Jews. Block, Franck, Grabfelder, Uri and Bernheim were some of the more prominent names in the industry. The whiskey industry provided an opportunity that was not always available to them in their native lands. They came to America to earn their fortunes, and the whiskey industry allowed them to do so. The experiences of Isaac Wolfe Bernheim and his brother Bernard are typical of this opportunity.

Isaac W. Bernheim came to America from Schmieheim, Baden, in 1867. He had very little money and spent the first year in America as a "peddler in Yankee notions," as he described himself in his autobiography. When his horse died, he settled in Paducah, where he entered the liquor business as an accountant and saved enough money to help his brother Bernard join him in 1872. Together, they started the firm of Bernheim Brothers in Paducah. They did well in that city but soon grew large enough that they needed better transportation to ship their goods to market. They moved to Louisville in 1888, and their business increased. Isaac's brother-in-law, Nathan Uri,

partnered with them for a time before starting his own company in 1891. That same year, Bernheim Brothers purchased a large amount of whiskey from the Pleasure Ridge Park Distillery. A fire destroyed the warehouses holding this whiskey in 1896. Bernheim Brothers had to sue the U.S. government to prevent them from going bankrupt when the government said they had to pay the taxes on the whiskey destroyed in the fire. They won the case and used the insurance money to build their own distillery on Bernheim Lane. They ran that distillery until Isaac Bernheim retired in 1915. He had sold the distillery to United American Company in 1911.

Isaac Wolfe Bernheim, 1935. *Courtesy University of Louisville Photographic Archives.*

Bernheim was a very generous person who gave back to his adopted country. In 1892, a flood ravaged Paducah, and Bernheim donated coal and bread to the victims there. In 1901, he donated the statue of Thomas Jefferson to the City of Louisville to stand in front of the courthouse. In 1929, Bernheim was appalled by the fact that the commonwealth of Kentucky did not have statues in the Statuary Hall of the Capitol Building in Washington, D.C., and donated the statues of Ephraim McDowell and Henry Clay to represent Kentucky. His final legacy is Bernheim Forest in Bullitt County. In 1929, he purchased and donated the land for Bernheim Arboretum and Research Forest. This ten-thousand-acre forest was to be kept in a natural state with development necessary only for public use and enjoyment. Outside of Kentucky, he donated money to the first library at the Hebrew Union College in Cincinnati and a fountain for his native town of Schmieheim.

Prohibition brought an end to many distilling-related activities in Louisville. There were only six companies with licenses to sell alcohol for "Medicinal Use." A.Ph. Stitzel Distillery was one of them. Whiskey could be prescribed at a rate of one pint every ten days to consumers, and these companies could sell to pharmacies to meet the need. They also could sell twelve pints a year to doctors and dentists for office use. Finally, they could

Thomas Jefferson monument, 1906. *Courtesy Library of Congress.*

sell twelve pints of brandy or rum to bakers for cooking purposes. This was not a lucrative business, and the other German American distillers in the city never bothered to apply for a license. They still owned whiskey, but they sold it to one of the companies with a license or simply allowed one of these companies to bottle and sell it for them.

Prohibition ended on December 5, 1933. The distilling industry had changed, and the German influence on the industry was greatly reduced. Stitzel merged with W.L. Weller and Sons and built a new distillery in Shively. Arthur Philip Stitzel was a partner with Alex T. Farnsley and Julian P. Van Winkle in the new Stitzel-Weller Distillery. He remained a partner until his death in 1947. The industry became dominated by larger corporations, and very little of that industry was located in Louisville. The invention of the automobile and the improvements in the highway system made Louisville less important as a center of transportation, and the distilleries in the city were few compared to the pre-Prohibition days. There were many German American workers in the industry, but they were no longer the owners of the distilleries.

HOTELS AND RESTAURANTS

BY RICK BELL

As Louisville grew into an important river port following the introduction of the steamboat in 1811, the community needed hotels, inns, taverns and restaurants to serve the thousands of travelers passing through. Shortly after the end of the pioneer era, German hoteliers and restaurateurs became an important part of the town's growing hospitality industry.

Henry Hyman, reportedly Louisville's first Jewish citizen, moved to the city from Berlin and took a full-page advertisement in the 1832 *City Directory* to promote the attractions of his Western Coffee House and Hyman's Altar on the south side of Market Street between Fourth and Fifth. In his ad, Hyman boasts:

> *No pains or expense has been spared, to render it one of the most comfortable* Restorateurs *in the Western country. His* Saloon *(upstairs) being large and comfortable, is well calculated for large* Dinner *and* Supper Parties*; and the adjacent rooms being handsomely furnished, and retired, are well adapted for small* Music *or* Singing Parties*. His Bar, as formerly, will be regularly supplied with a general assortment of the best Liquors in the country. There will also be kept a regular Ordinary, from 6 o'clock A.M., until 12 P.M., abounding with* Beef Steaks, Cold Hams, Turkeys, Ducks, Geese, Fowls, Partridges, *and every delicacy that can be procured in the Louisville market.*

By 1849, Hyman had moved and announced his Table d'Hote, Ordinaire and Oyster Saloon on Fifth Street between Market and Jefferson. Elaborately outfitted with a twelve-foot-high French mirror and brass chandelier, Hyman's Altar also claimed a separate entrance to its Julep Saloon.

During the economic boom of the steamboat era, a number of Germans owned and operated hotels downtown in proximity to the waterfront and local merchants. C.C. Rufer opened his hotel on Fifth Street between Main and Market in 1856. It introduced such innovations to Louisville as steam heat and electric call bells. Like many of its contemporaries, Rufer's Hotel operated on the European plan, where rooms were rented but no meals were provided in the price.

Nick Bosler came from Germany to America in the 1850s and worked at a foundry in Pittsburgh before becoming a mate on a steamboat. During the Civil War, he operated a saloon in Portland and later opened his first hotel on Market Street between Sixth and Seventh. Just prior to his death in 1882, Nick Bosler took over the old Jaeger Halle on Market Street between Fifth and Sixth. It was here that his family continued to operate Bosler's Hotel. During World War I, the facility was renamed the Antler Hotel to de-emphasize its German roots.

Another inn of that era was Senning's European Hotel, located on the southwestern corner of Second and Jefferson Streets. Frederick Carl Senning, an emigrant from Kesse, Germany, later owned and operated Senning's Park in Louisville's south end, adjacent to Iroquois Park, as well as the city's first bowling alley at Eighth and Main Streets. Senning's Park, featuring a zoo and outdoor beer garden, opened in 1902 and later became known as Colonial Gardens. Senning's Hotel was sold to Democratic alderman August Miller in 1905.

Without question, the two most important German-born Louisvillians to engage in the hospitality trade were Louis and Otto Seelbach, natives of Bavaria. Louis arrived first and opened a restaurant and café at Sixth and Main Streets in 1874 and, with his brother Otto, formed the Seelbach Hotel Company. In 1886, they acquired control of the handsome building, originally a merchandise store, on the southwestern corner of Sixth and Main Streets, and here they operated the Seelbach European Hotel. They continued to operate this hotel until 1905, when they opened their new facility. In later years, under different ownership, the hotel was known as the "Old Inn" and continued to serve travelers.

In 1903, the brothers took a calculated risk and began construction of a grand hotel on the corner of Fourth and Walnut (Muhammad Ali Boulevard)

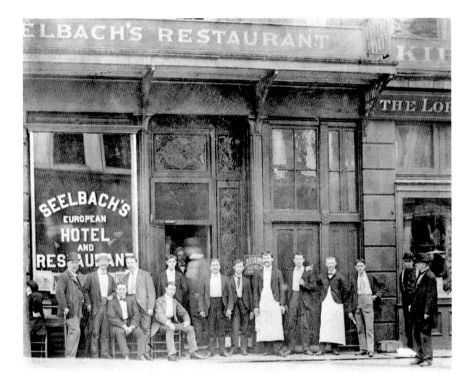

Seelbach's European Hotel and Restaurant, 1890s. Louis and Otto Seelbach—the two seated men—appear in the image. *Courtesy University of Louisville Photographic Archives.*

Streets. Moving several blocks south of the main commercial areas near the river, the Seelbach brothers' new plans dwarfed any hotel built in the city before. When the $1 million hotel opened for business in May 1905, a great deal of local development followed the Seelbach down Fourth Street.

Designed by Louisville architect W.J. Dodd and F.M. Andrews of Dayton, the Beaux-Arts hotel was the epitome of style and taste for decades. Complete with marble, murals and elaborate fixtures, the hotel boasted the city's first rooftop gardens with a trellis covered in electric lights. The basement rathskeller, constructed of Rookwood Pottery, is the only such room in the world and was forced to close during Prohibition. The hotel's formal Oak Room restaurant set the standard for excellence in dining for generations.

When the building celebrated its grand opening in 1905, over twenty-five thousand people viewed the hotel in the first five hours. The crush of people was so great that seven women fainted and had to be rescued from the crowd. There were more than 1,500 meals served on the first day of

operation. The hotel claimed 190 rooms with a staff of three hundred and a payroll of $12,000 a month.

The Seelbach brothers sold their hotel in 1926, and it closed in 1975, only to be restored and opened again in 1982. Today, it is listed on the National Register of Historic Places.

As the city developed, restaurants began to operate independently of hotels, and German proprietors operated many of the city's finest dining establishments. The Vienna Restaurant was opened by Frank Erpeldinger in 1893 on Fourth Street between Market and Jefferson. In 1905, it moved one block north to 133–35 South Fourth Street and was called the Vienna Model Bakery and Restaurant-Café. At its second location, the Vienna boasted an elaborate exterior and interior and was among the most impressive restaurants in Louisville history.

Just before Prohibition, stringent new blue laws caused Erpeldinger to lose his liquor license for serving beer on Sundays. The Vienna Restaurant closed in 1927, but its dramatic exterior, with its characteristic Rookwood Pottery signage and stained-glass windows, would remain for decades. Later known as the Brennan Building, its original colored windows were saved by Al J. Schneider and are now installed in the Down One Bourbon Bar at Third and Main Streets.

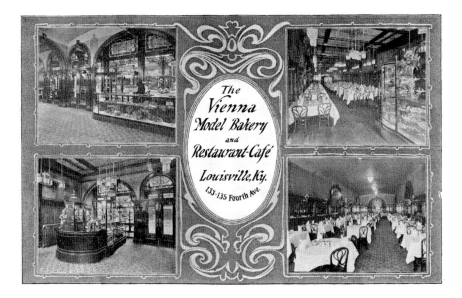

Vienna Model Bakery and Restaurant-Café. Louisville Anzeiger, *June 27, 1909.*

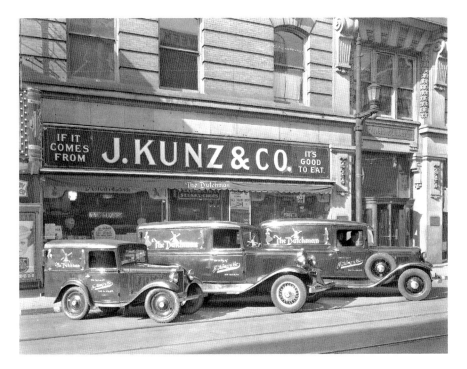

J. Kunz & Company "The Dutchman," 1930s. *Courtesy University of Louisville Photographic Archives.*

Less formal dining was provided during the 1920s by Zapp's Restaurant and Deli, located at 552 South Fourth Street. Zapp's catered to a new dining public when it began providing picnic lunches to be enjoyed during automobile excursions into the country. It boasted, "Everything good to eat that anyone could possibly desire or even think of, including cold meats, salads, sausages, cheese, pickles, large and small cakes, bread and rolls, olives and candies" for the modern driving family.

Kunz's "The Dutchman" was a Louisville favorite for decades. Beginning as a wholesale liquor outlet in 1892, it became a delicatessen and finally, a regular restaurant in 1941. Jacob Kunz Jr., a German-speaking Swiss, originally located his business on the 600 block of South Fourth Street but later moved to several other downtown locations, finally settling at Fourth and Market Streets. Featuring its signature charbroiled steak and baked potatoes, Kunz's was decorated with Teutonic themes, including a working windmill and huge beer steins throughout. The restaurant was closed in 2008.

After operating a cafeteria at Floyd and Breckinridge Streets with a partner for eighteen years, Ed Hasenour opened an upscale restaurant at the corner of Barret Avenue and Oak Street in 1952. Although Hasenour's was not decorated in the German style, the restaurant featured a number of German entrees. For his many successes in the restaurant business, Hasenour was named the Restaurateur of the Year by the Kentucky Restaurant Association in 1974. When Ed Hasenour died in 1988, his son assumed ownership of the business. After several years of financial difficulty, the restaurant closed in 1996.

Today, much of the traditional German heritage character has disappeared from Louisville, with only the Gasthaus German Restaurant currently in operation. Owned and operated by Michael and Annemarie Greipel and their five children, the Brownsboro Road facility is filled with decorations, culinary offerings, beer, wine and the delicious odors of true German cooking.

DRY GOODS AND DEPARTMENT STORES

BY HOLLY JENKINS-EVANS

Louisville, like many cities in the United States, saw the growth of a new kind of shopping after the Civil War. This was the department store, a democratic retail palace where all financial classes could buy. Some carried menswear and others children's wear and women's wear, and the largest carried everything from washers to furs. In Louisville, many of the most prominent were founded by first- and second-generation German Americans. Levy Brothers, Byck's and Kaufman-Straus may have been the best known, but there were many others such as Bensinger's, Besten and Langen, Loevenhart's and Herman Straus.

Levy Brothers was one of the first big stores in Louisville, founded in 1861 by Moses Levy of Nierstein, Hessen. Arriving in 1856, he peddled menswear. By 1866, Levy's was located at the corner of Third and Market Streets. Moses's brother Henry joined him in 1872. After the Civil War, they became significant suppliers of uniforms such as the "Grey Potomac Special" for Confederate reunions and for the Confederate Soldiers Home in Pewee Valley, Kentucky.

The landmark Levy Brothers Building was completed in 1893. In 1908, electric lights were added outlining the exterior, leading to a local phrase, "Lit up like Levy's." "Look for the Bright Spot" was also in the store's well-regarded advertisements. To create lifelong customers, the store mailed out miniature trousers to newborn boys, redeemable for their first pair of pants. Levy's later mailed coupons for the boys' first haircuts at its barbershop. It sold a full line of men's and boys' clothing and sportswear, plus ladies' and

Levy Brothers letterhead, 1910. *Authors' collections.*

children's shoes. After the deaths of Moses in 1905 and Henry in 1912, the business was run by the second generation: Fred, Arnold, Stuart and James Levy. A Lexington, Kentucky branch opened in the 1920s, and women's wear was added in the 1940s. In 1955, Levy's opened its first suburban store in the Shelbyville Road Plaza, followed by stores at six more locations. The Levy family closed the downtown store in 1980 after 119 years. The last Levy's closed at Bashford Manor Shopping Mall in 1987.

Bensinger's began as a partnership of Nathan and Wolf Bensinger from Baden. Wolf arrived in New York in 1853 and Louisville in 1860. On Nathan's arrival in 1866, the two started a furniture business in a pushcart. From 1869 onward, Bensinger Brothers was on Market, lastly at 315 West Market Street. Nathan bought out Wolf in 1876, and the Bensinger Outfitting Company was born. Bensinger's sold home furnishings, lighting, musical instruments and phonographs. A 1906 fire gutted their building. The business carried on at their Jeffersonville branch while they rebuilt. On his retirement in 1919, Nathan turned Bensinger's over to sons Milton, Charles and Clifford. Nathan died in 1934. Bensinger's carried name-brand home furnishings for many years at up to five locations in Louisville and Indiana. Bensinger's left downtown in 1983 and closed about 1988.

Fleischaker's/Sternau Dry Goods was a family-owned, budget-minded dry goods store, beginning with Fleischaker & Brothers at 264 East Market Street in 1878. Eventually, Kentucky-born Emil Fleischaker bought 732 East Market Street, added his brother-in-law Max Austrian as partner and hired brothers-in-law Louis and Percy Sternau as clerks. In 1890, Emil sold the building to Fanny Sternau, his mother-in-law. By 1896, Sternau Brothers

Kaufman-Straus Company, about 1915. *Courtesy University of Louisville Photographic Archives.*

had absorbed Fleischaker's and in 1898, there was a Fanny Sternau Dry Goods on East Market Street and a Sternau Brothers at 1625 South Preston Street. The Fleischakers and Sternaus were of Bavarian descent. Emil died in 1903. By 1940, both the Sternau brothers were traveling salesmen. Sternau's closed in 1949.

Kaufman-Straus & Company was founded by Baden native Henry Kaufman in 1879 on Jefferson Street near Eighth. He acquired a partner, Kentucky-born Benjamin Straus, in 1883. Straus was of Württemberg descent. Kaufman's six-story location on Fourth Street was built in 1903 by architect Mason Maury on the site of the original public library. Kaufman's was a quality department store with clothing, dry goods, furniture, books and jewelry. After the deaths of Kaufman in 1918 and Straus in 1923, the City Stores bought the company in 1924. In 1960, it officially became Kaufman's of Kentucky. There were stores at Dixie Manor and the Mall St. Matthews by 1962. When L.S. Ayres bought Kaufman's in 1969, the name was retired.

Born in 1851 in Bavaria, Herman Straus arrived in the United States in 1863 to join his father, Isaac, a cattle trader. After a start clerking for Starr Brothers, he opened a store on Market Street near Sixteenth about 1869. He partnered with Sam Weis until 1879. He then founded Herman Straus Dry Goods in 1882 at 422 West Market Street. With a new building by 1889, and additions in 1894 and 1900, Herman had up to three hundred employees. Herman Straus and Sons eventually spread over nine buildings with a restaurant and soda fountain. Sales help still spoke German as needed. The store's slogan was "Where a dollar does its duty." Herman's sons Albert, Eugene and Bertram, with their brother-in-law, Walter Kohn, carried on after Herman's death on a European trip in 1903. A Fourth Street entrance was achieved in 1905. Walter was president in the later 1920s. In 1929–30, the business passed into outside hands and was last recorded in the 1937 *City Directory*.

Brothers Lee and Henry Loevenhart founded Loevenhart's menswear in Lexington, Kentucky, in 1867. Lee, born in Wolfenhausen, Württemberg, immigrated to the United States in 1851 with his mother, who died after their arrival in Cincinnati. He then spent five years in Nashville, Tennessee, and sold jewelry throughout Mississippi. In 1898, Lee branched out and opened a Louisville store at the corner of Market and Third Streets. Loevenhart's was extensively remodeled in 1924, reopening with Schilling's Orchestra at a gala event. Lee died in 1926, exactly twenty-eight years after opening. Loevenhart's was an innovator, with early air delivery, air-conditioning and neon signs. Lee was followed into the business by three more generations: children Jesse, Percy, Edgar and Pauline; grandson Lee Loevenhart Grossman; and finally great-grandson Kenneth Grossman. Loevenhart's moved to Oxmoor Center in 1971, where it added women's tailored apparel in 1979. Loevenhart's closed in 1995.

Appel's Menswear, later Louis Appel and Sons, was founded in 1883 at 440 West Market Street. Louis, a native of New York, was the son of George Appel, a Savannah dry goods merchant from Posen. Appel's carried menswear, hats, women's hosiery and shoes. By 1912, Appel's had moved to Fourth Street to join the cluster of fine men's stores at Fourth and Jefferson Streets. Sons Joseph, Walter and Sidney joined the company. Joseph was president by 1917. A 1922 fire at the neighboring Courier-Journal Building caused significant water damage, but Appel's recovered. Appel's later moved to 425 South Fourth Street. Walter died first in 1932, followed by eighty-year-old Louis in 1936, Joseph in 1965 and Sydney in 1978. Appel's closed in 1963.

Besten and Langen Company began in 1892 in Louisville and Indianapolis. A native of Westphalia, Henry Besten immigrated in 1880 at the age of eighteen with his parents and settled in Louisville. Ewald Langen ran the Indianapolis store while Henry headed the Louisville branch. The partners split in 1904, but the name remained unchanged in Louisville. Besten and Langen started as an exclusive ladies' tailor and furrier but

Byck's Department Store, 1938. *Courtesy University of Louisville Photographic Archives.*

soon added women's and children's clothing and a beauty salon. Always on Fourth Street, in 1916, Besten built a new store at 518 South Fourth Street, next to the Seelbach Hotel. His sons Clarence and Emil became officers in the company. Henry died in 1929. The business apparently was sold out of the family in 1930, and the last *City Directory* entry is in 1963.

Byck's got its start in Louisville when second-generation German Americans Louis and Werner Byck of Savannah opened a shoe store, Byck Brothers & Company at 416 South Fourth Street in 1902. In 1920, Byck's opened its signature Art Deco building at 534 South Fourth Street and, shortly thereafter, added quality ladies' clothing. While Werner remained in Savannah (there also was an Atlanta store), three generations of the family carried on the business in Louisville. Fashion-forward Byck's was also socially forward as one of the first downtown stores to have integrated dressing rooms. In 1946, Byck's added a suburban store in St. Matthews. At Dann Byck Sr.'s death in 1960, his wife, Mary Helen Byck, took over. She was followed by Dann Byck Jr., who expanded to Oxmoor Center and Bashford Manor Shopping Mall and into Lexington, Kentucky, in the early 1970s. In January 1991, Byck's closed the Bashford Manor store, and the following July, it closed all remaining locations.

DAIRIES

BY ROBERT J. EHRLER

Dairying has been more than an occupation for the inhabitants of the alpine regions of Switzerland, Germany and Austria. Rather, it has been a central part of their culture for millennia. Caesar observed that the barbarian tribes beyond the Alps survived on a diet of milk, cheese and meat. At least since the Middle Ages, dairying has been the primary agricultural activity in those alpine regions. Dairying has shaped not only the culture of those German-speaking peoples, but the mountains themselves through replacement of forest with high alpine meadows. The traditions of these dairying peoples would also come to shape dairying in Louisville.

In the early days, Louisville was small enough to allow many families to keep a cow to meet their own needs. As the city grew, ownership of a family cow became increasingly impractical, and families began to purchase dairy products from commercial dairymen. Reliable labor was scarce, and the Swiss immigrants in particular were recognized for their dairy skills. One local farmer boasted of his "reliable, sober, and careful" Swiss milker who "takes great pride in sending to market milk and cream second to none." Dairying provided an ideal opportunity for Swiss German immigrants who wished to start businesses of their own on a shoestring because the basic accoutrements of the dairy business were little more than a horse and wagon, butter churn, milk cans, a dipper and, of course, some cows. A typical early Louisville dairyman was Swiss immigrant Joseph Ehrler, who founded the family dairy in 1867 when his employer gave him a horse and wagon in lieu of back wages. There were seven dairymen listed in the *City Directory* in 1869,

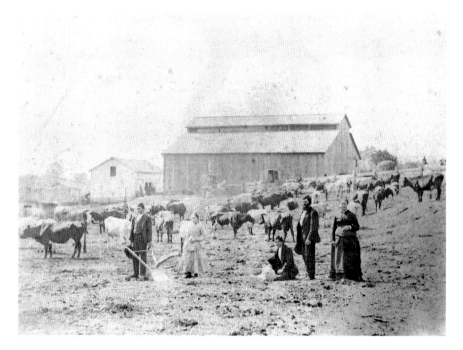

Zacharias Birchler dairy farm, about 1877. *Authors' collections.*

the first year that "dairymen" was listed as a separate occupation. All had German surnames, and four were located in what is now the Germantown neighborhood.

Over the last quarter of the nineteenth century, the number of dairymen in Louisville increased dramatically, with 22 listed in the city directory in 1880, 75 in 1890, 86 in 1900 and 116 in 1910. Many other dairymen who sold their milk on a wholesale basis were not listed in the directories. Despite the increase in the city's population, there were plenty of small pasture tracts in or near the city, so Louisville and its environs became a patchwork quilt of dairy farms. In 1907, there were 111 dairy farms with 3,200 cows in Louisville. During the 1890 to 1910 period, about 75 percent of the dairymen listed in the city directory and milk supply surveys had German surnames. Their dairies ranged in size from "alley dairies" (a small operation with a couple of cows kept in a shed off the alley) to large 100-cow herds. The average Swiss German dairyman had a small herd consisting of fewer than 30 mixed-breed cattle maintained on a farm of fewer than thirty acres. Some dairy operations were located at the infamous Rawlings Street cattle sheds, where cattle were crowded together in unsanitary conditions and maintained on

an unhealthy diet of distillery slop. With the extension of railroads and later highways, it became feasible to transport milk to Louisville from adjacent counties, but Jefferson County remained Kentucky's top milk-producing county through the 1950s.

By the 1890s, the Swiss German milkman making his rounds in a horse-drawn wagon was a common sight on the streets of Louisville. He dipped milk from cans or small tanks into containers left on customers' doorsteps. In the early 1900s, glass bottles, often embossed with his name, were adopted as more sanitary packaging for milk. Dairymen initially delivered milk twice daily, after each milking, to minimize spoilage, but delivery schedules were relaxed to once daily as more customers acquired iceboxes. The dairies listed in the city directories processed milk from their own herds or milk received from other dairymen. They separated milk from cream and made cheese, butter and sometimes ice cream. Most of the Swiss German home delivery dairies were small businesses with a single milk wagon. However, some were major enterprises, such as Von Allmen Brothers, which was founded in 1919 with a stock capitalization of $100,000.

Swiss or German families in the dairy business included the following: Balz, Birchler, Bisig, Bodeman, Buser, Ehrler, Eppihimer, Fineberg, Gauman,

Liebert Brothers Dairy delivery wagon, about 1940. *Courtesy Louis H. Liebert.*

Goldstein, Grantz, Gudgel, Hirsbrunner, Huntemann, Kaelin, Kalmey, Kamer, Liebert, Mack, Meiners, Merhoff, Meyers, Niemeier, Ochsner, Oehrle, Reichmuth, Schlossberg, Schneider, Schoenbachler, Schott, Schurch, Thielmeier, Ulrich, Von Allmen and Zehnder. A surprising number of these families emigrated from a single village, Einsiedeln, Switzerland.

While most people received their milk via home delivery, milk could also be purchased from creameries, or milk depots, specializing solely in dairy products or operated as part of corner groceries, bakeries, butcher shops and confectioneries. The creameries received their milk from other dairymen. Just as they dominated the dairy farms and home delivery dairies, the Swiss Germans also were heavily involved in the operation of creameries.

The Swiss German grocery store creameries were small operations. Louis Hofelich operated a typical creamery at his grocery and meat store located on Gray Street. In 1907, he received 28 gallons of milk each day from three dairymen at 6:00 a.m. and 5:00 p.m. He sold 10 gallons of whole milk, 12 gallons of skim milk and 6 gallons of buttermilk each day and churned 16 pounds of butter twice a week. F.C. Klotz Creamery, located on Market Street, was representative of the larger stand-alone creameries. He received 200 gallons of milk and 5 gallons of cream each day from six dairymen. He sold 150 gallons of whole milk, 30 gallons of buttermilk, 5 gallons of skim milk and 2 gallons of cream each day and also made varying amounts of ice cream. In those days, dairy farmers sold milk to the creamery for about ten cents per gallon, and the creamery charged a retail price of twenty-five to thirty cents.

The small dairy was profitable when processing milk involved little more than straining it, separating cream from milk and churning butter. In the early 1900s, dairies came under increasing pressure to pasteurize their milk to protect public health. The small Swiss German dairymen generally opposed pasteurization, contending that it altered the natural state of milk and was unnecessary due to the cleanliness of their operations. While in 1907 only one Louisville dairy pasteurized its milk (J.P. Gray Sanitary Milk Company), by 1920, half of the dairies sold pasteurized milk. In the 1920s and 1930s, more efficient refrigeration was developed, horse-drawn milk wagons gave way to delivery trucks and milking machines replaced milking cows by hand. The need for greater capital investment increasingly forced the small Swiss German dairies to sell out or close. The number of dairies listed in the 1934 *City Directory* fell to forty-one, with approximately half of the owners being of Swiss or German descent. The number of dairies listed in the *City Directory* fell to twenty-seven in 1949 and eleven in 1960.

Bisig's Dairy delivery truck, 1960s. *Courtesy Michael A. Bisig.*

While the decade of the 1960s was good for at least one of the old Swiss German dairies, Ehrler's, which grew to be the largest independent dairy in Kentucky, it sounded the death knell for the others. By 1970, the only Swiss German dairies left standing were Von Allmen's and Ehrler's, and neither would survive the decade under independent ownership as the milkman went the way of the dodo bird. Finally, as the post–World War II real estate boom fueled skyrocketing land prices, virtually all of the old Swiss German dairy farms in Jefferson County were planted in a final crop of asphalt and tract houses. Incompatible with a dairy business that had moved to an industrial scale, the old Swiss German dairies were replaced by dairy farms with one-thousand-cow herds producing milk processed and sold by multinational corporations.

While the old Swiss German dairies of Louisville are gone, they continue to cast long shadows. The dairy farms live on in the names of streets: Oehrle Drive, Von Allmen Court, Ehrler Drive. The milkmen live on through their colorful bottles that turn up at flea markets and on Internet auction sites to remind us of a time when our food supplies were truly local. While seemingly dead, the old dairies are not quite buried. The Bisig family carried on as the last of the old home delivery milkmen until closing in 2006, only to be succeeded by Ehrler's Micro Dairy, which started home delivery service again in 2012.

23.

BAKERIES AND CONFECTIONERIES

BY MICHAEL E. MALONEY

Envision Louisville's Uptown neighborhood (now Phoenix Hill) in 1885, a bustling, primarily German area centered at Shelby and Market Streets. Henry Knabeschuh, an emigrant from Lischeid, Hessen, awakens to join his comrades with Professor Erhard Eichorn's Orchestra, a professional troupe consisting of some thirty-two musicians. Bidding "Auf Wiedersehen" to wife Lisetta and their twelve children, he steps outside, greeted by the delicious smells enveloping his home at 807 East Market Street. Within a two-block radius, eleven German bakers and confectioners operate: Theodore Ising, Michael Goldsmith, S. Breheme, John Burkhardt, Henry Bachmann, Nicholas Wiest, Henry Pfeiffer, Charles J. Raible, Anna M. Suck, William Ewering and Crecentia Hermann. Kuchens, cheesecakes, strudels, cream cakes, candied fruits and nuts, klotchies, Danish, lebkuchens, springerles, chocolates and the staple of the German diet, breads—sourdoughs, wheats, ryes, pretzels and countless other varieties—constituting a near endless symphony of smells, all compete for the senses of Louisville's citizens as they stroll the streets in those early waking hours.

Baking is deeply rooted in the German ethos, its bakers industrious and talented, working in a craft steeped in centuries of tradition. Of German trades, baking, like brewing, would certainly be a trade closely associated with Teutonic culture. Bakers were among the earliest German citizens of Louisville, as noted in a November 10, 1889 *Courier-Journal* article stating, "Daniel Jacobs, baker, settled here in 1827" and "built the first brick house in the upper part of the city." A retired printer for the *Louisville Daily Journal*

recalled in a November 27, 1867 article that in 1832, he doubted that "there were twenty-five heads of families…of German birth living in Louisville," which included bakers John Schmelzing, Gottlieb Schoninger and Christian Shaeffer and his brother Louis, each with a confectionery business. By 1838, John Kek, George Lehman, John Schrod and Joseph Schmidt had also opened shops. The *Louisville Daily Courier* of August 18, 1859, stated that bakeries consumed about fifty thousand barrels of flour per year, but "there are such numbers of bakers…whose business is on a small scale that we have found great difficulty in making an estimate of…business transacted by them." Of 48 bakeries named, considered large or representative of smaller principal shops, 38 had German proprietors. One of the largest, making cakes, breads and crackers, was Union Bakeries, headed by Jacob Merker. Similarly, of 95 bakeries listed in 1885, an astounding 86 appear to have German ownership. Include confectioners, and that number jumps to 172, with at least 128 headed by Germans, or nearly 75 percent of those engaged in the baking and/or confection businesses.

As immigrants continued to swell the population, two events dramatically influenced German immigration to Louisville in completely different ways, the Bloody Monday riots of 1855 and the American Civil War. The riots were vividly recalled in a *Courier-Journal* article of November 7, 1897, that featured a graphic illustration of German Charles Becker's bakery in Uptown being ransacked and burned. Hundreds of immigrants left Louisville after Bloody Monday. The war reversed this unfortunate trend, and with peace, German immigration resumed at levels not seen in many years.

Like taverns, bakeries were within easy walking distance of homes, many featuring goods and special treats created from recipes uniquely their own. Numerous bakeries familiar to generations are now gone: Carl Vogel's Belmar Bakery near Audubon Park; Kistler's (Clifton), which supplied rye bread to the Brown Hotel; Deckman's, Fleig's, Glassner's, Krall's, Metzler's, Metzroth's and Shelby Bakeries (Germantown/Schnitzelburg); Beisler's (Highland Park); Wirth's (Highlands); Ising's (Uptown); and Bodner's and Mann's (West End). While the majority of bakeries remained family driven, a distinction should be noted that business at some, such as Bachmann's and Hellmueller's (also known as the New York Bakery), developed to such an extent that the focus grew to be more commercial in nature, supplying wholesale breads and crackers to grocers, steamboats and others.

On the following pages are some current and past well-known bakeries and confectioneries.

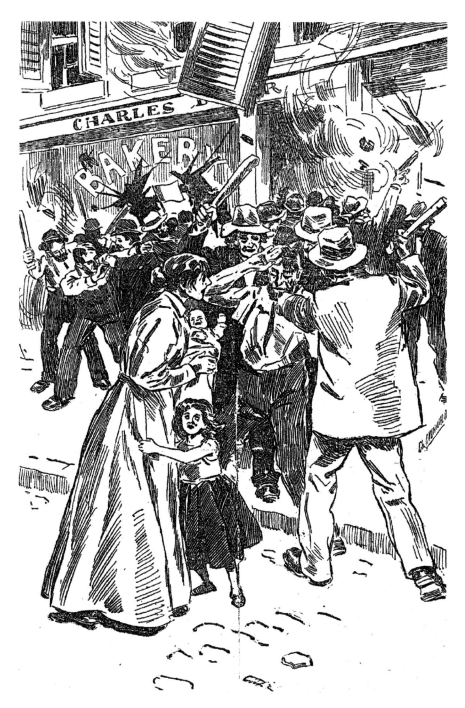

Bloody Monday Riots on Shelby Street near Becker's Bakery. Courier-Journal, *November 7, 1897.*

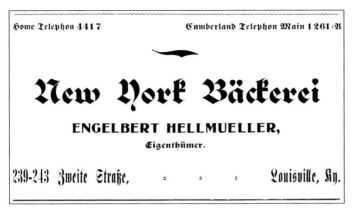

Hellmueller's New York Bakery. *Louisville Anzeiger, June 27, 1909.*

BUSSMANN'S BAKERY: Konrad Bussmann (1929–2004), born in what is now Bosnia, lived in Austria and West Germany following World War II. In 1955, he immigrated to Louisville, where he opened a bakery in the Clifton neighborhood in 1956, owned since 1997 by Nancy Sanford.

DUNDEE CANDY SHOP: The shop was founded in 1946 by Irma Issler (1905–1996), a German Jewish immigrant, and is currently owned by Maria Moore.

EHRMANN'S BAKERY: William Ehrmann (1820–1918), from Herrenthierbach, Württemberg, settled in Louisville by 1847. He and his brother Gottlieb (1826–1915) opened a bakery and confectionery on Market Street, but they later operated baking, confection and candy concerns independently. In 1891, Gottlieb's son Emil (1860–1914) started baking in the Highlands. Brother George (1852–1942) took over in 1903, and his family ran it until 1946. Emil Miller operated the bakery until he sold in 1956 to Arthur Steilberg, who relocated to Mid-City Mall in 1962. Gerald Driskell operated the bakery from 1980 until his death in 2003.

HEITZMAN'S BAKERY: Perhaps the best-known and most prolific of Louisville's family bakers, Jacob Heitzman (1861–1956) immigrated to the United States in 1885, opening a bakery on Baxter Avenue in 1891. Sons Charles and Joseph followed in the business. Paul and Mary Agnes Heitzman Osting took over in 1959. The bakeries, now led by the fourth generation, include various family branches that operate throughout the city, including a wholesale component.

LEHMANN'S BAKERY: Arriving in 1923, German immigrant Otto Lehmann (1901–1972), born in Axien, Saxony-Anhalt, worked a variety of jobs before opening a bakery in the late 1920s, operating at two locations on

Market Street, first at Forty-sixth and then at Fortieth Street. After he was disabled by a gas explosion in the 1950s, Lehmann's wife, Cecilia, and their four sons continued to operate the bakery until selling it in the 1960s.

MUTH'S CANDIES: On East Market Street since 1921, this fourth-generation establishment creates treats, including the Modjeska, named for famous Polish American actress Helena Modjeska and originally created by Louisville confectioner Anton Busath (1843–1908). After a 1947 fire closed Busath's, the Modjeska recipe was acquired by Rudolph Muth (1894–1953).

NORD'S BAKERY: Nord's, and its predecessor, Klein's, has been in business nearly eighty-five years. Proprietor Mike Nord operates the bakery from its longtime location on Preston Street in the St. Joseph neighborhood.

PEEGE'S BAKERY: Emil Peege (1846–1903), of Nossen, Saxony, near Dresden, opened a bakery in the Russell neighborhood about 1890. Son Charles assumed the business upon Emil's death and operated it until he died in 1924. Charles's wife, Theresa, ran the bakery until 1932, when a fire destroyed it. Peege's Bakery was renowned for its linzertorte.

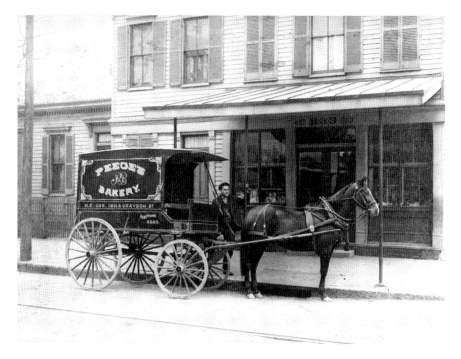

Peege's Bakery, about 1910. *Authors' collections.*

PLEHN'S BAKERY: Kuno Plehn (1883–1965), a native of Kiel, Germany, immigrated to the United States in 1904. After serving in the U.S. Army, including a post at Louisville's Camp Zachary Taylor, Plehn opened a bakery in 1922 on Shelby Street, moving to St. Matthews in 1924. During the 1937 flood, Plehn's was one of the few bakeries making bread, running its mixers with a belt hooked to a truck outside. In 1945, nephew Bernie Bowling Sr. bought the bakery, which has been operated by his sons since 1980.

SCHIMPFF'S CONFECTIONERY: Schimpff's was founded by Bavarian immigrants who opened a confectionery in Louisville in the 1850s. The current location in Jeffersonville has been in continuous operation since 1891, when Gustav A. Schimpff started his confectionery on the advice of brother Charles. The business continues under fourth-generation descendant Warren Schimpff and his wife, Jill.

SOLGER'S CONFECTIONERY: Theodore Solger (1837–1911), New Albany–born son of German immigrants, apprenticed in Louisville and then went into business with Joseph Wolf before opening his own confectionery shop at Fourth Street and Broadway in 1868. Son Will (1870–1934) sold the business in 1919 to make way for the Brown Hotel.

WARISSE'S BAKERY: Warisse's, founded by Alsatian immigrant Nick Warisse (1862–1936) and continued by his son Edmond (1898–1970), was a wholesale bakery with facilities in Portland and New Albany. It produced well-known breads, including Nick's, Town Talk and Aunt Hattie's until closing in the late 1960s.

WOHLLEB'S BAKERY: Wohlleb's, started on West Broadway in 1919, continued for more than ninety years and later included Hikes Point and Preston Highway locations before closing in 2010. Its chocolate doughnut icing, selected via a taste test, has been available through thousands of 7-Eleven stores since that time.

Traditional German baking also endures through recent immigrants. Klaus Riedelsheimer, trained in Germany, arrived in Louisville in the 1970s and worked for many notable restaurants. In 2010, Riedelsheimer began baking a wide variety of his sought-after pretzel breads that can be found in nearly a dozen of the area's popular dining establishments, including Holy Grale and the Exchange Pub + Kitchen.

24.

PHARMACIES

BY MARY MARGARET BELL

In the early days of the settlement at the Falls of the Ohio River, physicians dispensed medicines within their practices, the common system throughout the newly created United States. As the settlement grew into the city of Louisville, provision of medicines became a distinct business.

German immigrants in the area took part in the burgeoning growth that established Louisville as the headquarters for the supply of drugs and medicines to the surrounding settlements in Kentucky and Indiana in the early nineteenth century. Henry McMurtrie noted the existence of three drugstores, "two of them extensive," and twenty-two physicians in his 1819 *Sketches of Louisville and Its Environs*.

By 1838, drugstore operators included H. Rosengarten at Market and Jefferson Streets and Rupert and Lindenberger on the north side of Main Street near Fifth. Louisville's pharmaceutical community was influenced by an influx of educated German pharmacists who immigrated to the United States, fleeing European revolutions in the late 1840s. One of the foremost émigrés, Emil Scheffer, a pharmacist and chemist, became the owner of Kneiss's drugstore on Market Street near Preston. He led efforts to continue the teaching of German in the local public schools in the late 1860s.

An American-born pharmacist of German descent, C. Lewis Diehl, held prominent positions in efforts to produce pharmaceuticals in the city and to create formal education for professionals in the area. Diehl became the director of a reestablished pharmaceutical manufacturing concern, the Louisville Chemical Works, in the late 1860s. The renewed works failed to

prosper, but Diehl became one of the founders of the Louisville College of Pharmacy in 1870, and he was appointed the college's first president. The college was later absorbed by the University of Kentucky in the mid-twentieth century as the precursor to its school of pharmacy. Diehl also operated his own pharmacy in the late 1800s and early 1900s.

Pharmaceutical wholesalers by the 1870s included C.W. Kemperdick, Nock and Son and William Schmidt, all on Market Street in an area where pharmacy activity in the era was concentrated.

The Frankel family was operating a small chain of Frankel Drug Company pharmacies by the 1920s. The stores included two on South Third Street and locations on Southern Parkway, Bank Street and Bardstown Road.

Henry Buschemeyer left Germany in 1848 and settled in Louisville. All of his sons became pharmacists. John H. Buschemeyer's career later included medical school, service as a physician and election as an alderman and mayor of Louisville. The brothers Henry, Charles, Julius and their families

Frankel Drug Company was located on Bardstown Road at Grinstead Drive. *Courtesy University of Louisville Photographic Archives.*

operated Buschemeyer drugstores from the late 1800s until the 1950s in the downtown area and the suburbs.

In 1922, Leo Wagner bought the former Hagen's Pharmacy at Fourth Street and Central Avenue. Wagner's Pharmacy became, and remains, a famous hangout for horsemen and racing writers coming from nearby Churchill Downs. Wagner's is better known for its breakfast, lunch and track supplies than its continued role as a medicine dispensary.

By 1930, other pharmacies operated by German Americans in the city and the first suburbs included Bertelkamp on Walnut (Muhammad Ali Boulevard) Street; Blum Brothers on Brook Street; Kaplin and Berman on Dixie Highway; Kranz on Bardstown Road; Krupp on Chestnut Street; Meyer's on Story Avenue; Neff on Portland Avenue; Rademaker's on Madison Street; Rompf on Broadway; Schneider's and Schreiber's, each on Dixie Highway; Schuckman's and Schwartz, each on Walnut Street; Strader's on Oak Street; Zahn's on Bardstown Road; and Zubrod's on Sixth Street. Pfeiffer Drug Company offered two locations, one on Jefferson Street and one on Griffiths Avenue.

In another twenty years, German names were also represented by Doerhoefer on Market Street, Fine Drug Company on Oak Street, John Fischer and Brother on Shelby Street, Lintner's on Shelby Street, Markendorf on Broadway, Wobbe's on Frankfort Avenue and Wirth Drug Store on Walnut Street.

As the Frankel family gradually left the scene, other German-associated chains developed in Derby City and its growing suburban regions. One was Otto Drug Stores and another was Zegart Drug Stores. Additional pharmacies with German names by the early 1960s were Berman's on Fourth Street, Neubauer Drugs on Bardstown Road, Salzman Drugs on Walnut Street, Vollmer Pharmacy on Barret Avenue, Voss Pharmacy on Central Avenue, Waldman's on First Street, Wintergeist on Third Street, Zax on Brookline Avenue, Zeiden on Second Street and Zurlage on Brownsboro Road. The suburbs included Fihe-Kupper on Dixie Highway by the early 1970s.

National pharmacy chains emerged in the twentieth century, but the German-named pharmacies took advantage of conditions favoring small locally owned businesses in the first part of the century. Sweeping changes came to pharmacies throughout the United States in the 1980s. Managed-care insurance plans and government programs, such as Medicare and Medicaid, played greater roles in the provision of medicine and were part of the creation of the modern-day healthcare industry. These changes

Schreiber Drug Store was located on Preston Street near Broadway. This image is from 1926. *Courtesy University of Louisville Photographic Archives.*

heightened competition, squeezed profits and pushed a trend toward consolidation among drugstores.

By the end of the twentieth century, national chains bought out more and more independent pharmacies and smaller local drug chains. The stores

bearing German names in Louisville gradually disappeared, occasionally leaving only ghost signs to mark where they once did thriving business. Today, Kupper & Sons on Manslick Road is one of the few remaining stores with a German heritage.

Louisville consumers were otherwise left with chains of varying origins to choose as prescription providers. One, based in Cincinnati, still brought a Teutonic name to the region: Kroger (originally Kroeger).

FUNERAL HOMES AND CEMETERIES

BY C. ROBERT ULLRICH

Many of the first German undertakers in Louisville were carpenters and cabinetmakers who found work making coffins during the Civil War. Two of these were George and Herman Ratterman—born in 1836 and 1839, respectively—who established a funeral business in 1864 at Market and Eleventh Streets under the name "G.&H. Ratterman, Carpenters and Makers of Fine Coffins." The Ratterman brothers immigrated to Louisville in 1845 from Ankum in the former kingdom of Hanover. After their deaths in the 1880s, their business passed to John B. Ratterman, a son of George. The Ratterman Funeral Home was moved to Market and Twenty-first Streets in 1914.

Another German undertaker who originally was a cabinetmaker was Henry Bosse, who was born in 1836 in Bad Iburg, Hanover, and immigrated to Louisville in 1853. He and his brothers, Joseph and Bernard, made coffins for Union soldiers who died at the Louisville Marine Hospital during the Civil War. In 1865, they established a funeral business at Green (Liberty) and Jackson Streets under the name "H. Bosse & Brothers Undertakers." In 1908, the management of the business was assumed by Henry Bosse Jr. Two other German cabinetmakers who also were engaged in the funeral business were John B. Dieker and Michael C. Brinckmann, who were listed as undertakers in the Louisville city directories between 1867 and 1870.

Three long-lived funeral businesses, established by Germans in the late nineteenth century, were those owned by August Lefert, John Schaefer and Clemens Schildt. August Grosse Lefert, born in Burgsteinfurt, Westphalia,

Henry Bosse, about 1870. *Courtesy Bosse Funeral Home.*

owned a funeral home at Walnut (Muhammad Ali Boulevard) and Wenzel Streets from 1867 to 1905. John Schaefer, a native of Prussia, was an undertaker in Louisville from 1870 to 1893.

Clemens Henry Schildt was born in 1823 in Herne, near Bochum, Westphalia. He owned a furniture business at Market and Floyd Streets as early as 1861 and was listed as an undertaker in the Louisville *City Directory* as early as 1865. After his death in 1893, his funeral business was passed to his sons and became known as C. Schildt & Sons. The business was last located on Broadway at Clay Street in 1946.

Gustav S. Rosenberg, born in 1854 in Germany, established a funeral business for the Jewish community of Louisville in 1888. His business originally was located at First and Oak Streets. When he died in 1925, Rosenberg bequeathed half of his business to his closest friend, Herman Meyer, who later bought full interest in the company.

Herman Meyer, a native of Spiesen in the Rhineland, was born in 1856. He and a son, Emanuel, changed the name of the G.S. Rosenberg Undertaking Company to Herman Meyer & Son and relocated the business to Third Street near Gaulbert Avenue in 1927.

Edward Schoppenhorst, the youngest son of Johann Heinrich Wilhelm Schoppenhorst, a native of Ladbergen, Westphalia, left the family laundry and linen service in 1892 to enter the undertaking business. He and his wife, Flora, established a funeral home located at Market and Eighteenth Streets in the former residence of a riverboat captain. After her husband's death in 1941, Flora Schoppenhorst continued to manage the business until she died in 1965.

Albert Neurath, the son of German immigrant August Neurath, bought an undertaking business from John P. Schoenlaub in 1904 and established a funeral home at Market and Clay Streets. Eventually, Alton E. Neurath joined his father in the business, which became known as Neurath & Son Funeral Home. Alton Neurath sold the business in 1975.

The German Reformed Presbyterian and Lutheran congregations established a cemetery in Jeffersontown in 1799. While a few German immigrants may be buried in this cemetery, most of those interred were descendants of Germans who immigrated to America during the colonial period.

The first cemetery established for German immigrants in Louisville was St. Mary (now St. John) Cemetery at Duncan and Twenty-sixth Streets. It was founded in 1849 on land purchased from the Sisters of Charity of Nazareth by the Diocese of Louisville.

The imposition of a six-dollar burial fee at St. Mary Cemetery caused opposition from a faction of parishioners at St. Boniface Church in the eastern German neighborhood. They wanted a burial ground where the poor could be buried free of charge, so they formed the St. Boniface Benevolent Society to purchase property on Preston Street for St. Stephen Cemetery, which was to be free of ecclesiastical control. Bishop Martin J. Spalding refused to consecrate the cemetery and banned the St. Boniface Benevolent Society from meeting on church property. The St. Boniface Benevolent Society immediately renamed itself the St. Stephen Cemetery Association and still manages the cemetery today.

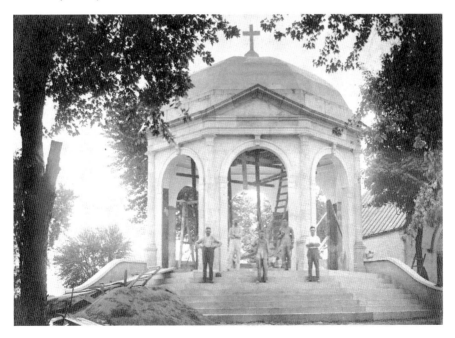

St. Michael Cemetery Chapel, about 1920. *Courtesy Filson Historical Society.*

Scarcely had St. Stephen Cemetery been placed under interdict than the Diocese of Louisville acquired the former dairy farm of Thomas Goss, a native of Baden, to establish a cemetery on the east side of Louisville. The new burial ground, known as St. Michael Cemetery, was consecrated in 1851.

Adath Israel (Hebrew) Cemetery was established as a burial ground for Louisville's Jewish community, many of whom were German immigrants. The cemetery, first mentioned in 1859, was located at Preston and Woodbine Streets. In 1955, the construction of Interstate 65 through Louisville forced the removal of graves from the cemetery to its present location on Preston Street south of Eastern Parkway. Among those who were buried in the original cemetery were Adolph and Frederika Brandeis, the parents of Supreme Court justice Louis Dembitz Brandeis.

GERMANTOWN AND SCHNITZELBURG

BY DONALD A. HAAG SR.

Germantown is roughly bordered by the CSX Railroad tracks, Breckinridge Street, Barret Avenue, Beargrass Creek, Eastern Parkway and Goss Avenue. Prior to settlement, Beargrass Creek caused flooding and health problems in the area. Still, Germantown became a popular settling spot for immigrants in the 1850s and the land developed over time, first in what is known as "Old Germantown" and later in the "Ellison section."

Schnitzelburg is a triangular-shaped neighborhood bounded by Shelby Street, Goss Avenue and Clarks Lane. It is considered by some to be part of Germantown, but others insist it is a separate entity. This is understandable because the two neighborhoods developed in different ways, and there is a great deal of community pride in each.

By 1858, the first houses were erected on Cane (St. Catherine) Street, Milk (Oak) Street, Shelby Street, Swan Street and Mary Street (northwest of Dandridge Avenue) in an area referred to as Old Germantown. The areas immediately south and east remained unsettled until after the Civil War. The post–Civil War days saw immigrants continuing to flow into the area, and in 1868, all of Germantown was annexed by the City of Louisville. During the 1870s, the Louisville & Nashville Railroad tracks were laid on the western edge of Germantown and Schnitzelburg, and more streets were built. The area developed heavily during the 1890s, and by the early 1900s, it had the largest concentration of shotgun houses in the city.

By the mid-1880s, a second section of Germantown was developed, known as the Ellison section because Ellison Avenue ran the entire length.

The area was bounded by Dandridge Avenue on the north, Schiller Avenue, Beargrass Creek, Texas Avenue and Goss Avenue. This area also was mostly swampland, which in later years was drained and filled in order for houses to be built. By 1915, the Ellison section was growing rapidly with the exception of an area where a large part of the swamp remained near the banks of Beargrass Creek (later filled in). The development of the Ellison section was mostly complete by 1935.

In Schnitzelburg, developer and landowner David H. Meriwether plotted the area in 1866, and streets were laid out during the 1870s. In 1884, 95 percent of the land was owned by four individuals—Emma Milton, Lydia Carter and David and Mary Jane McHenry. Emma, Lydia and Mary Jane were daughters of David H. and Lydia Meriwether, early Schnitzelburg landowners. Some streets were named after these families. In 1887, most of the area was still dairy farms. The only industries near the area were the Huber Brewery and the Arctic Test Oil Company, both located on Shelby Street.

The railroad tracks, constructed in the 1870s, soon attracted new industries to the Germantown and Schnitzelburg communities, which in turn attracted new settlers to the area. In 1888, Louisville Textiles (the Cotton Mill) was built on Goss Avenue next to the railroad tracks. Also, the company built many of the homes in the surrounding area on Ash, Mulberry and McHenry Streets for employees. The American Woolen Company located a factory on the corner of Dandridge and Reutlinger Avenues. The Hope Worsted Mills was built on the corner of Swan and Kentucky Streets. All three mills are listed on the National Register of Historic Places.

In 1891, the Louisville Railway Transit Company extended its streetcar tracks from Shelby Street and Ormsby Avenue. The new tracks traveled south on Shelby Street, east on Stonewall (Burnett Avenue) Street, north on Texas Avenue and west on Goss Avenue, thus creating the Shelby Streetcar Loop. The old streetcar barn on Shelby Street still stands. During the next five years, more homes were built in the Schnitzelburg area with a large majority of them on Ash and Milton Streets. The year 1895 saw the introduction of two families who had much to do with the development of Schnitzelburg. The Hartstern and Ziegler families ran combination saloon-groceries in Schnitzelburg. Christian and Jake Hartstern owned a saloon-grocery at the intersection of Shelby and Ash Streets. Philip Hartstern owned a grocery at Shelby and Mulberry Streets. The Ziegler family owned a grocery, tavern and beer garden at Shelby Street and Burnett Avenue for many years, starting in the late 1880s. Other beer gardens were popular, for example, Fischer's Beer Garden (later Seng's) on Goss Avenue.

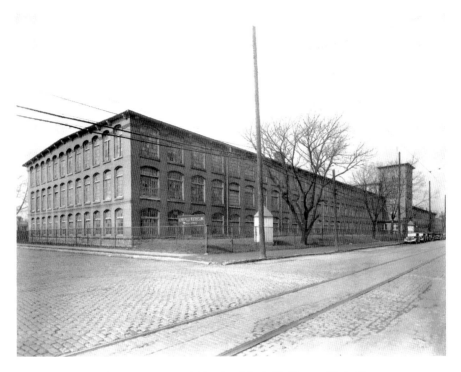

Louisville Textile Mill, 1937. *Courtesy University of Louisville Photographic Archives.*

By the beginning of the twentieth century, Schnitzelburg was growing rapidly, with houses being built on all streets. The Louisville Soap Company was located on Shelby Street next to the Kentucky Refining Company. The Red Cross Sanitarium stood on Shelby Street at the foot of Lydia Street. The Besendorf Shoe Store was at Shelby and Milton Streets for many years. By the early 1930s, Schnitzelburg's rapid expansion was coming to a halt—only a few vacant lots remained.

Goss Avenue is the dividing street between Schnitzelburg and Germantown and is named after Thomas Goss, who purchased 242 acres of land in 1849—part of the David Meriwether property and originally part of the Alexander Spottswood land grant. Goss operated a large dairy farm, roughly bounded by Clarks Lane, Burnett Avenue, Texas Avenue and the south fork of Beargrass Creek. The farmland was gradually sold off and eventually became part of St. Michael Cemetery, Louisville Cemetery and other farms. From 1880 to early 1900s, George and Catherine Wetterau owned a dairy farm on the corner of Goss and Texas Avenues. Other well-known farm owners in the area included

Charles Weber, Ferdinand and Barbara Bauer, William Blumleve, Fred Schurch and Joe Goss.

It is difficult to imagine what life must have been like for the early German settlers in Germantown and Schnitzelburg. In 1901, *Courier-Journal* reporter Elizabeth Waltz traveled to the area on the Shelby streetcar. She wrote:

> *The area is distinctly out in the country, and outsiders arriving on the streetcar are met with wonder and sometimes disapproval. Children are quaintly dressed. Mothers are severely sober. The community has an atmosphere of effort, of continued labor, and little pleasure. Everything is serious and sensible. Life is toil and frivolity would win little sympathy here.*

As Germantown and Schnitzelburg developed, there were many local businesses, such as groceries, shoemakers, barbers, dry goods stores, saloons and taverns, bakeries, churches, schools, theaters, restaurants and banks, so that nearly every service a resident might need could be found close by. Shelby Street was the main shopping district, and shop owners often lived behind or over their businesses. Business owners were often friends or neighbors. Some businesses operated for many years and continue today, and some former business buildings now serve other purposes. Hauck's Handy Store on Goss Avenue is over one hundred years old and is still in business. Heitzman's Bakery, Glassner's Bakery and Taphorn's Tavern were once household names and are fondly remembered by older residents.

The German immigrants who settled in Germantown and Schnitzelburg unknowingly founded neighborhoods that would play an important role in Louisville history. They contributed a large work force to the factories and mills of the community, and their buying power provided a livelihood for smaller businessmen. However, their most significant contribution was community pride, as manifested in doing a job slightly better than other workers. This pride also found its way into homes—the residents swept not only their walkways but the streets and gutters, too. Houses were painted, foundations and porches were whitewashed, and the grass was neatly cut in the summer months. Clothes were sometimes threadbare but always clean and starched. Neighbors could be counted on for a helping hand in a crisis, large or small. Germans were family-oriented and found strength and comfort in one another. It was those ties that bound them together in family and community.

Today, numerous taverns and restaurants, such as Check's Café and Eiderdown, dot the street corners in Germantown and Schnitzelburg,

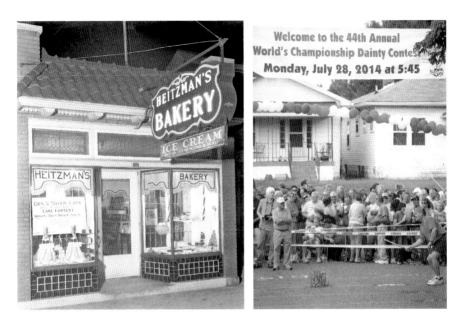

Left: Heitzman's Bakery, 1933. *Courtesy University of Louisville Photographic Archives.*

Right: World Championship Dainty Contest, 2014. *Courtesy Ronald K. Schildknecht.*

and neighborhood residents still take pride in the many traditions passed on to them by the early immigrants. One of those traditions is the World Championship Dainty Contest, held annually at Goss and Hoertz Avenues. The contest is based on an old European children's game and is played with a "dainty," a small wooden stick about five inches long with pointed ends. In the contest, the dainty is placed on the ground and the contestant strikes at its pointed end with a long stick attempting to flip it into the air. While the dainty is airborne, the contestant swings at it with the long stick, trying to bat it as far as possible. The person who hits the dainty the farthest is the winner.

ANTI-GERMAN SENTIMENT DURING THE WORLD WARS

BY JOHN E. KLEBER

Early twentieth-century notable Americans, such as Theodore Roosevelt and Woodrow Wilson, observed certain signs of "malfunction in the melting pot." Their concern and that of others would result in, during the 1920s, a quota system that limited the number of immigrants. By 1929, that total was a mere 153,714 whereas millions had come in the years following the Civil War. The "malfunction" primarily was due to the shift in nationality of the immigrants, who were more and more often coming from southern and Eastern Europe. Due to linguistic and cultural differences—but also large numbers—these immigrants seemed to be more difficult to assimilate. In addition, an emerging nationalism resulted in an Anglo Americanization campaign.

Germans in the United States might have been spared this renewed feeling of xenophobia had it not been for external events causing wrenching and radical changes in attitudes and actions. After all, they were part of the "old" immigration from northern and western Europe. By 1910, more than 90 percent had taken out naturalization papers. Although Germans were the largest immigrant group arriving in the late nineteenth century, they were looked upon in a favorable light. They were considered to be industrious, thrifty, honest, orderly, disciplined, stable and intelligent, if sometimes stubborn and graceless in manner. They continued to be unwarrantably proud of their origins and culture. And the German language was the single most important weapon to ward off Americanization and assimilation. This proved dangerous because many Germans were unable or unwilling

to separate cultural chauvinism from political and national chauvinism. In Louisville, enough Germans arrived to keep old ethnic loyalties alive. From 1860 until 1910, the German-born population of Jefferson County remained between thirteen thousand and fifteen thousand.

The external event that turned attitudes against Germans was the outbreak of the Great War. The late nineteenth century had been characterized by an increasing European nationalism. This resulted in both colonialism and strident militarism. Sparking the configuration was the assassination of the Archduke Franz Ferdinand of Austria-Hungary on June 28, 1914, by a Serbian anarchist. On July 28, war began between Germany, Austria-Hungary and Turkey on one side and the allies Britain, France and Russia on the other. The official position of the United States was to remain neutral.

Neutrality was a pipe dream, as Americans chose sides, usually based on nationality. Germans were drawn together in their opposition to British propaganda and loans made to Allied countries. Politicians were reminded that millions of Germans voted, and they increasingly supported the Republican Party as Democratic president Woodrow Wilson moved ever closer to Allied support. German Americans promoted imperial German loans. They recalled that Britain had once been our enemy. However, more factors drew the United States toward the Allies almost from the time Germany marched through Belgium and into France. Tales of German atrocities there resulted in the increasing use of the derogatory term "Hun."

In Louisville, the term was employed by the renowned editor of the *Courier-Journal* Henry Watterson, who returned to frequent, albeit less-than-neutral, editorial writing against the "Kaiserists." On September 5, 1914, he wrote that the war was one involving dynamic absolutism on the one side and popular freedom on the other. Two days before, he had written a banner that read "To Hell with the Hohenzollerns and the Hapsburgs." It was a frequently reprinted headline. Watterson believed that Germany needed "a drubbing to learn its place in the world." When the *Lusitania* was sunk in May 1915, he called it a "ship carrying a harmless ship's company of noncombatant men,

Henry Watterson, late 1800s. *Courtesy Library of Congress.*

women, and children…Nothing in the annals of piracy can in wanton and cruel ferocity equal the destruction of the *Lusitania*." Playing much the same role that his predecessor, George Prentice, did in fomenting the Bloody Monday riots, Watterson went on to write numerous such editorials, winning a Pulitzer Prize in 1917. Stanley Zinke's letter to the *Courier-Journal* on May 18, 1915, accusing Watterson of lacking lucidity and "shameful one-sided opinions" carried little weight against such a formidable adversary.

Following a series of German "atrocities," including the Zimmermann telegram and unrestricted submarine warfare, President Wilson asked for a declaration of war on April 2, 1917. Congress overwhelmingly concurred. Anti-German attitudes took a more ominous turn. As early as 1914, there was pressure on immigrants to "Americanize." Now the cry was "100 percent Americanism." Historian John Higham summarized it best: "By threat and rhetoric 100 percent Americanizers opened a frontal assault on foreign influence…They set about to stampede immigrants into citizenship, into adoption of the English language, and into an unquestioning reverence for existing American institutions…They used high-pressure, steam-roller tactics. They cajoled and they commanded." As an example, all enemy aliens had to register for a certificate card. In the beginning, it was only men over the age of fourteen, but later, women were added as well. Each went to the basement of Louisville's city hall to be photographed, fingerprinted and questioned on topics relating to business, habits and relatives. Their names and addresses were printed in the newspapers. Failure to go through this process meant detention for the remainder of the war. It was estimated that five hundred thousand "citizens of the German Empire or Imperial German government" would be registered nationwide.

Louisville soldiers departing for World War I. Courier-Journal, *May 24, 1918.*

In 1917, an Espionage Act provided for the summary arrest of individuals guilty of unpatriotic utterances. Attorney General Thomas Gregory organized 200,000 untrained volunteer detectives to give the Justice Department information about suspected aliens and disloyal citizens. It was called the American Protective League. In time, hundreds of thousands of investigations were conducted as alien and citizen alike came under suspicion in a frenzy of hysteria and paranoia that negated American ideals of liberty. On April 5, 1918, at noon, Linus Weber, a butcher and native of Biedenbach, was arrested at his home at 1434 Story Avenue. His crime was making disloyal remarks, specifically that the White House and everyone in it ought to be blown up. Since registering as an enemy alien in July 1917, he had been under surveillance. Witnesses gave proof of his utterances to Justice Department representatives. Upon his arrest, he was taken by streetcar to the customhouse and told he had violated his registration. He denied any unpatriotic act and said he had a wife and nine children, ages two to twenty, to which the arresting officer, E.H. James, replied, "I know you have but when you registered you were admonished to keep your mouth shut…You talked too much and your actions encouraged and caused disloyalty." By that afternoon he was jailed for the duration of the war. He was the first civilian in Louisville to be interned, and it acted as a strong deterrent against freedom of speech.

Not all anti-German manifestations were as serious as internment. Some were demonstrations of liberty and others ridiculous to the point of humor. Throughout America, hamburgers were renamed Salisbury steaks, sauerkraut became liberty cabbage, German shepherds became Alsatian shepherds, dachshunds were liberty dogs and German measles were now liberty measles.

German-language newspapers and books were burned. Musical organizations purged Wagner, Schubert and Schumann. German-language schools were closed. German disappeared from schools and churches and even over the telephone in semipublic places. Socialists, many of whom were German, were sought out for punishment. In Louisville, Henry Fischer of Fischer Packing Company and a member of the Socialist Labor Party was investigated. Labor leader Eugene V. Debs was sentenced to prison for violating the Espionage Act. The Industrial Workers of the World's offices were raided and many of its leaders brought to trial for upsetting America's war plans.

Louisville followed the country as the German language disappeared from churches and schools. German names associated with banks and

"Hoch der Kaiser," an anti-German cartoon from 1918. *Authors' collections.*

insurance companies were dropped. German-language newspapers ceased publication. In Cleveland, one-time editor of the *Louisville Anzeiger* Waldemar von Nostitz was arrested for saying, "I am a subject of the Kaiser." Green Street was renamed Liberty Street in 1918. An ever-visible sign of war was the sprawling Camp Zachary Taylor created in June 1917, where more than

150,000 troops were eventually trained, many of them of German heritage. Later, they fought bravely under the command of General John J. Pershing, himself of German descent. Some six hundred acres of prime real estate along the Taylorsville Road, which was owned by Baron Waldemar Konrad von Zedtwitz, a German national, was seized by the federal Custodian of Alien Property Office. Ultimately fifty acres were developed by Abram Bowman into an airfield. In World War II, it was an important training site for glider combat. At war's end in November 1918, America was much less a country of German heritage. It was personal for author Kurt Vonnegut: "The anti-Germanism in this country…so shamed and dismayed my parents that they resolved to raise me without acquainting me with the language or the literature or the music or the oral family histories which my ancestors had loved. They volunteered to make me ignorant and rootless as proof of their patriotism."

By the 1930s, newspaper editor H.L. Mencken's observation that the melting pot had swallowed up the German Americans as no other group, even the Irish, was true. That partially explains why there were far fewer examples of anti-German sentiment when America went to war in 1941. While there were seven million persons of German stock then, over 75 percent were born in America and two-thirds of the German-born had arrived before World War I. Then, too, most saw the terror and aggression of Nazi leaders and rejected its fascist ideology. Only briefly did Germans feel a sense of pride in Germany's new successes under Adolph Hitler. By 1934, they too were boycotting German-made goods and fell in line behind the American point of view.

Germany declared war on the United States on December 11, 1941. As in World War I, all enemy aliens—Germans, Italians, Japanese—fourteen years and older were required to apply for certificates of identification at the Federal Building. It was estimated that the number was approximately nine hundred in Louisville. They had to surrender short wave radios, firearms and cameras.

At the same time, approximately one-third of the eleven million Americans in the armed forces were of German stock. They were led by men with names such as Eisenhower and Nimitz.

Many trained at Fort Knox, where the armored divisions and corps were created. In addition, it was the site of one of the fifteen prisoner-of-war camps in Kentucky. Opening in February 1944, Fort Knox held both German and Italian prisoners. There they performed duties as cooks, launderers, carpenters, mechanics, et cetera. Some worked in the

Fort Knox prisoner of war Seppe Hallas and his wife during World War II. *Authors' collections.*

Jeffersonville Quartermaster Depot and at Louisville's Nichols General Hospital. However, agriculture remained the top priority. In camp, they were subjected to indoctrination to convert their political beliefs while extolling the virtues of freedom and democracy. By June 1946, they had been repatriated in hopes they would help in creating a progressive postwar Germany.

Louisville's economy grew during World War II as industries turned to war production. Private companies such as Ford, Hillerich & Bradsby and Henry Vogt contributed to the war effort. Thousands of new workers from the rural areas came to work here. African Americans and women enjoyed new job opportunities. Working beside them were men and women of German descent. This time few questioned their loyalty. As reformer and statesman Carl Schurz noted, "We German-Americans are the hyphen between Germany and America; we present the living demonstration of the fact that a large population may be transplanted from one to another country and may be devoted to the new fatherland for life and death."

28.

GERMAN CULTURAL INFLUENCES IN MODERN TIMES

BY DON HEINRICH TOLZMANN AND C. ROBERT ULLRICH

Germans have contributed to the culture of America in numerous ways: The influence of German cuisine is seen throughout America, especially in meats, pastries and beers. Frankfurters, hamburgers, sausages, sauerkraut, strudel and pretzels are all familiar American dishes. Also, almost half of all current beer sales in the United States can be attributed to German immigrants such as Eberhard Anheuser, Adolphus Busch, and Frederick Pabst. German restaurants are found in almost every large American city, and German fare, such as sausages and beer, is common at street fairs and sporting events throughout the country.

German American celebrations, such as Oktoberfest and German American Day, are commonplace in the United States. German American Steuben Parades, held in honor of Revolutionary War hero Friedrich Wilhelm von Steuben, are among the largest annual parades in New York, Philadelphia and Chicago. German customs, such as Santa Claus, the Christmas tree and the Easter Bunny, have become fixed in American culture. Germans have even introduced the word *Gemütlichkeit* (state of warmth or friendliness) into the American vocabulary.

German American cultural life has its roots in the structure of the German immigrant family and the various organizations and institutions (religious and secular) that German Americans established. The most important aspect is the family unit, which fostered German customs and traditions, passing them on to succeeding generations. German American

Sausage platter and beer. *Courtesy Loreley Restaurant & Biergarten, New York.*

families were often larger than the average family, and many German Americans married and resided in areas near their extended family. This kind of cohesiveness contributed to the preservation of German customs, traditions and cultural life.

In writing about German settlement and influences in the Ohio Valley, Gustav Koerner stated, "Here, as well as elsewhere, where Germans settled in sufficient numbers, German social life emerged, including their festivities, outside activities, musical enjoyments, and their quite noticeable influence on social customs."

Koerner makes two important points: first, there has to be a large concentration of Germans in a given area for their social and cultural life to develop, and second, when they were so concentrated in a given area, their customs and traditions would exert a considerable degree of influence elsewhere. Conditions were just right in Louisville for this to happen in 1850, when 20 percent of the population was German. By 1900, German immigrants and their descendants were firmly entrenched in Louisville's culture. There were German churches, schools, banks, businesses and manufacturers, and Germans were involved in every facet of government and society.

With all that Germans had contributed to Louisville, the prestige of their achievements was nearly destroyed by the anti-German sentiment caused by the two world wars of the twentieth century. These negative feelings did not subside until well after World War II. In fact, it was not until the 1960s that it became "okay to be German," and celebrations of German culture and heritage flourished once again. By this time, most of the native German population that existed before the wars had died and their descendants had become assimilated. Today, while the number of native Germans living in Louisville is small, fully one-third of the population of Louisville has German ancestry, which well exceeds the national average.

While Louisville's German American and Swiss American social organizations are very old, the modern celebrations of Louisville's German heritage started only in the 1960s. For example, the German-American Club Gesangverein, which was founded in 1878, did not host its first public Oktoberfest until 1965, when the club relocated from downtown to a rural site with ample grounds for a festival. The German-American Club Oktoberfest has continued as an annual event to this day and is celebrated on a weekend in mid-September. Also, the German-American Club hosts other public events year-round, such as beer gardens and concerts, and has a mixed chorus that is a member of the Nord-Amerikanischer Sängerbund.

The Kentuckiana Germanic Heritage Society, which was founded in 1991, became an auxiliary organization of the German-American Club in 2002. Now known as the Germanic Heritage Auxiliary, the organization regularly sponsors programs related to German culture and heritage. Most notably, it collaborated with the Metro Louisville Mayor's Office and the Ancient Order of Hibernians to present a daylong program in commemoration of the 150th anniversary of Bloody Monday in 2005.

The Gruetli Helvetia Society, which was organized as the Gruetli Society in 1850, is still an organization for men of Swiss heritage. Most of the founders of the society were German speaking and tended to live in German immigrant neighborhoods. The Gruetli Society and other Swiss societies established the very popular Swiss Park on Lynn Street in 1923, which became the center of civic celebrations for many years. In 1993, faced by a dwindling and aging membership, the society sold Swiss Park to a Fraternal Order of Police lodge, which still operates it under the same name. The Gruetli Helvetia Society continues today and has several events each year for its members.

St. Joseph Catholic Church in Butchertown opened its one hundred-year-old annual parish picnic to the public in 1966 and renamed it the

German-American Club Oktoberfest, 2014. *Courtesy Gary L. Sego.*

"German Heritage Festival." Under the auspices of the parish, the German Heritage Festival became the "Butchertown Oktoberfest" in 2002. Today, the Butchertown Oktoberfest is a two-day celebration in the autumn with food, German bands, a German-language Mass and German classical music concerts in the church.

In 1974, as part of the bicentennial celebration of the founding of Kentucky at Harrodsburg, the City of Louisville began a series of summer ethnic festivals on the Riverfront Belvedere in downtown Louisville. Each weekend, a different culture was featured. By far, the largest was the German weekend, which featured German music, food and drinks and ethnic dancing. The summer celebrations continued through the United States Bicentennial in 1976 and the bicentennial of the city of Louisville in 1978. However, in the 1980s, public support for many of the ethnic festivals lagged, and they were discontinued in 1986.

Strassenfest began in 1978 as a spinoff of the summer German ethnic weekend festival sponsored by the City of Louisville. The Strassenfest, or "street festival," celebrations were begun by Third Century, part of the

Gutenberg monument and St. Martin Cathedral in Mainz. *Courtesy Wikimedia Commons.*

Louisville Central Area, a civic booster organization. Strassenfest was held in early autumn and featured German bands, dancing, food and drinks. The last Strassenfest was celebrated in 2000.

In 2003, Metro Louisville began WorldFest as a celebration of all immigrant cultures to Louisville, both old and new. Over 120 different cultures celebrate WorldFest on the Riverfront Belvedere on Labor Day weekend.

The City of Louisville began an informal cultural relationship with Mainz, Germany, in 1977. The relationship featured student exchanges between universities and business and professional exchanges. A formal Sister City agreement was signed in 1994. In addition to educational and professional exchanges, Mainz has invited participants from Louisville and its other partner cities to events in Mainz, such as the Mainz Marathon and an art festival known as "Kunst in der Stadt." In 2000, the City of Louisville helped Mainz celebrate the 600th birthday of its favorite son, Johannes Gutenberg, by hosting an exhibit of items on loan from the Gutenberg Museum in Mainz at the Main Branch of the Louisville Free Public Library.

BIBLIOGRAPHY

Overview

Riebel, Raymond C. *Louisville Panorama: A Visual History of Louisville.* 3rd ed. Louisville, KY: Liberty National Bank and Trust Company, 1960.

Rowell, Elsie. "The Social and Cultural Contributions of the Germans in Louisville from 1848–1855." Master of arts thesis, University of Kentucky, 1941.

Stierlin, Ludwig. *Der Staat Kentucky und die Stadt Louisville mit besonderer Beruecksichtigung des Deutschen Elementes.* Louisville, KY: Anzeiger Press, 1873.

Ullrich, C. Robert, Jane K. Keller and Joseph R. Reinhart. "Germans." In *The Encyclopedia of Louisville.* Edited by John E. Kleber. Lexington: University Press of Kentucky, 2001, 328–29.

Yater, George H. *Two Hundred Years at the Falls of the Ohio: A History of Louisville and Jefferson County.* 2nd ed. Louisville, KY: Filson Historical Society, 1987.

Immigration, Xenophobia and Bloody Monday

Bodnar, John. *The Transplanted.* Bloomington: Indiana University Press, 1985.

Handlin, Oscar. *The Uprooted.* Boston: Little, Brown and Company, 1952.

Koerner, Gustave. *The German Element in the Ohio Valley.* Edited and translated by Don Heinrich Tolzmann. Baltimore, MD: Clearfield Company, 2011.

Luebke, Frederick C. *Germans in the New World.* Urbana: University of Illinois Press, 1990.

Turner, Wallace B. "The Know Nothing Movement in Kentucky." *The Filson Club History Quarterly* 28 (July 1954): 266–83.

Catholic Churches

Archdiocese of Louisville Archives. Individual parish files.

Crews, Clyde F. *An American Holy Land: A History of the Archdiocese of Louisville.* 3rd ed. Mount Vernon, IN: Windmill Publications, 1999.

Spalding, Sean, ed. *St. Martin of Tours Church: 150 Years of Worship and Service.* Louisville, KY, 2003.

Wuest, John B., OFM. *The Hundred Years of St. Boniface Parish: A Historical Sketch.* Louisville, KY, 1937.

Franciscan Friars

Conventual Franciscans, Province of Our Lady of Consolation, Mount Saint Francis, IN.

Crews, Clyde F. *An American Holy Land: A History of the Archdiocese of Louisville.* 3rd ed. Mount Vernon, IN: Windmill Publications, 1999.

Franciscan Friars, Province of St. John the Baptist of the Order of Friars Minor, Cincinnati, OH.

Ursuline Sisters and Catholic Schools

"Annals of the Ursuline Sisters of Louisville: 1858-1914." Unpublished manuscript held by the Ursuline Sisters of Louisville Archives, Louisville, KY.

Crews, Clyde F. *An American Holy Land: A History of the Archdiocese of Louisville.* 3rd ed. Mount Vernon, IN: Windmill Publications, 1999.

Schweri, Helen Margaret. *Under His Mighty Power: A History of the Ursuline Sisters of the Immaculate Conception, Louisville, Kentucky.* Louisville, KY: Ursuline Sisters, 1983.

Protestant Churches

Behney, J. Bruce, Paul H. Eller and Kenneth W. Krueger, eds. *The History of the Evangelical United Brethren Church.* Nashville, TN: Abingdon Press, 1979.

Lile, R. Kenneth. *Thy Hand Hath Provided—A Historical Rhapsody in Five Movements: A Celebrative History of the Louisville Conference of the United Methodist Conference of the United Methodist Church 1846–1996.* Franklin, TN: Providence House Publishers, 1996.

Waltmann, Henry G., ed. *History of the Indiana-Kentucky Synod of the Lutheran Church in America.* Indianapolis, IN: Central Publishing Company, Inc., 1971.

Woyke, Frank H. *Heritage and Ministry of the North American Baptist Conference.* Oakbrook Terrace, IL: North American Baptist Conference, 1979.

Protestant and Secular Schools

Fields, Linda W., Concordia Lutheran Church. Private communication, 2014.

Fowlkes, Mary Anne. "Kindergarten Movement." In *The Encyclopedia of Louisville.* Edited by John E. Kleber. Lexington: University Press of Kentucky, 2001, 483–84.

A Place in Time: The Story of Louisville's Neighborhoods. Louisville, KY: Courier-Journal and the Louisville Times Company, 1989.

Stewart, Ann Hart. "Lutherans." In *The Encyclopedia of Louisville.* Edited by John E. Kleber. Lexington: University Press of Kentucky, 2001, 579–80.

White, Terry L. *A Home for Children: A History of Brooklawn.* Edited by John E. Kleber. Louisville, KY: Montage Publishing Solutions, Inc., 2001.

William N. Hailmann Kindergarten Collection. Charles E. Young Research Library, UCLA, Los Angeles, CA.

German Christian Orphanages, Hospitals and Elder Care

Amster, Betty Lou, and Barbara G. Zingman. *The Mission: The History of Methodist Evangelical Hospital, 1960–1993.* Louisville, KY: Methodist Evangelical Hospital Foundation Inc., 1994.

Rutherford, Glenn O., and William E. Gdaniec Jr. *Love's Home: The Works and Wonders of St. Joseph Children's Home, 1849–2002.* Louisville, KY: St. Joseph Orphans Society, 2002.

White, Terry L. *A Home for Children: A History of Brooklawn (1851–2001)*. Edited by John E. Kleber. Louisville, KY: Brooklawn, 2001.

Woyke, Frank H. *Heritage and Ministry of the North American Baptist Conference*. Oakbrook Terrace, IL: North American Baptist Conference, 1979.

Jewish Community and Synagogues

Ely, Carol. *Jewish Louisville: Portrait of a Community*. Louisville, KY: Jewish Community Federation of Louisville's Foundation for Planned Giving, 2003.

Landau, Herman. *Adath Louisville: The Story of a Jewish Community*. Louisville, KY: H. Landau and Associates, 1981.

University of Louisville. Oral History Collection.

Weissbach, Lee Shai. *The Synagogues of Kentucky: Architecture and History*. Lexington: University Press of Kentucky, 1995.

Newspapers

Arndt, Karl J.R., and May E. Olson. *German-American Newspapers and Periodicals 1732–1955*. Heidelberg, Germany: Quelle & Meyer, 1961.

Stierlin, Ludwig. *Der Staat Kentucky und die Stadt Louisville mit besonderer Beruecksichtigung des Deutschen Elementes*. Louisville, KY: Anzeiger Press, 1873.

Wittke, Carl Frederick. *German-Language Press in America*. Lexington: University of Kentucky Press, 1957.

Breweries

Guetig, Peter R., and Conrad D. Selle. *Louisville Breweries: A History of the Brewing Industry in Louisville, Kentucky, New Albany, and Jeffersonville, Indiana*. Louisville, KY: Mark Skaggs Press, 2014.

Insurance Maps of Louisville, Kentucky. New York: Sanborn Map Company, 1892 and 1905.

Louisville Anzeiger, 1849–1938.

One Hundred Years of Brewing in America. Chicago, IL: H.S. Rich and Company, 1903.

Saloons and Beer Gardens

Guetig, Peter R., and Conrad D. Selle. *Louisville Breweries: A History of the Brewing Industry in Louisville, Kentucky, New Albany, and Jeffersonville, Indiana.* Louisville, KY: Mark Skaggs Press, 2014.

Insurance Maps of Louisville, Kentucky. New York: Sanborn Map Company, 1892 and 1905.

Louisville Anzeiger, 1849–1938.

Louisville Daily Journal. "Among the Beer Kegs." July 7, 1868.

Singing Societies

Gwinn, Erna Ottl. "The Liederkranz in Louisville 1848–1877." *The Filson Club History Quarterly* 49 (July 1975): 276–90.

———. "The Liederkranz in Louisville 1877–1959." *The Filson Club History Quarterly* 55 (January 1981): 40–59.

———. "Liederkranz Society." In *The Encyclopedia of Louisville.* Edited by John E. Kleber. Lexington: University Press of Kentucky, 2001, 513.

Hill, Mildred. "History of Music in Louisville." In *The Memorial History of Louisville from Its First Settlement to the Year 1896*. Vol. 2. Edited by J. Stoddard Johnston. New York: American Biographical Publishing Company, 1896, 85–97.

Lee, Alfred E. *History of the City of Columbus, Capital of Ohio.* New York: Munsell & Company, 1892.

Wengler, Wolfgang H., assistant archivar, Nord-Amerikanischer Sängerbund. Private communication, 2014.

The Turners

Hofmann, Annette R. *The American Turner Movement: A History from Its Beginnings to 2000.* Indianapolis: IUPUI Max Kade German-American Center and the Indiana German Heritage Society Inc., 2010.

Louisville Courier-Journal. "Exercises by Vorwaerts: An Enjoyable Gymnastic Exhibition by German Turners at National Park Yesterday." August 19, 1889.

———. "Louisville Turners: A History of the Society with a Successful Record in War and in Peace." June 22, 1889.

Metzner, Henry. *History of the American Turners*. 3rd ed. Rochester, NY: National Council of the American Turners, 1974.

Steinlage, Forrest F. "Turners/Turnvereins." In *The Encyclopedia of Louisville*. Edited by John E. Kleber. Lexington: University Press of Kentucky, 2001, 894–95.

Butchertown

Kubala, Edna. *Louisville's Butchertown*. Charleston, SC: Arcadia Publishing, 2010.

A Place in Time: The Story of Louisville's Neighborhoods. Louisville, KY: Courier-Journal and the Louisville Times Company, 1989.

Pohlkamp, Diomede. *Butchertown of Yesterday*. Louisville, KY: Rogers Church Goods Company, 1946.

The Shotgun House: Urban Housing Opportunities. Louisville, KY: Preservation Alliance of Louisville and Jefferson County, 1980.

Williams, David. "Butchertown." In *The Encyclopedia of Louisville*. Edited by John E. Kleber. Lexington: University Press of Kentucky, 2001, 149–50.

Germans in the Mexican War and the Civil War

Keller, Christian B. "New Perspectives in Civil War Ethnic History and Their Implications for Twenty-First Century Scholarship." In *This Distracted and Anarchical People: New Answers for Old Questions about the Civil War–Era North*. Edited by Andrew L. Slap and Michael Thomas Smith. New York: Fordham University Press, 2013, 123–41.

Louisville Anzeiger, 1849–1938.

Reinhart, Joseph R. *A History of the 6th Kentucky Volunteer Infantry U.S.* Louisville, KY: Beargrass Press, 2000.

Report of the Adjutant General of the State of Kentucky. Vols. 1–2, *1861–1866 (Union)*. Frankfort, KY: John H. Harney, 1866.

Report of the Adjutant General of the State of Kentucky: Mexican War Veterans. Frankfort, KY: John D. Woods, 1889.

Stierlin, Ludwig. *Der Staat Kentucky und die Stadt Louisville mit besonderer Beruecksichtigung des Deutschen Elementes*. Louisville, KY: Anzeiger Press, 1873.

Manufacturing

American Carpenter and Builder Magazine, October 1908.

Ashland (KY) Sunday Independent, n.d.

"Bittner's." In *The Encyclopedia of Louisville*. Edited by John E. Kleber. Lexington: University Press of Kentucky, 2001, 94.

Bowling Green (KY) Daily News, April 1, 1973.

Carrell, William P. "National Tobacco Works." In *The Encyclopedia of Louisville*. Edited by John E. Kleber. Lexington: University Press of Kentucky, 2001, 647–48.

Falk, Gary. *Made in Louisville*. Louisville, KY: Publisher's Printing Company, 2013.

Johnston, J. Stoddard. "Personal History and Biography." In *The Memorial History of Louisville from Its First Settlement to the Year 1896*. Vol. 2. Edited by J. Stoddard Johnston. New York: American Biographical Publishing Company, 1896, 361–642.

Kramer, Carl E. "Meatpacking." In *The Encyclopedia of Louisville*. Edited by John E. Kleber. Lexington: University Press of Kentucky, 2001, 602–03.

Louisville Kentucky: Resources and Industries. Louisville, KY: Louisville Railroad Publishing Company, 1903.

Rockwell, Anne. Private communication, 2014.

Ullrich, C. Robert, Jane K. Keller and Joseph R. Reinhart. "Germans." In *The Encyclopedia of Louisville*. Edited by John E. Kleber. Lexington: University Press of Kentucky, 2001, 328–29.

Agriculture and Food Industries

History of the Falls Cities and Their Counties. Vol. 1. Cleveland, OH: L.A. Williams & Company, 1882.

Kramer, Carl E. *Drovers, Dealers, and Dreamers: 150 Years at Bourbon Stock Yards, 1834–1984*. Louisville, KY: Bourbon Stock Yard Company, 1984.

———. "Meatpacking." In *The Encyclopedia of Louisville*. Edited by John E. Kleber. Lexington: University Press of Kentucky, 2001, 602–03.

Louisville Anzeiger. Sixtieth anniversary issue, June 27, 1909.

A Place in Time: The Story of Louisville's Neighborhoods. Louisville, KY: Courier-Journal and the Louisville Times Company, 1989.

Whiskey Industries

Bernheim, Isaac Wolfe. *The Story of the Bernheim Family*. Louisville, KY: John P. Morton & Company, 1910.

Veach, Michael R. *Kentucky Bourbon Whiskey: An American Heritage*. Lexington: University Press of Kentucky, 2013.

Hotels and Restaurants

Garr, Robin. "Real German Comfort Food at Gasthaus." *Louisville Eccentric Observer*, June 18, 2014.

"Hasenour's Restaurant." In *The Encyclopedia of Louisville*. Edited by John E. Kleber. Lexington: University Press of Kentucky, 2001, 575.

Louisville Courier-Journal. "License Surrendered after Threat of Arrest." May 3, 1916.

———. "Old Inn Offered for Sale by Seelbach Interests." September 7, 1913.

———. "Rufer's Hotel." May 7, 1876.

———. "The Seelbach Opens in Welcome to Thousands." May 2, 1905.

———. "The Treacherous Trigger." February 25, 1882.

———. Zapp's Restaurant and Deli advertisement. July 2, 1922.

Louisville Morning Courier. "Marble Hall." April 30, 1849.

Perkins, Gay Helen. "Kunz's Restaurant." In *The Encyclopedia of Louisville*. Edited by John E. Kleber. Lexington: University Press of Kentucky, 2001, 491.

"Senning's Park." In *The Encyclopedia of Louisville*. Edited by John E. Kleber. Lexington: University Press of Kentucky, 2001, 803.

Western Coffee-House and Hyman's Altar advertisement. In *Louisville Directory of the Year 1832*. Louisville, KY: Richard W. Otis, 1832.

Dry Goods and Department Stores

Bennett, Jim. "Birmingham's Confederate Reunion of 1916 Drew Thousands." *Jefferson County Historical Association Newsletter*. Birmingham, AL, January 2014.

Ely, Carol. *Jewish Louisville: Portrait of a Community*. Louisville, KY: Jewish Community Federation of Louisville's Foundation for Planned Giving, 2003.

Grossman, Lee L., and Ken L. Grossman. Private communication, 2011.

Miller, Kenneth L. "Department Stores." In *The Encyclopedia of Louisville*. Edited by John E. Kleber. Lexington: University Press of Kentucky, 2001, 244–46.

Williams, Rusty. *My Old Confederate Home: A Respectable Place for Civil War Veterans*. Lexington: University Press of Kentucky, 2010.

Dairies

Allen, Robert McDowell. *Milk Supply of Kentucky: Louisville*. Vol. 133–46. Lexington: Agricultural Experiment Station of the State College of Kentucky, 1908.

Ewing, Niels. "Dairies." In *The Encyclopedia of Louisville*. Edited by John E. Kleber. Lexington: University Press of Kentucky, 2001, 237–38.

Valenze, Deborah. *Milk: A Local and Global History*. New Haven, CT: Yale University Press, 2011.

Bakeries and Confectioneries

Daut, Carrie. "The Circuit." *Louisville Magazine*, March 2012, 11.

"Ehrmann's Bakery." In *The Encyclopedia of Louisville*. Edited by John E. Kleber. Lexington: University Press of Kentucky, 2001, 268.

Lashley, Lea. "Sweet Memories: Childhood Bakeshop Inspiration for 7-Eleven's Newest Breakfast Treat." *Dallas Examiner*, February 15, 2010.

Louisville Courier-Journal. "The Evolution of a Bakery." November 2, 1919.

Woodward, Mary Alan. "Muth's Candy Store Is a Proud Downtown Landmark." *St. Matthews (KY) Voice-Tribune*, February 9, 2012.

Pharmacies

Bell, Mary Margaret. "Pharmacy." In *The Encyclopedia of Louisville*. Edited by John E. Kleber. Lexington: University Press of Kentucky, 2001, 699–701.

Diehl, C. Lewis. "Pharmacy and Pharmicists." In *The Memorial History of Louisville from Its First Settlement to the Year 1896*. Vol. 2. Edited by J. Stoddard Johnston. New York: American Biographical Publishing Company, 1896, 49–56.

Rockwell, Anne Buschemeyer. Private communication, 2014.

Stierlin, Ludwig. *Der Staat Kentucky und die Stadt Louisville mit besonderer Beruecksichtigung des Deutschen Elementes.* Louisville, KY: Anzeiger Press, 1873.

Funeral Homes and Cemeteries

"Adath Israel Cemetery and Temple Cemetery." National Register of Historic Places Inventory, Nomination Form. Washington, D.C.: U.S. Department of the Interior, 1981.

Riehm, C.E. "Catholic Cemeteries of Louisville and Jefferson County." Louisville, KY: Archdiocese of Louisville, 1979. Unpublished manuscript held by Catholic Cemeteries, Louisville, KY.

Germantown and Schnitzelburg

Craskey, Erin, Reverend Jerry Eifler and Steve Magre. *Louisville's Germantown and Paristown: A Unique Short History.* Fortieth anniversary booklet. Louisville, KY: Germantown-Paristown Neighborhood Association, 2013.

"Germantown." In *The Encyclopedia of Louisville.* Edited by John E. Kleber. Lexington: University Press of Kentucky, 2001, 339–40.

Heil, James. "Germantown, 1885–1935." Unpublished manuscript held by Donald A. Haag Sr., Louisville, KY.

"Schnitzelburg." In *The Encyclopedia of Louisville.* Edited by John E. Kleber. Lexington: University Press of Kentucky, 2001, 790.

Anti-German Sentiment during the World Wars

Holl, Richard E. "Swastikas in the Bluegrass." *Register of the Kentucky Historical Society* 100 (Spring 2002): 139–66.

Krock, Arthur. *The Editorials of Henry Watterson.* New York: George H. Doran Company, 1923.

Luebke, Friedrich C. *Germans in the New World.* Urbana: University of Illinois Press, 1990.

Rippley, LaVern J. *The German-American.* Boston: Twayne Publishers, 1976.

Yater, George H. *Two Hundred Years at the Falls of the Ohio: A History of Louisville and Jefferson County.* 2nd ed. Louisville, KY: Filson Historical Society, 1987.

German Cultural Influences in Modern Times

Koerner, Gustave. *The German Element in the Ohio Valley.* Edited and translated by Don Heinrich Tolzmann. Baltimore, MD: Clearfield Company, 2011.

Rattermann, Heinrich A. *Kentucky's German Pioneers: Heinrich A. Rattermann's History*. Edited and translated by Don Heinrich Tolzmann. Westminster, MD: Heritage Books Inc., 2007.

Tolzmann, Don Heinrich. *German-Americana: Selected Essays*. Milford, OH: Little Miami Publishing Company, 2009.

INDEX

Y

Z

The authors. *From left to right, seated*: Conrad D. Selle, Sister Martha Jacob, Holly Jenkins-Evans, Joseph R. Reinhart, Carl E. Kramer, Gary Falk, Kathleen Pellegrino, Peter R. Guetig, Victoria A. Ullrich and C. Robert Ullrich; *standing*: Michael E. Maloney, Mary Margaret Bell, John E. Kleber, Mary Jean Kinsman (editor), Reverend Gordon A. Seiffertt, William C. Schrader, Kevin Collins, Robert J. Ehrler and Donald A. Haag Sr. *Not shown*: Rick Bell, Father Adam Bunnell, Carol A. Ely, Jordan M. Gabbard (editor), Father Camillus Gott, Jane K. Keller, Edna Kubala-Mott, Mary Ann Sherby (editor), Don Heinrich Tolzmann and Michael R. Veach. *Courtesy Duke Marsh.*

ABOUT THE AUTHORS

MARY MARGARET BELL, coordinator, Archives and Retrieval Systems, Jefferson County Public Schools, and author of "Pharmacy" and "Taylor Drug Stores" in *The Encyclopedia of Louisville* (2001).

RICK BELL, historian and author of *The Great Flood of 1937: Rising Waters, Soaring Spirits* (2007) and *Louisville's Waterfront Park: A Riverfront Renaissance* (2011).

FATHER ADAM BUNNELL, OFM CONV., PHD, special assistant to the president for International and Interfaith Relations, Bellarmine University and author of *Before Infallibility: Liberal Catholicism in Biedermeier Vienna* (1990).

KEVIN COLLINS, author of more than fifty articles on law, civil liberties and Kentucky history for five encyclopedias and one magazine.

ROBERT J. EHRLER, in-house attorney for a major corporation and owner of Ehrler's Micro Dairy.

CAROL A. ELY, PHD, executive director of Historic Locust Grove, adjunct professor of public history, University of Louisville and author of *Jewish Louisville: Portrait of a Community* (2003).

GARY FALK, historian, author of *Louisville Remembered* (2009) and *Made in Louisville* (2013) and coauthor of "Music" in *The Encyclopedia of Louisville*

(2001) and "Louisville Musical History" in *The New Grove Dictionary of Music and Musicians* (2013).

FATHER CAMILLUS GOTT, OFM CONV., PHD, guardian of St. Paul Friary, Louisville, Kentucky.

PETER R. GUETIG, coauthor of *Louisville Breweries: A History of the Brewing Industry in Louisville, Kentucky, New Albany, and Jeffersonville, Indiana* (2014) and "Beer Gardens" and "Brewing Industry" in *The Encyclopedia of Louisville* (2001).

DONALD A. HAAG SR., longtime Germantown resident and authority on Louisville's Germantown and Schnitzelburg neighborhoods.

SISTER MARTHA JACOB, OSU, PHD, archivist for the Ursuline Sisters of Louisville.

HOLLY JENKINS-EVANS, owner of Past Perfect Vintage Clothing and author of *Louisville Department Stores: A Short History* (2011).

JANE K. KELLER, retired Jefferson County Public Schools English teacher and coauthor of "Germans" in *The Encyclopedia of Louisville* (2001).

JOHN E. KLEBER, PHD, professor emeritus of history, Morehead State University, and editor of six books, including *The Kentucky Encyclopedia* (1992) and *The Encyclopedia of Louisville* (2001).

CARL E. KRAMER, PHD, retired director, Institute for Local and Oral History; adjunct assistant professor of history, Indiana University Southeast; and author of twelve books about the history of the Louisville Metropolitan area.

EDNA KUBALA-MOTT, historian and author of *Louisville's Butchertown* (2010).

MICHAEL E. MALONEY, Louisville Mayor's Office for Special Events.

KATHLEEN PELLEGRINO, former vice-president and deputy general counsel of Humana, Inc.

Joseph R. Reinhart, historian and author of five books about Germans in the Civil War and coauthor of "Germans" in *The Encyclopedia of Louisville* (2001).

William C. Schrader, PhD, professor emeritus of history, Tennessee Technological University.

Reverend Gordon A. Seiffertt, retired UCC minister and authority on German Evangelical and Reformed churches in Louisville.

Conrad D. Selle, coauthor of *Louisville Breweries: A History of the Brewing Industry in Louisville, Kentucky, New Albany, and Jeffersonville, Indiana* (2014) and "Beer Gardens" and "Brewing Industry" in *The Encyclopedia of Louisville* (2001).

Don Heinrich Tolzmann, PhD, professor emeritus of German-American studies, University of Cincinnati; president of the Society for German-American Studies; and author of more than twenty-five books about German American history.

C. Robert Ullrich, PhD, professor emeritus of civil and environmental engineering, University of Louisville, and coauthor of "Germans" in *The Encyclopedia of Louisville* (2001).

Victoria A. Ullrich, president of the German-American Club, Germanic Heritage Auxiliary.

Michael R. Veach, bourbon historian for the Filson Historical Society, author of *Kentucky Bourbon Whiskey: An American Heritage* (2013) and author of fifteen entries on whiskey industries in *The Encyclopedia of Louisville* (2001).

Visit us at
www.historypress.net
..
This title is also available as an e-book